Design and the Elastic Mind

The Museum of Modern Art, New York

Published on the occasion of the exhibition Design and the Elastic Mind, February 24–May 12, 2008, at The Museum of Modern Art, New York, organized by Paola Antonelli, Senior Curator, and Patricia Juncosa Vecchierini, Curatorial Assistant, Department of Architecture and Design

The exhibition is made possible by the Mrs. Hedwig A. Van Ameringen Architecture and Design Exhibition Fund.

Generous funding is provided by NTT DoCoMo, Inc., and Patricia Phelps de Cisneros.

Additional support is provided by The Contemporary Arts Council of The Museum of Modern Art.

Produced by the Department of Publications, The Museum of Modern Art, New York
Edited by Libby Hruska and Rebecca Roberts
Designed by Irma Boom
Production by Elisa Frohlich
Typeset in Courier Sans
Printed and bound by Oceanic Graphic Printing, Inc., China
Printed on 120 gsm Arctic Amber Preprint

In reproducing the images contained in this publication, the Museum obtained the permission of the rights holders whenever possible. In those instances where the Museum could not locate the rights holders, notwithstanding good-faith efforts, it requests that any contact information concerning such rights holders be forwarded, so that they may be contacted for future editions.

Library of Congress Control Number: 2007939768
ISBN: 978-0-87070-732-2

Published by
The Museum of Modern Art
11 West 53 Street, New York, NY 10019-5497
www.moma.org

Distributed in the United States and Canada by D.A.P./Distributed Art Publishers, Inc., New York

Distributed outside the United States and Canada by Thames & Hudson, Ltd., London

Cover design by Irma Boom
Cover type by Daniël Maarleveld

Printed in China

Contents

4 Foreword
Glenn D. Lowry

8 Preface
Barry Bergdoll

14 **Design and the Elastic Mind**
Paola Antonelli

28 Portfolio 1

46 **Applied Curiosity**
Hugh Aldersey-Williams

58 Portfolio 2

80 **Nanotechnology:
Design in the Quantum Vernacular**
Ted Sargent

98 Portfolio 3

120 **Critical Visualization**
Peter Hall

132 Portfolio 4

150 **All Together Now!**
Paola Antonelli

162 Portfolio 5

186 Index
189 Photograph Credits
190 Acknowledgments
191 Trustees of The Museum of Modern Art

Foreword

With Design and the Elastic Mind, The Museum of Modern Art once again ventures into the field of experimental design, where innovation, functionality, aesthetics, and a deep knowledge of the human condition combine to create outstanding artifacts. MoMA has always been an advocate of design as the foremost example of modern art's ability to permeate everyday life, and several exhibitions in the history of the Museum have attempted to define major shifts in culture and behavior as represented by the objects that facilitate and signify them. Shows like Italy: The New Domestic Landscape (1972), Designs for Independent Living (1988), Mutant Materials in Contemporary Design (1995), and Workspheres (2001), to name just a few, highlighted one of design's most fundamental roles: the translation of scientific and technological revolutions into approachable objects that change people's lives and, as a consequence, the world. Design is a bridge between the abstraction of research and the tangible requirements of real life.

The state of design is strong. In this era of fast-paced innovation, designers are becoming more and more integral to the evolution of

society, and design has become a paragon for a constructive and effective synthesis of thought and action. Indeed, in the past few decades, people have coped with dramatic changes in several long-standing relationships—for instance, with time, space, information, and individuality. We must contend with abrupt changes in scale, distance, and pace, and our minds and bodies need to adapt to acquire the elasticity necessary to synthesize such abundance. Designers have contributed thoughtful concepts that can provide guidance and ease as science and technology proceed in their evolution. Design not only greatly benefits business, by adding value to its products, but it also influences policy and research without ever reneging its poietic, nonideological nature—and without renouncing beauty, efficiency, vision, and sensibility, the traits that MoMA curators have privileged in selecting examples for exhibition and for the Museum's collection.

Design and the Elastic Mind celebrates creators from all over the globe—their visions, dreams, and admonitions. It comprises more than two hundred design objects and concepts that marry the most advanced scientific research with the most attentive consideration of human limitations, habits, and aspirations. The objects range from

nanodevices to vehicles, from appliances to inter-
faces, and from pragmatic solutions for everyday
use to provocative ideas meant to influence our
future choices. Organized by Paola Antonelli,
Senior Curator, Department of Architecture and
Design, and Patricia Juncosa Vecchierini, Curatorial
Assistant, this exhibition reaffirms the Museum's
engagement with contemporary design practice
and its ongoing reflection on the future respon-
sibilities of design.

Glenn D. Lowry
Director, The Museum of Modern Art

Preface

Design and the Elastic Mind explores the explosively reciprocal relationship between science and design in the contemporary world. After a generation of postmodern styling in which design seemed more related to the techniques of marketing than to the horizons of new knowledge, this exhibition brings together a truly impressive range of current practices, reflecting a mutual interchange that is almost without precedent. Of course, at least since the scientific revolution of the sixteenth and seventeenth centuries, design and science have been intertwined in a way first dreamed of by Leonardo da Vinci. By the time of Francis Bacon and Galileo, design was serving as the handmaiden to laboratory experimentation, which itself was key to the new scientific knowledge, based in observation. Design and science first aligned in making invisible harmonies and mechanics visible. Objects were conceived both as instruments to lay bare nature's secrets and as concrete representations of that newfound knowledge. As this knowledge ever-increasingly surpassed the physical realm of everyday perception, design came to reflect the underlying structures and patterns of nature, as seen through magnification first by telescope, then by microscope, and later by new types of photography, such as X-rays and the like. All of these had a dramatic impact on artistic practices, and also on design.

In recent years the threshold of perception has transcended the visual altogether. Medicine has developed techniques for imaging phenomena that do not have a visual manifestation, and natural phenomena are recorded in abstract patterns that have no counterparts in the observable world. Design, too, deals increasingly with a wider spectrum of the senses. It is vital to the creation of the physical forms and representations that allow research to be communicated, expanded, and, ultimately, applied.

Continuing an investigation she began in 2002 with the exhibition and catalogue SAFE: Design Takes On Risk, in Design and the Elastic Mind Paola Antonelli addresses the role of design in a world in which humans have surpassed their Enlightenment roles as neutral observers and have become actors on the very forces of nature. While the show's viewpoint is largely optimistic, embracing science and design as agents of progress, there is also a clear undertone of urgency. Together, design and science must deal with the consequences of our ability to engineer natural phenomena. In the wake of the 2007 Global Environment Outlook report of the United Nations Environment Program, the urgency is no longer anecdotal.

The prescience of this book and of the exhibition it accompanies—and, indeed, of the works, themselves—lies in the recognition of a very concrete trend. The blurring of boundaries between the real and the virtual and our ever-increasing reliance on advanced

technology in everyday life have prompted designers to look to the languages and processes of today's mutating sciences. At the same time, scientists have discovered that design can help them master complexity and take advantage of the new building blocks provided by nanotechnology, for instance. Design and the Elastic Mind is not concerned only with designers who have an interest in the latest scientific achievements, but also with scientists who are (unconsciously or otherwise) engaged in the act of design.

The emphasis on scale in design, from the dazzlingly large to the infinitesimally small, has its antecedents in the influential 1968 film Powers of Ten, by Charles and Ray Eames. That seminal film, created during the period of the Cold War, demonstrates an incredibly contemporary concern. As in the Cold War era, in today's political and scientific climate huge techno-logical and scientific advances are underway and new behaviors are projected and celebrated. As then, we are gripped by the anxiety that accompanies rapid change, from the Internet's profound restructuring of our everyday lives to our capacity to map the human genome, while we simultaneously engage in astoundingly hopeful explorations of both aesthet-ics and technology. It is the elastic mind—with the flexibility and strength to embrace progress and to harness it—that is best suited to confront this world of seemingly limitless challenges and possibilities.

Design and the Elastic Mind explores the changing scales of experiment in contemporary design and science, recalibrating design and its role in the shaping of experience.

Barry Bergdoll
Philip Johnson Chief Curator of
Architecture and Design

Ben Fry (American, born 1975)
Aesthetics + Computation Group (est. 1996),
MIT Media Laboratory (USA, est. 1980)
Genomic Cartography: Chromosome 21. 2001
Processing software

Design and the Elastic Mind
Paola Antonelli

History is punctuated by uproariously wrong
predictions made by savvy individuals blindsided by
progress: Ferdinand Foch, Marshal of France in the
early part of the twentieth century, stated in
1911 that airplanes were interesting toys of no
use for the military; movie producer Darryl F.
Zanuck forecast in 1946 the demise of television;
and Ken Olsen, of Digital Equipment Corporation,
dismissed in 1977 the idea that anyone would want
to keep a computer at home. Revolutions are not
easy on us, especially when they occur as rapidly
and as frequently as they have in the past 150
years. A few exceptional individuals are already
wired for change, and the masses have a tendency
to either admire them as visionaries or burn them
at the stake as witches and heretics. However,
these individuals do not represent the majority.
In order to step boldly into the future, the
majority needs design.
 Adaptability is an ancestral distinction of human
intelligence, but today's instant variations in
rhythm call for something stronger: elasticity.
The by-product of adaptability + acceleration,
elasticity is the ability to negotiate change
and innovation without letting them interfere
excessively with one's own rhythms and goals.
It means being able to embrace progress, under-
standing how to make it our own. One of design's
most fundamental tasks is to help people deal
with change. Designers stand between revolutions
and everyday life. They study and appreciate

people's strengths and insecurities, their need for easy access to objects and systems and their cautiously adventurous wishes—a little frisson a day is acceptable but anything more becomes overwhelming. Designers have the ability to grasp momentous changes in technology, science, and social mores and to convert them into objects and ideas that people can understand and use. Without designers, instead of a virtual city of home pages with windows, doors, buttons, and links, the Internet would still be a series of obscure strings of code,[1] all cars would look like technologically updated Model Ts, and appliances would be reduced to standardized skeletons. Without a visual design translation, many fundamental concepts—such as the scope of the human genome or its comparison with that of other primates (see p. 142)—would remain ungraspable by most. Designers give life and voice to objects, and along the way they manifest our visions and aspirations for the future, even those we do not yet know we have.

Each new technological era brings its own malady, a sense of displacement that inevitably accompanies innovation—that is why innovation is often disruptive. Like East Germans after the fall of the Berlin Wall, some feel nostalgia for a more comfortable, albeit less progressive, past. Let's count today's disruptions: We routinely live at different scales, in different contexts, and at different settings—Default, Phone-only, Avatar On, Everything Off—on a number of screens, each with its own size, interface, and resolution, and across several time zones. We change pace often, make contact with diverse groups and individuals,

sometimes for hours, other times for minutes, using means of communication ranging from the most encrypted and syncopated to the most discursive and old-fashioned, such as talking face-to-face—or better, since even this could happen virtually, let's say nose-to-nose, at least until smells are translated into digital code and transferred to remote stations. We isolate ourselves in the middle of crowds within individual bubbles of technology, or sit alone at our computers to tune into communities of like-minded souls or to access information about esoteric topics.

Over the past twenty-five years, under the influence of such milestones as the introduction of the personal computer, the Internet, and wireless technology, we have experienced dramatic changes in several mainstays of our existence, especially our rapport with time, space, the physical nature of objects, and our own essence as individuals. In order to embrace these new degrees of freedom, whole categories of products and services have been born, from the first clocks with mechanical time-zone crowns to the most recent devices that use the Global Positioning System (GPS) to automatically update the time the moment you enter a new zone. Our options when it comes to the purchase of such products and services have multiplied, often with an emphasis on speed and automation (so much so that good old-fashioned cash and personalized transactions—the option of talking to a real person—now carry the cachet of luxury). Our mobility has increased along with our ability to communicate, and so has our capacity to influence the market with direct feedback, making us all into arbiters and opinion makers. Our idea of privacy and private property has evolved in unexpected ways, opening the door

top: James Powderly, Evan Roth, Theo Watson, and HELL. Graffiti Research Lab. **L.A.S.E.R. Tag.** Prototype. 2007. 60 mW green laser, digital projector, camera, and custom GNU software (L.A.S.E.R. Tag V1.0, using OpenFrameworks)

New forms of communication transcend scale and express a yearning to share opinions and information. This project simulates writing on a building. A camera tracks the beam painter of a laser pointer and software transmits the action to a very powerful projector.

Design and the Elastic Mind

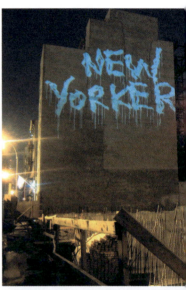

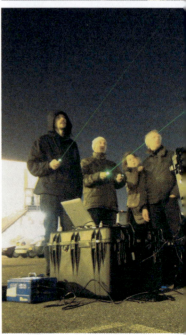

Paola Antonelli Design and the Elastic Mind

bottom: James Powderly, Evan
Roth, Theo Watson, DASK, FOXY
LADY, and BENNETT4SENATE.
Graffiti Research Lab. **L.A.S.E.R.
Tag graffiti projection system.**
Prototype. 2007. 60 mW green
laser, digital projector, camera,
custom GNU software (L.A.S.E.R.
Tag V1.0, using OpenFrameworks),
and mobile broadcast unit

for debates ranging from the value of copyright
to the fear of ubiquitous surveillance.[2] Software
glitches aside, we are free to journey through
virtual-world platforms on the Internet. In fact,
for the youngest users there is almost no differ-
ence between the world contained in the computer
screen and real life, to the point that some digital
metaphors, like video games, can travel backward
into the physical world: At least one company,
called area/code, stages "video" games on a large
scale, in which real people in the roles of, say, Pac
Man play out the games on city streets using mobile
phones and other devices.

<u>Design and the Elastic Mind</u> considers these
changes in behavior and need. It highlights current
examples of successful design translations of
disruptive scientific and technological innovations,
and reflects on how the figure of the designer is
changing from form giver to fundamental interpreter
of an extraordinarily dynamic reality. Leading up to
this volume and exhibition, in the fall of 2006 The
Museum of Modern Art and the science publication
<u>Seed</u> launched a monthly salon to bring together
scientists, designers, and architects to present
their work and ideas to each other. Among them
were Benjamin Aranda and Chris Lasch, whose
presentation immediately following such a giant of
the history of science as Benoit Mandelbrot was
nothing short of heroic, science photographer Felice
Frankel, physicist Keith Schwab, and computational
design innovator Ben Fry, to name just a few.[3]
Indeed, many of the designers featured in this
book are engaged in exchanges with scientists,
including Michael Burton and Christopher Woebken,
whose work is influenced by nanophysicist Richard
A. L. Jones; Elio Caccavale, whose interlocutor is
Armand Marie Leroi, a biologist from the Imperial

College in London; and the designers from Loop.pH, who are working on a project with John Walker, the winner of the 1997 Nobel Prize for Chemistry.[4]

As Hugh Aldersey-Williams discusses in his essay in this volume, the exploration of the promising relationship between science and design is of particular relevance. While technology still traditionally acts as the interface, the conversation between design and science has become more direct and focused. What the computer has done for designers, the nanoscale is doing for scientists: It is giving them a whole new taste of the power of unobstructed design and manufacture. In an outstanding essay in the 2006 book Sensorium: Embodied Experience, Technology, and Contemporary Art, Peter Galison introduces the concept of "nanofacture": "Nanoscientists want to know what devices they can make....In the halls of 'pure' science, such a pragmatic stance toward the real is still relatively new. Indeed, it is an extraordinary and extraordinarily disturbing alteration of the practice of research, and in the very self-definition of what it means to be a scientist."[5] Scientists Thomas G. Mason and Carlos J. Hernandez, architecture firm Aranda/Lasch, nanotechnologist Paul W. K. Rothemund, and designer James King are examples of those engaging in an embryonic dialogue between design and science that is bound to change the world.

Fundamental to this dialogue is the appreciation of the role of scale in contemporary life. Two essays, the first by nanophysicist Ted Sargent and the second by visualization design expert Peter Hall, describe the ways in which scientists and designers tackle the extremely small and the extremely large in order to bring them to a human scale. Last comes my own essay about scale, albeit of the social kind, which discusses the remarkable new relationship between the individual and the collective sphere and the effects it is having on the theory and practice of our built environment.

All of these essays are accompanied by examples

below and bottom: Dick Powell and Richard Smith. Seymourpowell. SpaceShipTwo: Interior for Virgin Galactic Spaceship. Concept. 2006

Steamships, trains, telephones, and airplanes changed our sense of scale and our rapport with time and space. Suborbital flight will soon push us even farther.

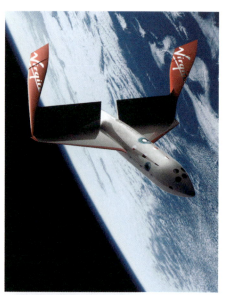

9 Johan Liden and aruliden. **Motorola Sparrow RFID (Radio Frequency Identification) scanning device.** Concept. 2006–ongoing. Injection-molded plastic, glass, and aluminum, 2 3/4 x 2 3/4 x 1/2" (7 x 7 x 103 cm)

The time has come to take control of the dozens of features available for portable devices. Getting more information on the surrounding context—whether commercial, cultural, or geographic—is a function that will presumably become more and more important.

of singular design creativity that introduce new areas of study and influence as well as the new types of functional gradients that designers are trying to endow objects with, taking their cues from sources as varied as nanostructures, biological systems, topography, and cosmology. The goal is to facilitate as seamless a movement as possible from fast to slow, virtual to physical, cerebral to sensual, automatic to manual, dynamic to static, mass to niche, global to local, organic to inorganic, and proprietary to common, to mention just a few extreme couplings. Some examples are by bona fide designers, others by scientists and artists who have turned to design to give method to their productive tinkering, what John Seely Brown has called "thinkering."[6] They all belong to a new culture in which experimentation is guided by engagement with the world and open, constructive collaboration with colleagues and other specialists.

Design 1:1

Today, many designers have turned several late twentieth-century infatuations on their heads, for instance with speed, dematerialization, miniaturization, and a romantic and exaggerated formal expression of complexity. After all, there is a limit beyond which micro-keyboards are too small for a person's fingers and complexity simply becomes too overwhelming. Examples abound in all fields of people's desire to return to what is perceived as a human dimension, including gastronomy (the Slow Food movement), agriculture (organic produce), travel (ecotourism), production of energy (distributed generation), economic aid (microinvestment), and politics (the town hall meeting), to name just a few.[7] These all revolve around the idea that global issues should be tackled bottom-up and that an individual or local spark can start a powerful chain reaction with global implications.

The most contemporary of design theory is devoted to the quest for an environment, whether virtual

or physical, built in human proportion—much the way in architecture a hypothetical 1:1 model would represent buildings as life size. Designers who believe in this preach simplicity, and they labor to give objects souls and personality and to ease their communication with people and with other objects.[8] They apply the same bottom-up methodology to spawn innovations that are organically attuned to human nature and to the world, and they rework priorities so that human beings always come before any celebration of progress, as in the project One Laptop per Child or in Jonathan Harris's moving Internet interface We Feel Fine. These designers domesticate innovation and make sure that objects will deliver value and meaning and therefore justify their presence in people's lives, as with Mathieu Lehanneur's delicately high-tech Elements. And out of consideration for people's well-being, they help us incorporate healthy behaviors within our frenetic habits, as seen in Marie-Virginie Berbet's Narco office capsule.

The idea of human scale has changed since Charles and Ray Eames's famous 1968 film <u>Powers of Ten</u> because human perception has been expanded and augmented by technology. Distance is not what it used to be, and neither is time: Not only does it range from the attosecond (10^{-18} seconds, or the time it takes for light to travel the length of three hydrogen atoms) to the Long Now, the concept that inspired Danny Hillis to establish a foundation whose goal is to promote thinking for the next ten thousand years,[9] but some professionals' routine commute is a twice-a-month Tokyo–New York round-trip while others work across several time zones without a need to state their position at any time. Indeed, where and when have become hard to pin down on any who.[10] There is a standoff between the two ancient Greek notions of time: chronos, the shared convention of sequential time marked by the sundial, and kairos, the subjective moment that allows an individual to adapt and evolve with circumstances. While no one would argue that we are beholden to the former, the shift toward the latter is seen in the urge to record and share personal, life-defining moments that is at the source of the proliferation

Farshid Guilak and Franklin Moutos. Orthopaedic Bioengineering Laboratory, Duke University School of Medicine. **3-D woven scaffolds for tissue regeneration.** 2001–07. Poly(glycolic acid) fibers or poly(e-caprolactone) fibers, woven fiber scaffold: 1 1/8 × 11 3/4 × 1/32" (3 × 30 × 0.1 cm); weaving machine: 23 5/8 × 39 3/8 × 39 3/8" (60 × 100 × 100 cm)

Scientists study textile weaving and other crafts techniques in order to better design and perform their experiments.

of Weblogs and other tagged and mapped meta-diaries. This obsessive chronicling of personal information online—from pets' names to breakfast preferences, the phenomenon of over-sharing is frequent and is the subject of several etiquette-themed discussions—points to people's attempts to share their epiphanies and impose their own individual experiences of time, memory, and life over the global network that runs on conventional time. Counting on extraordinary advances in data storage capacity and on new, easy-to-use software, we can finally sit back and remember everything.[11] From the revelation that women do not need to have menstrual periods to studies whose goal is to dramatically reduce the amount of sleep needed in order to be perfectly functional and even the debate on human lifespan—which some say soon could be stretched at least half again as long as current expectations—the focus now is on ways to break the temporal rhythms imposed by society in order to customize and personalize them.

If design is to help enable us to live to the fullest while taking advantage of all the possibilities provided by contemporary technology, designers need to make both people and objects perfectly elastic. It will entail some imaginative thinking—not simply following a straight line from A to C passing through B. Several design principles can be used to accomplish this. One recurrent theme in design today is a stronger involvement of the senses to both enhance and integrate the delivery of high-tech functions, as in James Auger and Jimmy Loizeau's and Susana Soares's scent-based projects or in the synesthesia-inspired work of Eyal Burstein and Michele Gauler—both of which demonstrate technology's ability to deepen our sensorial awareness and spectrum.[12] Similarly, an appeal to people's sense of identity and place can be found in many projects included here, such as in the bioengineering of "love moles" and "bone rings," or in those that address memory in a literal way, such as Michele Gauler's Digital Remains.

Design schools like the Academy of Art and Design in Eindhoven, The Netherlands (offering, for instance, postgraduate courses in Humanitarian Design and Sustainable Style and Interior, Industrial, and

Identity Design), or the Royal College of Art, London, focus their courses on senses and sensuality, identity, memory, and on other staples of human life that are as old as humankind—birth, death, love, safety, and curiosity—yet are rendered urgent by the speed with which technology is moving. These principles differ from the so-called human-centered design that functionalist industrial designers of the past fifty years have employed to shift their attention from the object to the "user";[13] they are reminders of the great responsibility that comes with design's new great power of giving form and meaning to the degrees of freedom opened by the progress of technology. Such a holistic approach calls for the development of well-honed analytical and critical muscles and for a new, self-assured theory of design. At the Royal College of Art, for instance, Anthony Dunne, head of the Design Interactions Department, preaches the importance of "critical design," which he defines as "a way of using design as a medium to challenge narrow assumptions, preconceptions, and givens about the role products play in everyday life."[14] "Design for Debate," as this new type of practice is also called, does not always immediately lead to "useful" objects but rather to servings of exotic food for thought whose usefulness is revealed by their capacity to help us ponder how we really want our things to fit into our lives. Noam Toran's Accessories for Lonely Men and IDEO's Social Mobiles comment on, respectively, solitude and the need for a new etiquette in the age of wireless communication. And we certainly need such meditation more than we need another mobile phone design.

Indeed, even as technology offers us more and more options, many agree that we in fact require fewer—not more—objects in our lives. This very simple belief unites the diverse and yet similarly idealistic efforts of many designers worldwide who are trying to inform our lives with the same economy of energy and materials as found in nature. In addition to balancing our lives with the imperatives of new technology, designers today must also consider the impact of their creations on the environment. Organic design has had many different connotations in history, but in its most contemporary meaning it encompasses not only the enthusiastic exploration of natural forms and structures but also interpretations of nature's

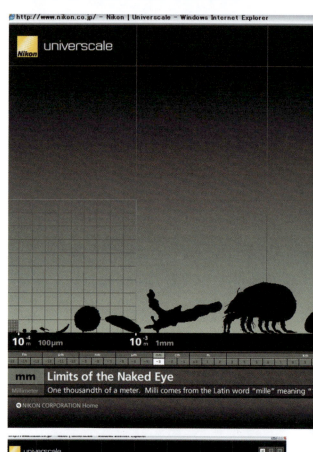

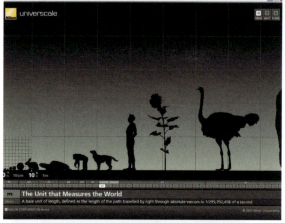

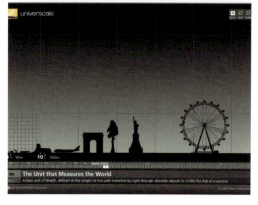

Business Architects Inc. for Nikon Corporation. **Universcale, Web application describing the size of things in the universe.** 2005. Illustrator, Photoshop, Flash, and VxEditor software

Charles and Ray Eames's 1968 film Powers of Ten was particularly representative of scale as related to the human dimension. New applications relying on updated technologies attempt the same feat.

economical frameworks and systems. It emerges from the rapidly growing realization that we need to learn to use less matter and energy and to be more efficient. Several factors make contemporary organic design radically different from its past expressions. Towering among these is the computer, whose capacity to master complexity has, perhaps surprisingly, allowed a closeness to the forms and structures of nature never achieved before. Moreover, the urgent need to manage nature's resources more thoughtfully and economically has provoked a sense of responsibility that is felt—or at least worn as a badge—by contemporary thinkers and doers. This trend can be seen in the pervasive use of the term DNA and the suffix -scape to describe any kind of organically integrated context (e.g., "homescape") and of biologically inspired attributes, such as "cellular," to describe the organic skeleton of such entities as the organization of new religious sects, lighting systems, and buildings. Even "viral" has taken on a positive meaning by indicating successful infectious and self-replicating design and communication phenomena.

When it comes to design, however, a badge is not enough: According to an annual review by Britain's Design Council, eighty percent of the environmental impact of the products, services, and infrastructures around us is determined at the design stage.[15] Design needs to engage directly and develop further some of the tools it is currently experimenting with, such as biomimicry,[16] algorithms and other forms of computational design, and nanotechnology. Nanotechnology, in particular, offers the promise of the principle of self-assembly and self-organization that one can find in cells, molecules, and galaxies; the idea that you would need only to give the components of an object a little push for the object to come together and reorganize in different configurations could have profound implications for the environment, including energy and material savings. "In nanotechnology, new materials and structures can be built atom-by-atom or molecule-by-molecule," explains the introduction to the course "Nano and Design" taught by engineer extraordinaire Cecil Balmond at the University of Pennsylvania, while algorithms are described by architects Chris Lasch and Benjamin Aranda as "a macro, a series of steps, a recipe for making bread." In the blog that complements his book Soft Machines, Richard Jones extols the potential of nanotechnology

in several areas, among them medicine, and talks about "persuading...cells to differentiate, to take up the specialized form of a particular organ," listing several reasons why nanotechnology would be beneficial to a sustainable energy economy.[17]

All these tools are about giving objects basic yet precise instructions and letting them fully develop and connect in networks and systems, and this is where one of the most powerful new directions for design lies. While traditional design is often about cutting existing materials to shape or, in the best cases, taming and adapting them, computational design and nanodesign are about generating objects, as can be seen in embryonic and conceptual examples such as Christopher Woebken's New Sensual Interfaces, and also about seeing them adapt to different circumstances, as in Chuck Hoberman's Emergent Surface responsive architecture.

As they advocate and obtain roles that are more and more integral to the evolution of society, designers find themselves at the center of an extraordinary wave of cross-pollination. Design-centered interdisciplinary conferences have existed for decades,[18] traditionally initiated by designers. Only recently have other communities started to seek designers' contributions, but this is only the beginning. To adapt and master new technologies and directions, design has branched out into dozens of specialized applications, from communication to interaction and from product design to biomimicry. On the other hand, in order to be truly effective, designers should dabble in economics, anthropology, bioengineering, religion, and cognitive sciences, to mention just a few of the subjects they need today in order to be well-rounded agents of change. Because of their role as intermediaries between research and production, they often act as the main interpreters in interdisciplinary teams, called upon not only to conceive objects, but also to devise scenarios and strategies. To cope with this responsibility, designers should set the foundations for a strong theory of design—something that is today still missing—and become astute generalists. At that point, they will be in a unique position to become the repositories of contemporary culture's need for analysis and synthesis, society's new pragmatic intellectuals. Like stones thrown in a large pond, we hope that the ideas advanced in this book will make waves, and that the waves will ripple into an irresistible discussion on the future role and responsibility of designers.

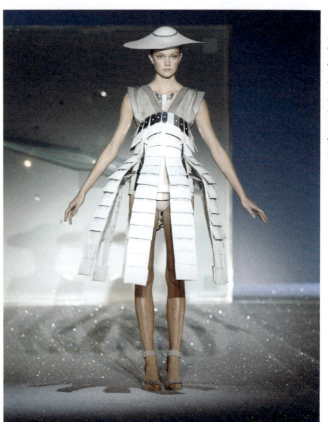

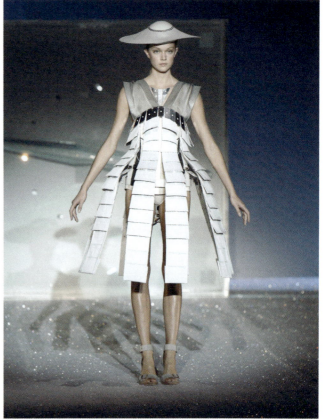

Hussein Chalayan. **Mechanical dress from the One Hundred and Eleven collection.** Prototype. 2006. Digitally printed cotton, metal plates with Swarovski crystals, organza, electric mechanisms, and electronic circuits, dimensions variable. Prototype by 2D3D, UK (2006)

As a metaphor for the need to have fewer, more elastic objects in our lives, Chalayan's convertible dress could inspire nanodevices and building facades alike.

Notes

1.
Mosaic, developed by Marc Andreesen and Eric Bina for the National Center for Supercomputing Applications and released in 1993, was the World Wide Web's first popular browser. Its success was due to its clear graphic user interface, which made it approachable and easy to use.

2.
For a fuller discussion of copyright issues, see my note 5 on p. 160 of this volume.

3.
Aranda/Lasch and Mandelbrot made their presentations at the second salon, on January 8, 2007. Mandelbrot is the mathematician who gave the strongest impetus to fractal geometry by linking it to nature and transformed it into a cultural phenomenon.

4.
Jones, a professor at England's University of Sheffield's Department of Physics and Astronomy, has written several books, among them Soft Machines: Nanotechnology and Life (London: Oxford University Press, 2004). Leroi's best-known book is the influential Mutants: On the Form, Varieties and Errors of the Human Body (New York: Harper Collins, 2003).

5.
Peter Galison, "Nanofacture," in Sensorium: Embodied Experience, Technology, and Contemporary Art, ed. Caroline A. Jones (Cambridge, Mass.: MIT Press, 2006), pp. 171–73. Galison is an esteemed historian of science and physics and a professor at Harvard University.

6.
Dan E. Atkins, John Seely Brown, and Allen L. Hammond, "A Review of the OEaI Resources (OER) Movement: Achievements, Challenges, and New Opportunities," Report to The William and Flora Hewlett Foundation, February 2007. OER stands for Open Educational Resources. Brown, chief scientist at Xerox until 2002 and director of the legendary Xerox Palo Alto Research Center (Xerox PARC) until 2000, is among the foremost experts on technology and innovation.

7.
The Slow Food movement was launched in Italy in 1986 to restore the pleasure of "real" food. It was so successful that it contributed to the "slow" concept now spreading to all dimensions of life, from cities to schools and even to money.

8.
Graphic designer and computer scientist John Maeda, who is also associate director of research at the MIT Media Lab, has translated his commitment to the ease of communication between people and objects into a full-fledged platform based on simplicity that involves the Media Lab as well as corporations like the Dutch electronics giant Philips. In this same vein, James Surowiecki's May 28, 2007, article in the New Yorker, titled "Feature Presentation," discusses the decline in popularity of objects encumbered by too many features, a phenomenon called "feature creep."

9.
According to its Web site, "The Long Now Foundation was established in 01996* to…become the seed of a very long-term cultural institution. The Long Now Foundation hopes to provide counterpoint to today's 'faster/cheaper' mind-set and promote 'slower/better' thinking. We hope to creatively foster responsibility in the framework of the next 10,000 years." ("*The Long Now Foundation uses five-digit dates; the extra zero is to solve the deca-millennium bug which will come into effect in about 8,000 years.")

10.
When going to Dubai, make sure you bring not only your bathing suit but also your favorite ski goggles, because chances are you will visit the Snow Dome for a quick downhill race on the perfect powdery slope, in order to escape the 110-degree temperature outside; and when ordering at a McDonald's drive-thru, don't be fooled into thinking that your interlocutor is in the booth—she might be in Mumbai. The outsourcing of call centers and customer service centers has greatly contributed to the establishment of our new time-space proportion.

11.
In the May 28, 2007, issue of the New Yorker, an article by Alec Wilkinson titled "Remember This? A Project to Record Everything We Do in Life" reported that the great computer scientist Gordon Bell had in 1998 set out to digitize and archive his whole life, from childhood pictures and health records to coffee mugs. The project is still in process.

12.
Amazing things are happening in the realm of the senses. Scientists and technologists are focusing on hearing, for instance, and on its untapped potential. Several researchers are experimenting on sonocytology, a way to diagnose cancer by listening to cells—or better, by reading sonograms. Professor James K. Gimzewski and Andrew E. Pelling at the UCLA Department of Chemistry

Scott Wilson. **iBelieve lanyard for iPod Shuffle.** 2005. ABS plastic, 3/8 × 4 3/4 × 3" (0.8 × 12 × 7.5 cm). Manufactured by National Electronic, China (2005)

It is an irresistible send-up of the public's fanatical adoration of Apple products and at the same time a pensive reminder of the growing importance of the spiritual sphere in a world rife with technology and ideology.

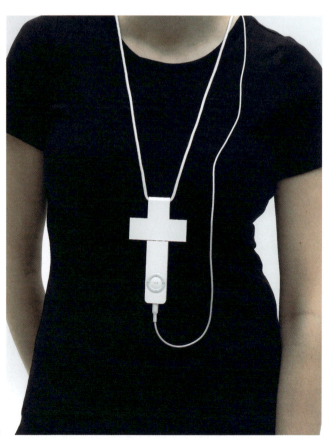

Moloudi Hadji. École cantonale d'art de Lausanne (écal). **Pierce'n Brush.** Prototype. 2003. Stainless steel and nylon, 1 1/4 × 1/4" (3.1 × 0.6 cm) diam.

Multifunctional objects for multi-tasking citizens of the world. Why waste the opportunity for a flexible-use tongue stud?

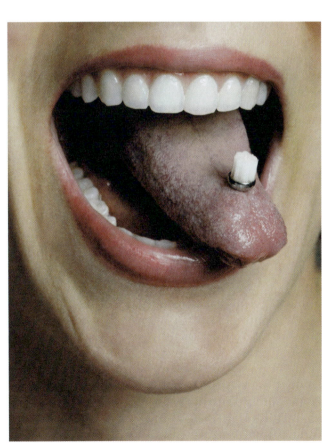

first made the discovery that yeast cells oscillate at the nano-scale in 2002. Amplifying this oscillation results in a sound that lies within the human audible range. As far as olfaction is concerned, one study has explored how certain dogs can sniff cancer in a person's breath (Michael McCulloch, Tadeusz Jezierski, Michael Broffman, Alan Hubbard, Kirk Turner, and Teresa Janecki, "Diagnostic Accuracy of Canine Scent Detection in Early- and Late-Stage Lung and Breast Cancers," <u>Integrative Cancer Therapies</u> 3 (March 2006): pp. 30–39).

13.
The champion of this attitude is renowned design critic Don Norman, whose work is directly aimed at product designers.

14.
Anthony Dunne, interview in <u>Domus</u> 889 (February 2006): p. 55. Moreover, the Web page intro-ducing the college's Design Inter-actions Department reads: "Designers often refer to people as 'users,' or sometimes as 'con-sumers.' In Design Interactions, we prefer to think of both users and designers as, first and fore-most, people. That is, we see ourselves as complex individuals moving through an equally complex, technologically mediated, consumer landscape. Interaction may be our medium in this department, but people are our primary subject, and people cannot be neatly defined and labeled. We are contra-dictory, volatile, and always sur-prising. To remember this is to engage fully with the complexities and challenges of both people and the field of interaction design."

15.
Design Council, <u>Annual Review 2002</u>, London: 2002, p. 19.

16.
As the Biomimicry.net Web site reads, "Biomimicry (from bios, meaning life, and mimesis, meaning to imitate) is a design discipline that studies nature's best ideas and then imitates these designs and processes to solve human problems." The Biomimicry Institute and its president, Janine M. Benyus, author of the 1997 book <u>Biomimicry</u> (New York: William Morrow), which popularized this field of study, is a resource for designers and companies interested in learning to observe nature and apply the same type of economical wisdom to issues ranging from mundane to existential, such as how to reduce our erosion of the world's resources.

17.
Engineer Cecil Balmond (of Arup), assisted by Jenny Sabin, teaches in the University of Pennsylvania's School of Design, in the Department

of Architecture. The quotation was taken from a description of the course for the spring 2007 semester. It continues, "The nano prefix means one-billionth, so a nanometer is one-billionth of a meter. Just as antibiotics, the silicon transistor and plastics... nanotechnology is expected to have profound influences in the twenty-first century, ranging from nanoscopic machines that could for instance be injected in the body to fix problems and the creation of artificial organs and prosthetics, all the way to self-assembling electronic components that behave like organic struct-ures and better materials that perform in novel ways." Chris Lasch and Benjamin Aranda, in a conver-sation with the author on March 14, 2007, talked about the role of algorithms in architecture, also well explained in their incisive volume <u>Tooling</u> (New York: Princeton Architectural Press, 2005). Richard A. L. Jones's blog is a precious resource for all those who want more information on the potential practical applications of nanotechnology in our future (see also note 4). See www.softmachines.org.

18.
A few of my personal favorites: the historical International Design Conference in Aspen, now defunct, the ongoing TED (Technology, Entertainment, Design, founded by Richard Saul Wurman and now run by Chris Anderson), and Doors of Perception (founded and still run by John Thackara).

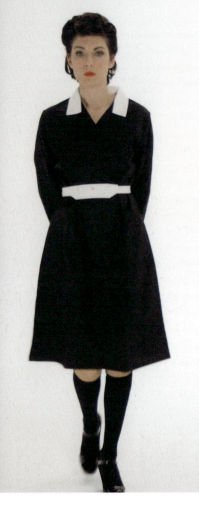

Anthony Dunne and Fiona Raby's outstanding design work is focused on sparking debate. As educators, they are both involved with the Royal College of Art, London, where Dunne is the head of the Design Interactions Department and Raby a tutor. The Design Interactions students explore the impact of the most advanced technologies on our daily routines, in particular the design potential of biotechnology and nanotechnology, both of which are now moving out of the research laboratory and into daily life. The resulting projects, a number of which are included in this volume, aim to raise a debate on the social, cultural, and ethical implications of emerging technologies.

Anthony Dunne (British, born 1964) and
Fiona Raby (British, born 1963)
Dunne & Raby (UK, est. 1994)
Technological Dreams Series: no 1, Robots
Models. 2007

As technology advances and robotic experiments abound—ranging from the pragmatic to the exquisitely absurd—designers are taking a closer philosophical look at our future interaction with robots. Will they be subservient, intimate, dependent, equal? Will they take care of us or will we take care of them? Anthony Dunne and Fiona Raby look at robots as individuals with their own distinct personalities and quirks, thinking that devices of the future might not be designed for specific tasks but instead might be given jobs based on behaviors and qualities that emerge over time.

Robot 1
High-density foam, 4 × 35 3/8" (10 × 90 cm) diam.
Robot 1 is very independent, but it needs to avoid electromagnetic fields, as these might cause it to malfunction.

Robot 2
Acrylic, 19 3/4 × 19 3/4" (50 × 50 cm) diam.
Robot 2 is very nervous; as soon as someone enters a room it turns to analyze them with its many eyes, becoming extremely agitated if the person gets too close.

Robot 3
English oak and acrylic, 15 3/8 × 8 × 36 3/4" (39 × 20 × 93.3 cm)
Robot 3 is a sentinel; it uses retinal scanning technology and demands that the user stare into its eyes for a long time to be recognized.

Robot 4
English oak, 32 × 18 7/8 × 6" (75 × 48 × 158 cm)
Robot 4 is very needy and depends on its owner to move it about. It is also extremely smart and has even evolved its own language, although you can still hear human traces in its voice.

1

3

2

4

Jon Ardern (British, born 1978)
Design Interactions Department (est. 1989),
Royal College of Art (UK, est. 1837)
ARK-INC Concept. 2006

According to Jon Ardern, a graduate of the Royal College of
Art's Design Interactions Department, it is too late to fix
the damage human beings have inflicted upon the earth and
society. Better to cut our losses and instead adapt our
lifestyle to the changed conditions. It is on these sunny
premises that Ardern has built his project of imagined social
structures and services for "a cultlike investment company,
called the Ark, that keeps you up-to-date on how badly the
world is doing while reassuring you that your investment in
post-crash life is doing well." Based on the assumption that
the abstract-value principle of the traditional economy will
be rendered useless, ARK-INC provides a range of products,
from manuals and books to films and radio broadcasts, that
keep users informed of external data such as wars and social
breakdown. It also mediates the transition to post-crash
civilization with services such as holidays in apocalyptic land-
scapes, designed to help users cope with disaster.

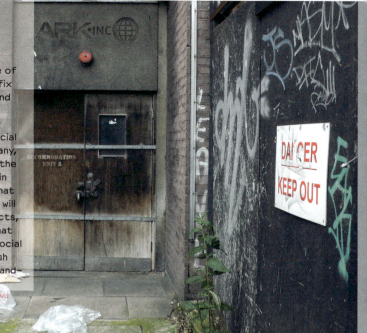

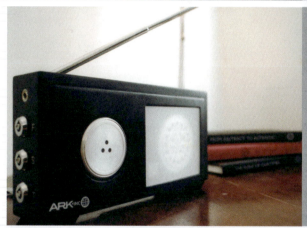

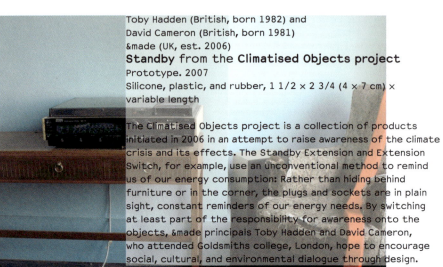

Toby Hadden (British, born 1982) and
David Cameron (British, born 1981)
&made (UK, est. 2006)
Standby from the Climatised Objects project
Prototype. 2007
Silicone, plastic, and rubber, 1 1/2 × 2 3/4 (4 × 7 cm) ×
variable length

The Climatised Objects project is a collection of products initiated in 2006 in an attempt to raise awareness of the climate crisis and its effects. The Standby Extension and Extension Switch, for example, use an unconventional method to remind us of our energy consumption: Rather than hiding behind furniture or in the corner, the plugs and sockets are in plain sight, constant reminders of our energy needs. By switching at least part of the responsibility for awareness onto the objects, &made principals Toby Hadden and David Cameron, who attended Goldsmiths college, London, hope to encourage social, cultural, and environmental dialogue through design.

Elio Caccavale (Italian, born 1975)

MyBio–reactor Cow Prototype. 2005
Fireproof nylon and polyester stuffing, 7 1/2 × 13 3/4 × 9 1/2"
(19 × 35 × 24 cm)

MyBio Xenotransplant Prototype. 2005
Fireproof nylon and polyester stuffing, boy: 7 1/2 × 6 1/4 ×
17 3/4" (19 × 16 × 45 cm); pig: 7 1/2 × 9 7/8 × 11 3/4" (19 ×
25 × 30 cm)

MyBio Spider Goat Prototype. 2005
Fireproof nylon and polyester stuffing, 7 1/2 × 12 1/4 × 11"
(19 × 31 × 28 cm)

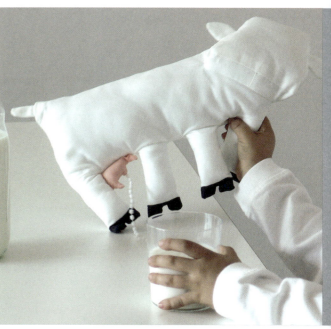

"MyBio is a collection of toys exploring the emergence of
biological hybrids in biotechnologies, as well as our moral,
social, cultural, and personal response to these 'transhuman'
creatures," explains Elio Caccavale, a graduate of the Royal
College of Art's Design Products Department. Each one of his
twelve MyBio dolls symbolizes a possible biofuture and intro-
duces young children to emerging technologies, inviting them
to think about the ways biotechnology can affect their lives.
MyBio-reactor Cow, for instance, depicts in a graphic way—with
the "milk thread" attached to the cow's udder—how cows' milk
provides proteins for pharmaceutical drugs. Similarly, MyBio
Spider Goat, with a spiderweb attached to the goat's udder,
demonstrates the famous 2001 experiment in which goats'
chromosomes were manipulated to include a spider gene so that
their mammary glands could produce a strand of silk three times
tougher than Kevlar. The two MyBio Xenotransplant dolls, MyBio
Boy and MyBio Pig, demonstrate the physical transfer of an
organ from animal to human. Caccavale also pursues the topic
of organ transplants in his Utility Pets project (see pp. 112–13).

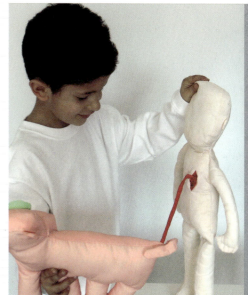

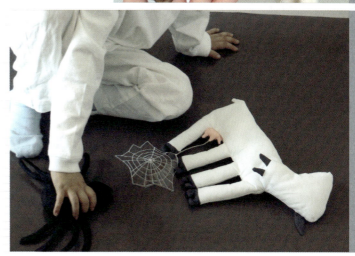

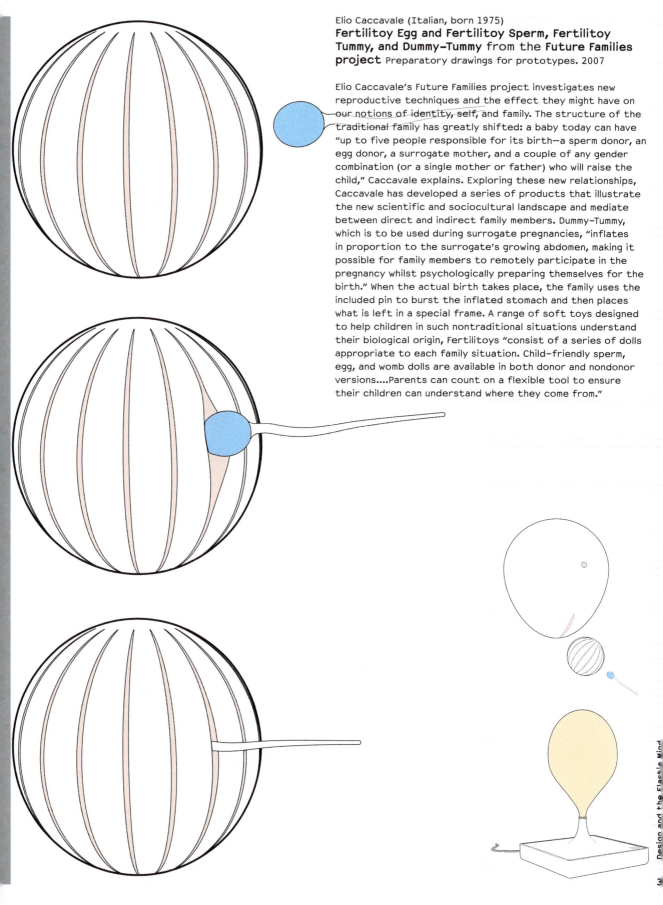

Elio Caccavale (Italian, born 1975)
Fertilitoy Egg and Fertilitoy Sperm, Fertilitoy Tummy, and Dummy-Tummy from the **Future Families project** Preparatory drawings for prototypes. 2007

Elio Caccavale's Future Families project investigates new reproductive techniques and the effect they might have on our notions of identity, self, and family. The structure of the traditional family has greatly shifted: a baby today can have "up to five people responsible for its birth—a sperm donor, an egg donor, a surrogate mother, and a couple of any gender combination (or a single mother or father) who will raise the child," Caccavale explains. Exploring these new relationships, Caccavale has developed a series of products that illustrate the new scientific and sociocultural landscape and mediate between direct and indirect family members. Dummy-Tummy, which is to be used during surrogate pregnancies, "inflates in proportion to the surrogate's growing abdomen, making it possible for family members to remotely participate in the pregnancy whilst psychologically preparing themselves for the birth." When the actual birth takes place, the family uses the included pin to burst the inflated stomach and then places what is left in a special frame. A range of soft toys designed to help children in such nontraditional situations understand their biological origin, Fertilitoys "consist of a series of dolls appropriate to each family situation. Child-friendly sperm, egg, and womb dolls are available in both donor and nondonor versions....Parents can count on a flexible tool to ensure their children can understand where they come from."

Volker Morawe (German, born 1970) and Tilman Reiff (German, born 1971) of ///////// fur //// art entertainment interfaces (Germany, est. 2001)
Academy of Media Arts, Cologne (Germany, est. 1994)
PainStation Prototype. 2001–04
Wood, steel, and custom electronics and mechanics, 39 3/8 × 39 3/8 × 31 1/2" (100 × 100 × 80 cm)

As Volker Morawe and Tilman Reiff explain, the main aspiration of contemporary game designers is to shape "compelling experiences that bridge the on-screen virtual world and the real world." Enter PainStation, a two-person console where making mistakes results in physical pain. The game is an adapted version of the classic 1972 Atari game Pong. The players, facing each other, "use their right hand to control a bat on screen, and must keep their left hand on the console's 'pain execution unit.' Removing the hand means breaking the circuit—game over." Every time the screen bat "misses a ball, the left hand suffers the consequences through the application of heat, electric shocks, or a quick whipping on the back of the hand." Not only do players become directly immersed in the game, but the combination of sound effects and the players' reactions makes it a compelling experience for the audience as well.

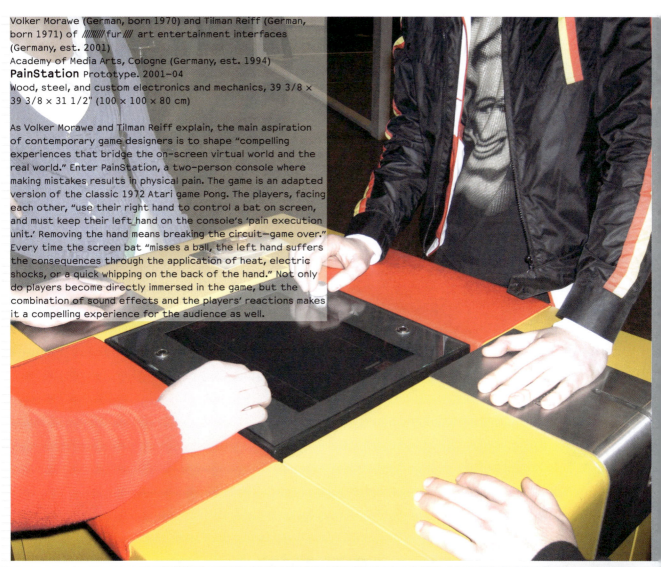

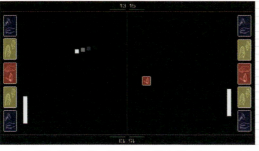

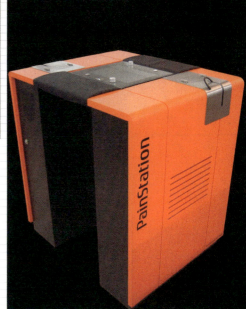

Noam Toran (American, born 1975)
Accessories for Lonely Men Models. 2001
Aluminum, plastic, and electronics

Noam Toran, a graduate of and professor in the Royal College of Art's Design Interactions Department, makes use of products and film as a means to investigate "anomalies in contemporary and speculative human behavior." The designer creates conceptual and darkly humorous products as well as their narratives and contexts. Accessories for Lonely Men are eight electronic devices designed to alleviate loneliness by simulating the "generic traces" that one's companion would normally leave behind. The collection includes a Sheet Thief set on a timer that "winds the bedclothes up on the other side of the bed while you're sleeping." Other joys of sharing a bed are re-created with a pair of Cold Feet and a Heavy Breather that breathes hot air down the user's neck. In the morning, the "Hair Alarm Clock attached to the headboard swishes hair onto the user's face to wake him up," while the steel finger of the Chest-Hair Curler rotates gently to swirl his chest hair in concentric circles. Other objects include Shared Smoke, which comes into its own after a solitary sex act, with one hole for the cigarette and another that exhales smoke; Plate Thrower, a rapid-fire plate launcher; and Silhouette Light, which projects the silhouette of a woman onto the wall.

One of the most researched types of interaction design focuses on objects that respond to our needs and stimuli rather than awaiting our instructions. For the past twenty years, engineers, scientists, architects, and designers have been working toward transforming objects from tools to companions and buildings from containers to open environments, using ever more sophisticated movement- and voice-recognition software.

Martino d'Esposito (Swiss/Italian, born Cyprus 1976)
Frédéric Kaplan (French, born 1974) of CRAFT Laboratory (Centre de Recherche et d'Appui pour la Formation et ses Technologies) (est. 2002), École Polytechnique Fédérale de Lausanne (Switzerland, est. 1853)
Wizkid Prototype. 2006–07
ABS plastic and polymer, 17 3/4 × 9 7/8 × 8" (45 × 25 × 20 cm)

To switch on a Wizkid, you just have to look at it. "Wizkids do not speak," explain designers Martino d'Esposito, a former student of the École cantonale d'art de Lausanne (écal), and Frédéric Kaplan, an expert in artificial intelligence, "but they pay a lot of attention to what happens around them. When set in autonomous mode, Wizkids become curious about their environment and start learning by themselves." As days go by, a Wizkid will learn to recognize its user and his or her habits, and to react to each context and situation. It will help with cooking and shopping; it will take pictures of the guests at a party; it will play games with the kids. At the office, a Wizkid will be a valuable executive assistant. During meetings, it will follow the conversation just like any other participant, nodding from time to time. The user can monitor a Wizkid's progress through visualization tools and improve its learning curve through special toys and educational kits that will satisfy its enormous curiosity.

James Auger (British, born 1970) and
Jimmy Loizeau (British, born 1968)
LED Dog Tail Communicator from the **Augmented Animals project** Prototype. 2006
LEDs, programmed electronic components, and automated wagging tail, 8 × 13 3/4 × 11 3/4" (20 × 35 × 30 cm)

The Augmented Animals project imagines a world where "technological innovations are equally appreciated and used by animals." The products in the series fit into three categories: traumas of domestication, survival, and reputation enhancers. "When animals are domesticated they enter an uncertain territory between the natural and the artificial. They must live within human terms and conditions, dislocated from their original environment, often leading a frustrating life. Many animals have developed ingenious mechanisms of defense, and with the help of technology they can overcome evolutionary shortfalls," explain James Auger and Jimmy Loizeau. The LED Dog Tail Communicator spells out in human words the messages that a dog wants to convey to his owner via his wagging tail, enabling new forms of communication between animal and human. Auger and Loizeau, graduates of the Royal College of Art's Design Products program, are featured several times in this volume because of their lucid and poetic take on how technology can help communication and memory.

Tomoaki Yanagisawa (Japanese, born 1980)
Design Interactions Department (est. 1989),
Royal College of Art (UK, est. 1837)
Living Sensors Model. 2005
Latex, plastic, and intravenous drip tube, 3 1/2 × 2 1/2 ×
1 3/4" (8.9 × 6.4 × 4.5 cm)

Designer Tomoaki Yanagisawa contemplates cloning technology
as the generator of new experiences and behaviors. Through
cloning, living human or animal skin could generate products
capable of the most immediate interactions with their sur-
roundings. A living sensor on a window, for example, communi-
cates both visually and emotionally the feeling of temperature,
from cold to hot, reacting with goose bumps or sweating.
"By using your own skin," Yanagisawa explains, "you can have
a personal sensor, or create a memento object with a pet's
or a lover's skin."

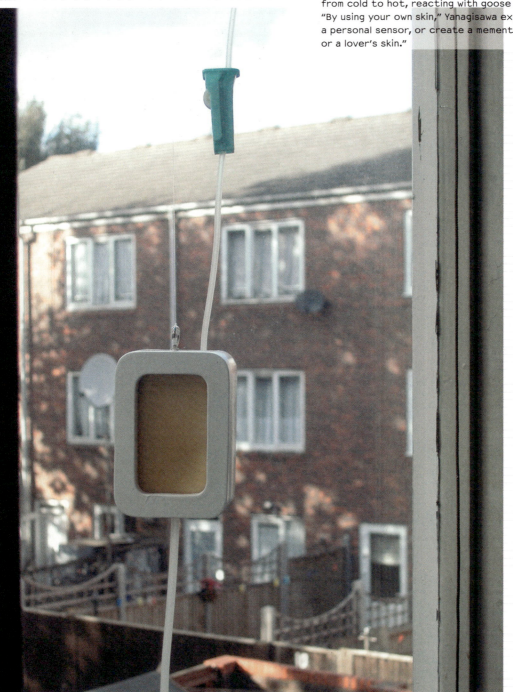

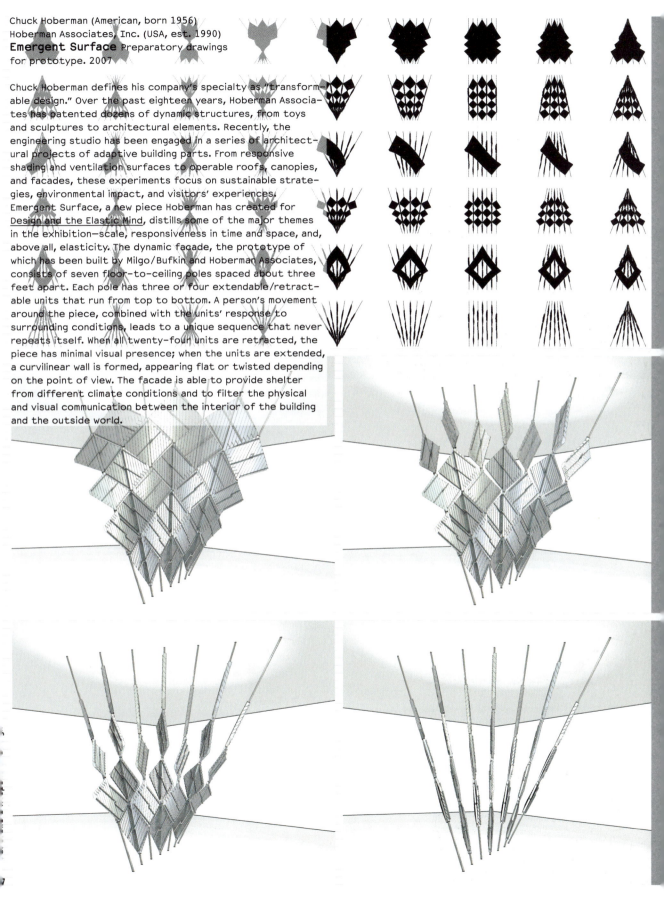

Chuck Hoberman (American, born 1956)
Hoberman Associates, Inc. (USA, est. 1990)
Emergent Surface Preparatory drawings
for prototype. 2007

Chuck Hoberman defines his company's specialty as "transform-
able design." Over the past eighteen years, Hoberman Associa-
tes has patented dozens of dynamic structures, from toys
and sculptures to architectural elements. Recently, the
engineering studio has been engaged in a series of architect-
ural projects of adaptive building parts. From responsive
shading and ventilation surfaces to operable roofs, canopies,
and facades, these experiments focus on sustainable strate-
gies, environmental impact, and visitors' experiences.
Emergent Surface, a new piece Hoberman has created for
Design and the Elastic Mind, distills some of the major themes
in the exhibition—scale, responsiveness in time and space, and,
above all, elasticity. The dynamic facade, the prototype of
which has been built by Milgo/Bufkin and Hoberman Associates,
consists of seven floor-to-ceiling poles spaced about three
feet apart. Each pole has three or four extendable/retract-
able units that run from top to bottom. A person's movement
around the piece, combined with the units' response to
surrounding conditions, leads to a unique sequence that never
repeats itself. When all twenty-four units are retracted, the
piece has minimal visual presence; when the units are extended,
a curvilinear wall is formed, appearing flat or twisted depending
on the point of view. The facade is able to provide shelter
from different climate conditions and to filter the physical
and visual communication between the interior of the building
and the outside world.

One way for designers to make the public feel comfortable with advanced technology is to incorporate instinctive human traits, for example in interfaces that can be commanded by moving items around with hands and fingers, by blowing onto them, or even by shaking the computer where they reside. Although technologies of this kind have already found commercial applications, most famously in the Nintendo Wii and the Apple iPhone, designers keep staging ingenious new demonstrations.

Dan Phiffer (American, born 1980) and
Mushon Zer-Aviv (Israeli, born 1976)
Interactive Telecommunications Program (est. 1979), Tisch School of the Arts, New York University (USA, est. 1965)
Atlas Gloves Prototype. 2005–06
atlasgloves.org
Processing software, Java.awt.Robot library, Google Earth, LED keychains, and Webcam

Atlas Gloves is a do-it-yourself physical interface for 3-D mapping applications like Google Earth. The user stands in front of a large-scale projection of the earth with a special set of illuminating gloves that track hand gestures like grabbing, pulling, reaching, and rotating. When the user gently squeezes the glove, an LED turns on, while a small camera attached to a computer tracks and translates each LED-enabled gesture into a set of possible actions: pan, zoom, rotate, and tilt. The open-source Atlas Gloves application can be downloaded from the Web site and operated from home using a Webcam and two self-made illuminating gloves. The Web site includes detailed instructions on how to make your own Atlas Gloves for about $8, using such common materials as ping-pong balls, glue, thread, pins, a nail, and LED keychains.

Eriko Matsumura (Japanese, born 1980)
Design Interactions Department (est. 1989), Royal College of Art (UK, est. 1837)
Hu-Poi Prototype. 2006
Epoxy resin and electronics, 23 5/8 × 2 3/8 × 2 3/8" (60 × 6 × 6 cm)

When faced with a cluttered room, the temptation at times is to clear the mess away in one sweeping gesture. The same feeling can happen in front of a cluttered computer desktop. The Hu-Poi interface allows for this unusual type of gestural control.

Troika (UK, est. 2003)
Newton Virus Prototype. 2005
Custom C++ software and Apple Sudden Motion Sensor

The Newton Virus suggests that laws of gravity also apply
to interfaces, causing desktop icons to fall down as if subject
to gravitational pull from the real world. Troika is developing
other ideas for computer viruses as "an underexploited art
form," using them for poetic purposes far from their tradi-
tional destructive and obstructive effects. Through their
Web site, Troika's designers invite anyone with programming
skills and imagination to participate in this challenge.

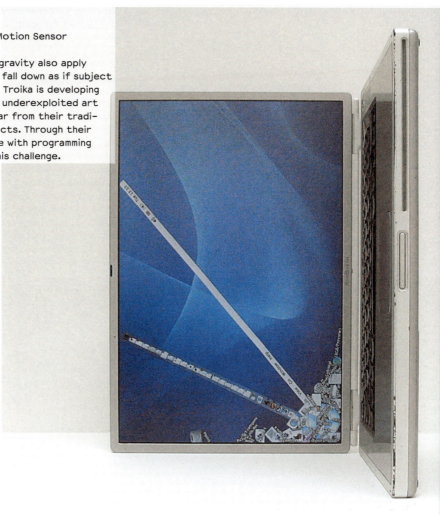

Oki Sato (Canadian, born 1977) of nendo (Japan, est. 1991)
Takaya Fukumoto (Japanese, born 1974) of Solution Design
Group, NEC Design, Ltd. (Japan, est. 1971)
NTT DoCoMo (Japan, est. 1992)
N702iS water-level interface 2005–06
Flash software
Manufactured by NEC Corporation, Japan (2006)

Another gestural interface that plays with virtual gravita-
tional forces, the N702iS cell phone displays an image of water
contained inside the phone's screen. When tilted, the accel-
eration sensor detects the angle, and the surface of the
liquid changes accordingly. The amount of liquid indicates
the battery level.

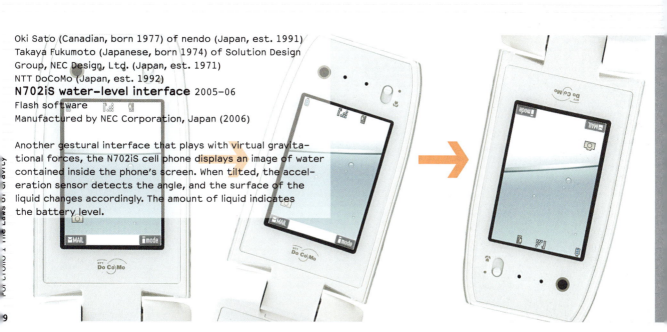

Moritz Waldemeyer (German, born 1974)
Pong Table Prototype. 2006
DuPont Corian, aluminum, and electronic circuits,
62 3/4 × 35 3/8 × 28 1/2" (160 × 90 × 72.6 cm)
Prototype by DuPont, Belgium; 2D:3D, UK; and
Moritz Waldemeyer, UK (2006)

Moritz Waldemeyer's skills in mechanical, electronic, and soft-
ware engineering fall into the so-called mechatronics area of
technology. A talented designer in his own right, Waldemeyer
has collaborated with architects and designers like Hussein
Chalayan, Ron Arad, Yves Béhar, and Zaha Hadid. His first solo
project is a collection of interactive electronic game consoles
that double as dining tables. The table pictured here re-creates
the classic game Pong, introduced by Atari in 1972 and the
first commercially successful computer game. The tabletop has
2,400 LEDs and two track pads embedded in its surface, turning
the white Corian into a digital gaming board. When turned off,
the integrated technology disappears completely.

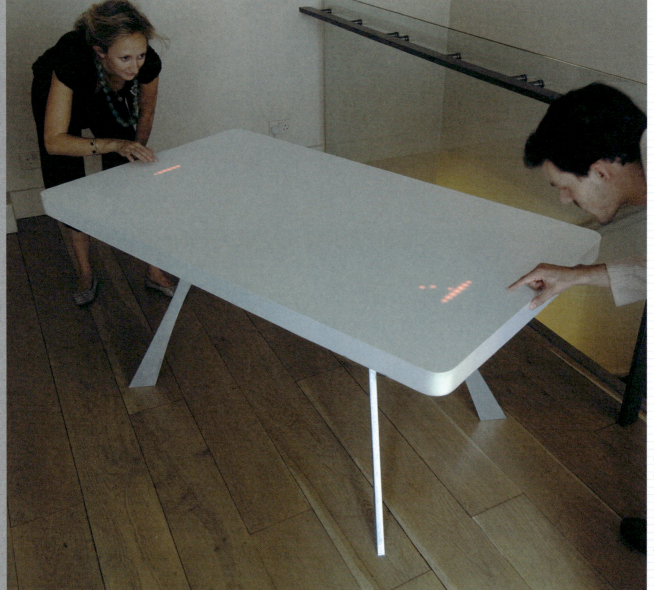

Much ink has been spilled on the future of print, on the disappearance of books and periodicals, and on the inexorable path toward a paperless future, yet we still cling to our paper-based artifacts. Despite the existence of several electronic reading devices, there are still a few hurdles left in the way of progress. One of them is our need to feel actual pages in our hands. Much research has been devoted to the development of pliable, ultra-thin displays that can be used not only for electronic books but also for such applications as TV sets and mutable credit/ID cards.

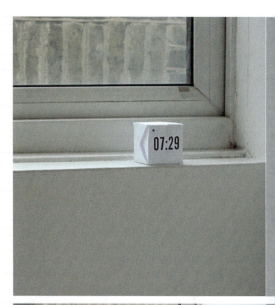

Miquel Mora (Spanish, born 1974)
Design Interactions Department (est. 1989),
Royal College of Art (UK, est. 1837)
Paper Alarm Clock from the **Flat Futures project: Exploring Digital Paper** Model. 2007
Paper and adhesive tape, folded: 1 7/8 × 1 7/8 × 1 7/8"
(4.8 × 4.8 × 4.8 cm); unfolded: 6 3/4 × 9 7/8" (17.6 × 25 cm)

Plastic Logic (UK, est. 2000)
"take anywhere, read anywhere" flexible display 2006
E Ink Imaging Film, dimensions variable
Manufactured by Plastic Logic, UK (2008)

The Flat Futures project aims to enhance the characteristics of paper rather than remove it completely from our lives. Research done at the British company Plastic Logic and emerging technologies such as e-ink (a film that is integrated into electronic displays and that can be applied to almost any flat surface) and OLEDs (Organic Light-Emitting Diodes, a revolutionary innovation that will make flat, rollable, bright, and economical screens a reality) were the inspiration. Today it's possible to print electronics onto flat and flexible surfaces like paper or plastic, and flat processors, displays, and batteries can be quite easy and inexpensive to produce. In the Flat Futures project, Miquel Mora explores the possibility of printing electronic components onto adhesive tape, envelopes, and paper, such as the disposable Paper Alarm Clock, which needs to be scrunched up in order to be turned off.

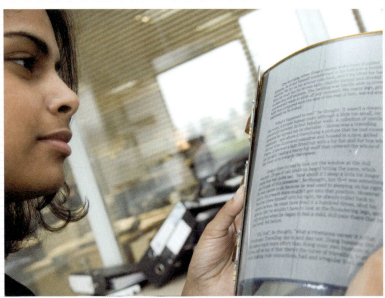

1

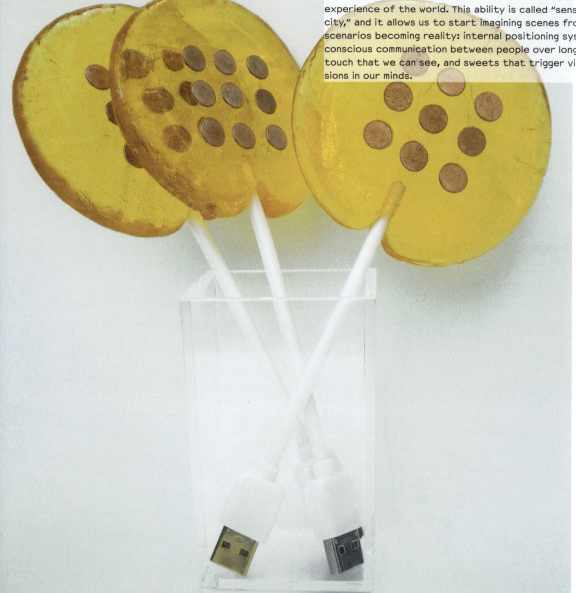

Eyal Burstein (Israeli, born 1977) and
Michele Gauler (German, born 1973)
Beta Tank (UK, est. 2007)
Eye Candy from the **Sensory Plasticity project**
Models. 2007
Copper, steel, polyurethane, and sugar, 2 3/8 × 6 × 3/8"
(6 × 15 × 1 cm)

Scientists are currently exploring the brain's ability to process
sensory stimuli as visual input, thus allowing, for example, blind
people to navigate through space. A commercial application
for people with balance impairments has already reached the
marketplace: Wicab manufactures a balance-correcting device
called the BrainPort, which works by sending tactile information
through the tongue. Eyal Burstein and Michele Gauler explore
the potential of this technology for people who are not visually
impaired. Eye Candy is a metaphor for our brain's extraordinary
elasticity—its potential to create new synapses and adapt
to new sensory input, to substitute one sense for another,
and to use additional sources of information to augment our
experience of the world. This ability is called "sensory plasti-
city," and it allows us to start imagining scenes from sci-fi
scenarios becoming reality: internal positioning systems, sub-
conscious communication between people over long distances,
touch that we can see, and sweets that trigger visual explo-
sions in our minds.

Susana Soares (Portuguese, born 1977)
Design Interactions Department (est. 1989),
Royal College of Art (UK, est. 1837)
BEE'S, New Organs of Perception Prototypes. 2007

Face Object: blown handmade glass, 14 1/8 × 9 7/8"
(36 × 25 cm) diam.
Prototype by Crisform, Portugal (2007)

Fertility Cycle Object: borosilicate, 10 1/4 × 6"
(26 × 15 cm) diam.
Prototype by Vilabo, Portugal (2007)

"Bees have a phenomenal odor perception," explains designer
Susana Soares. "They can be trained within minutes using Pavlov's
reflex to target a specific odor. Their range of detection
goes from pheromones and toxins to disease diagnosis."
Soares has conceived a series of alternative diagnosis tools
that use trained bees to perform a health checkup, detect
diseases, and monitor fertility cycles. The Face Object has
two chambers: The larger one is a bee container and the
smaller one serves as the diagnosis space. Bees trained to
target a specific odor in the breath, a marker of a particular
condition, will go into the smaller chamber if they sense it.
The Fertility Cycle Object has three chambers of different
sizes, relating to the different fertility periods: The largest
chamber corresponds to the ovulation periods, the second
to preovulation, and the third to postovulation. The bees
fly into a specific chamber for each period of the cycle.

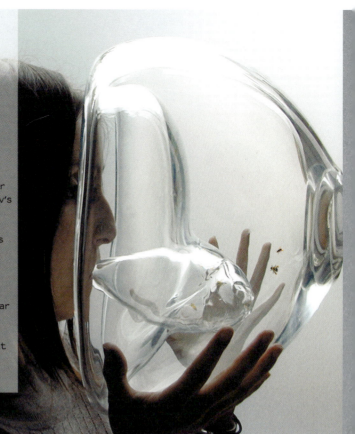

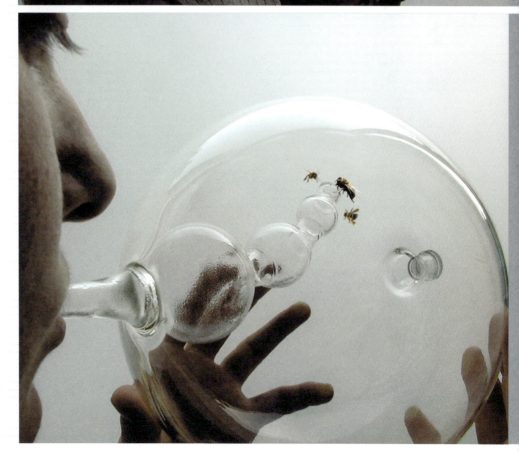

James Auger (British, born 1970) and
Jimmy Loizeau (British, born 1968)
Design Interactions Department (est. 1989),
Royal College of Art (UK, est. 1837)
Philips Design (The Netherlands, est. 1891)
Smell + Prototype. 2006–07
Epoxy resin, aluminum, and polyurethane, dimensions variable

James Auger, a research fellow in the Design Interactions
Department at the Royal College of Art, London, and Jimmy
Loizeau have been collaborating since 2000 on objects and
scenarios based on the observation of both routine and
unusual interrelations between individuals and technology.
Their latest work is an exploration of the hidden potential
of the olfactory sense and its role in human interaction and
behavior. Auger and Loizeau wish to capitalize on the fact
that "each body emits a particular odor and pheromone
formula that affects others in ways we are just now starting
to understand" by studying this phenomenon in a range of
domestic and social contexts: dating and genetic compatibi-
lity, cooking, health and diagnosis, and well-being. For instance,
a study of mating and marriage rituals has demonstrated the
role of body odor in identifying genetically appropriate mates.
This research led to the proposal for "a blind dating agency
aimed at individuals wishing to meet a suitable partner for
procreation." Olfactory cues "are given precedence over
visual stimuli and can be employed to make successful matches."

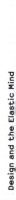

Mathieu Lehanneur (French, born 1974)
Elements project Prototypes. 2006

Q Quinton Spray
Stainless steel, PVC coating, and sensor, dimensions variable

dB White Noise Diffuser
ABS plastic, mini speakers, electric engine, and charger,
7 1/8" (18 cm) diam.

C° Infrared Heating
Elastomer, thermal camera, infrared heating, and memory-
shape alloy, 9 7/8 × 26" (25 × 66 cm) diam.

K Day Light Receiver-Transmitter
Aluminum, optical fibers, photoelectric cells, high-luminosity
white LEDs, and sensor, 11 × 11 × 11 3/4" (28 × 28 × 30 cm)

O Oxygen Generator
Glass, aluminum, Spirulina platensis, magnetic stirrer,
white LEDs, and oximetric probe, 18 1/2 × 16 1/2"
(47 × 42 cm) diam.

Our bodies are continually adapting to the changing environ-
ment. Designer Mathieu Lehanneur proposes to reverse the
process with his Elements, domestic appliances that create
microenvironments customized for each person in the house-
hold. Each Element works autonomously and is always alert,
monitoring conditions—air quality, light, body temperature,
background noise, and movement—and instantaneously acting
to keep them in ideal balance. Lehanneur has worked with
biologists, sleep specialists, and noise technicians to produce
a collection of devices that allows the home to work "like the
epidermis, reactive and capable of sensitivity to and recep-
tivity of our states."

The dB White Noise Diffuser
"moves around like a rolling
ball capturing the sound
level." It gravitates toward
the source of a sound to
create a band of white
noise that "enables the
brain to adjust to it and no
longer be disturbed by the
outside nuisance."

C° Infrared Heating acts
like an intelligent thermal
radar, a "campfire located
at the heart of a room"
that perceives tempera-
ture variations in those
close to it and emits
targeted heat toward
those different zones.

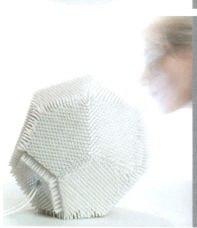

The K Day Light Receiver-
Transmitter, a light that
protects from seasonal
affective disorder, has
sensors that monitor and
average the light from the
past twenty-four hours
and activate a strong
light for a period of a few
seconds up to several
minutes to regulate our
biorhythms.

The Q Quinton Spray, an
immune system booster,
diffuses two types of
marine mineral concen-
trates, depending on
whether it is morning or
evening and whether the
person is going out or
returning home. The
Quinton isotonic serum
restarts the metabolic
functions of the organism
while a hypertonic serum
stimulates the immune
system and the body's
elimination functions.

The O Oxygen Generator,
"a veritable domestic
breathing machine," uses an
oximeter sensor that acti-
vates oxygen-producing
Spirulina platensis organisms,
a system being studied by
NASA for astronauts' long
trips in space.

Portfolio 1 Microenvironments

Applied Curiosity
Hugh Aldersey-Williams

Though they both lived and worked for many years in the Los Angeles area, it seems that designer Charles Eames and physicist Richard Feynman never met. From their studio at 901 Washington Boulevard in Venice, Charles Eames and his wife, Ray, created some of the most innovative furniture and other designs of the twentieth century. Feynman worked less than twenty miles away, at Caltech, and in 1965 was awarded the Nobel Prize for his development of quantum electro-dynamics, which explains the interaction of particles and electromagnetic radiation such as light in terms of quantum theory.

Not much in common, it might seem at first glance. But what set the Eameses apart from other designers was an ability—and an urge—to communicate complex ideas in visual terms. In addition to furniture, they produced films and exhibitions, many of them on scientific themes. Feynman, too, was acclaimed as a teacher and communicator for whom visualization was an essential tool. His most eloquent demonstrations of the power of visualization in science are the diagrams that now bear his name. These describe the interaction of radiation and particles of matter in a shorthand that is both mathematically accurate and graphically narrative. The timelines that the Eameses pioneered in order to present complex ideas in history and science have similar powers for a different audience. Both kinds of diagrams map time and space to portray relations between events that may be causal or coincidental.

There are more specific reasons to lament this missed connection. In 1959, Feynman gave a now-famous lecture titled "There's Plenty of Room at the Bottom."[1] In his characteristically iconoclastic way, he had looked broadly at science and found what others had largely missed, namely that it would be nice to be able to do chemistry with precision for a change, building desired molecules atom by atom rather than throwing together large quantities of reactants and leaving all the organization to chemical forces outside our control. Feynman imagined how novel and useful articles might be assembled atom by atom, giving as an example a robot that could enter the body to perform medical procedures. This was the seed of nanotechnology. The Eameses, in turn, invited contemplation of that nano-sized world in their 1968 film Powers of Ten, inspired by Kees Boeke's book Cosmic View: The Universe in Forty Jumps (1957). The eight-minute film is in effect a single zoom shot, calibrated according to the level of magnification seen at any instant through the camera, expressed in exponential powers of ten. The need for designers is implicit in Feynman's challenge. And the potential for designers to respond is evident from the nature of the Eameses' intelligence. The combining of these two forces is a consummation to be devoutly

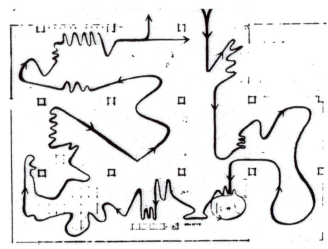

Charles Eames and Ray Eames. The Office of Charles and Ray Eames. **Traffic pattern for the exhibition** Good Design, Chicago. 1950

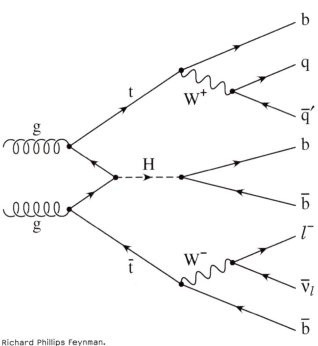

Richard Phillips Feynman. **Feynman Diagram.** 1949

Hugh Aldersey-Williams **Applied Curiosity**

below and pages 48–51:
Charles Eames and Ray Eames. The
Office of Charles and Ray Eames.
Stills from Powers of Ten: A Rough
Sketch for a Proposed Film Dealing
with the Powers of Ten and the
Relative Size of the Universe. 1968

wished for. Yet it did not happen in Los Angeles forty years ago, and it does not happen in general today.

The sense that there is a connection between science and design at all stems from the vague notion that these two disciplines were once one and the same. Leonardo da Vinci was the archetypal designer-scientist, the Renaissance man whom we unreasonably hold responsible for our contemporary expectation of such a synergy. Less than two centuries later, Robert Hooke and Christopher Wren, two of the founders of the Royal Society in 1660, the world's first academy of sciences, were architects and scientists both. But just a century after that, the split was beginning to appear. The attempts of the illustrious club of scientists and entrepreneurs known as the Lunar Society (members included chemist Joseph Priestley, steam-engine pioneer James Watt, and industrialist and potter Josiah Wedgwood) to maintain a dialogue already seemed strained. After one moonlit session, Wedgwood was driven to complain: "I have got beyond my depth....These wonderful works of Nature are too vast for my narrow microscopic comprehension. I must bid adieu to them for the present, & attend to what better suits my Capacity. The forming of a Jug or Teapot."[2] For the sciences were growing in volume and complexity. Beginning with the microscope and telescope, new technologies enabled investigation of regions invisible to the naked eye, further removing the scientific from the daily realm. The Industrial Revolution and the commercialization of design—which became known as one of the "useful arts"—merely served to widen the chasm.

Today, at the beginning of the twenty-first century, the communities of both science and design see that they have removed themselves too far from society—and from one another. For many designers, it is no longer enough to fulfill the demands of commercial clients. They wish their art to be something more than just "useful." Through critical or polemical projects, they signal their readiness to play a more transformative role in society. For their part, scientists are confronted by growing mistrust of what they do, and many realize that they must work harder to win public support.

Some science is necessarily remote. Science seeks to encompass the dimensions of time and space from the 10^{-18} meters to the 10^{25} meters of Powers of Ten—and beyond. Yet for most of us, scale is a prison. We see our world in feet and inches, meters and centimeters. It is hard enough to resee the same world even as little as a factor of twelve smaller or larger, as Gulliver found on his travels to the islands of Lilliput and Brobdingnag. The difficulties only multiply when we try to perceive the world far smaller than this. They do so because, confusingly, while some of the normal rules of nature continue to apply in microcosm, other apparently fundamental qualities, such as color or gravity, seem to apply no longer, and bizarre new rules may even come to the fore in their place.

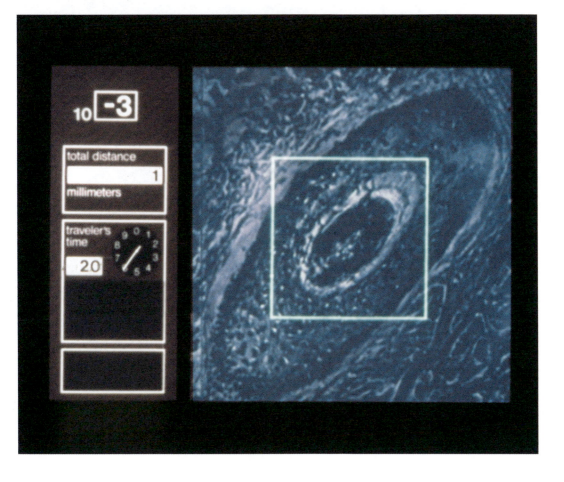

Visualization

Consider the symmetry of three-dimensional objects.
The British and American chemists who in 1985 discovered
a molecular new form of the element carbon—a surprise
addition to the long-familiar forms of diamond and
graphite—named it buckminsterfullerene. The molecule's
sixty carbon atoms are arranged in a hollow, symmet-
rical cage, like the structure of one of architect
Buckminster Fuller's geodesic domes. The shape of these
molecules proves structurally advantageous at the
scales of the chemical bond and human construction.
The same symmetrical form is found elsewhere in nature,
as well, for example in viruses and in the skeletons of
the marine protozoa known as radiolarians—intermediate
in scale between the molecular and the architectural.
Recent studies in physics, meanwhile, have found that
the same symmetry may be significant at the extreme
ends of the scale: in the shapes of clouds of nuclear
charge in the nuclei of atoms, and in some theories of
the structure of the universe.

The recurrence of such visual motifs suggests
persuasively that a design mentality may be helpful in
comprehending the miniature three-dimensional worlds
of microorganisms and molecules. By extension, perhaps
designers can have something to say about the peculiar
inside-out spatial realm that crystallographers find
convenient to use, or about the x-dimensional extent
of space-time (where x is four in the Einsteinian model
but possibly ten or eleven in the more recent and still
contentious "string" theory).

Visualization, however, can prove woefully misleading,
and scientists have long debated whether it is a useful
tool after all. Physicists Werner Heisenberg and Erwin
Schrödinger argued bitterly about this in the 1920s.
Schrödinger's image of a wave in a box describing the
behavior of a small particle in a field of force, such
as the negatively charged electron of a hydrogen atom
held in orbit around the positively charged proton
nucleus, was derided by Heisenberg, who felt that
visualization was invalid for quantum phenomena occur-
ring on a scale below the wavelengths of light.

Even at the scale of the visible, the way we visualize
things happening may not be the way they actually
happen. Scottish polymath D'Arcy Thompson's On Growth
and Form (1917) is a brilliant exploration of visual and
structural similarity among natural organisms, but even
this author is occasionally led into error by the
attraction of a visual image. Thompson reasoned, for
instance, that birds' eggs must have assumed their
characteristic shape for ease of passage along the
oviduct, where peristaltic contractions squeeze the
tapered end, forcing the egg onward so that it is laid,
as is observed, blunt end first. In fact, scientists
later found that eggs pass along the oviduct tapered
end first and flip round just before they are laid.

Writing a couple of generations after Robert Hooke's
Micrographia (1665) first revealed life under the
microscope, Jonathan Swift translated physical

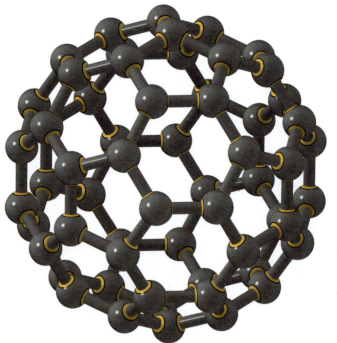

Joseph W. Lauher. State University
of New York at Stony Brook.
**Molecular Structure of Buckminster-
fullerene.** 2007. Chem-Ray Molecular
Graphics software

quantities related to the size of things with great care, knowing that a degree of rigor was vital in order to support his improbable tale. Thus, we learn that because Gulliver is twelve times taller than a Lilliputian, it takes a force 1,728 (12 cubed) times more powerful to move him about (because force relates to mass, and mass relates to volume, which is given by multiplying together all three linear dimensions). These more or less intuitive estimations quietly demonstrate the universality of physical laws: they apply indiscriminately at all scales; they do not themselves scale.

Swift's consistency breaks down, however, when it comes to less obvious laws of physics. If, when Gulliver wades into the sea to confound the navy of Blefuscu, Lilliput's enemy, he finds the water has its usual fluid qualities for him, then for the enemy ships it would be more like treacle, a glitch familiar from the execrable special effects in old films involving set-piece battles at sea. As you descend further in scale, still more physical laws become important that didn't assert themselves at the human scale. Try to envisage the forces present as a drug bonds to a receptor site, for example. The insertion of a key into a lock is the conventional metaphor. But it is misleading in physical terms because the forces relating to chemical bonds are unlike Newtonian forces in important ways. As Feynman wrote, "Atomic behavior is very difficult to get used to...both to the novice and to the experienced physicist."[3] Visualization becomes more treacherous the further you travel away from the human scale. Interestingly, some proponents of string theory think it may be more helpful to auralize rather than visualize what's going on: songs may be of more use than pictures!

Extension and Inspiration

With the caveat that it may be unwise to be too literal about these things, let us travel, like Gulliver, to "remote nations of the world," both vast and tiny. Sensory interpretations of aspects of the world that may not be sensed directly are just that: interpretations. They are not reality; they cannot be. But they can be appreciated for their suggestive power, even when this goes beyond what is scientifically authentic. It is simply a matter of being clear where the dividing line lies. For NASA, it is on occasion useful to be able to visualize the forces surrounding black holes. But for cosmologists, theoretical physicists, and mathematicians seeking to understand such phenomena, such visualizations may equally be a distraction. Similarly, it is not necessary to have a visual image of the connectedness of the Internet in order to use it effectively. Nor may having such an image help a software designer. But then again, it just might do something for someone else, in ways unforeseeable until the task is attempted. Thus Barrett Lyon's Opte Project; on the one hand it is art, but it is also a map of the Internet that brings to light new information about the system itself and its representations of the world.

Beyond the visual, images of science have merely

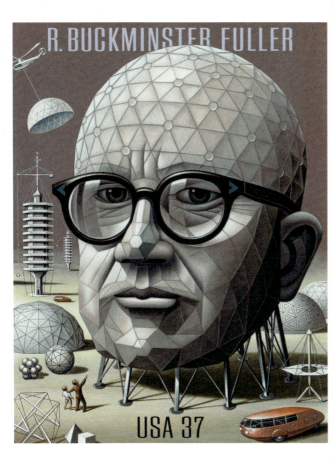

Buckminster Fuller stamp. (designed by Carl T. Herrman based on a painting by Boris Artzybasheff that appeared on the cover of <u>Time</u> magazine, January 10, 1964). 2003 (issued 2004). Prephosphored paper, 1 5/8 x 1 1/4" (4 x 3.2 cm)

metaphoric power, typically communicating a sense of progressiveness and optimism through the objects that adopt them. In the heady early days of nuclear power, excitedly whizzing atoms adorned the packaging of consumer products as banal as soap powder. George Nelson's Ball Clock is another product that contains an echo of this short-lived infatuation. The analytical technique of X-ray diffraction, which was used with such success to decode the structure of DNA and other biologically important molecules, produced sufficiently novel patterns, pleasingly combining randomness and repetition, that these were taken up in fabric designs of the period. The double helix of DNA itself has become an enduring motif expressive of the machinery of life in art, design, illustration, and figurative speech. Benoit Mandelbrot's fractal geometry undoubtedly lies behind the emergence of a new baroque in contemporary decorative art, seen in objects such as Tord Boontje's lampshades or Mathieu Lehanneur's Q Quinton Spray, a nebulizer for aromatherapeutic use. Such work sometimes seems so at odds with other trends in design aesthetics that one wonders whether it would ever have taken this form but for the gloss of scientific validity.

Using science for inspiration is all well and good, but caution is necessary if larger claims are made for it. Not only must it be understood when a concept cannot apply for physical reasons, for example due to a change of scale, but it is also important to be clear that inspiration stemming from science has no special status over and above inspiration from the usual sources in history or in other arts. Critic Charles Jencks is thus misled when he answers his own question, "Why should one look to the new sciences for a lead?" with these words: "Partly because they are leading in a better direction—towards a more creative world view than that of Modernism—and partly because they are true."[4] Both of these justifications seek to endow design that is inspired by science with a superior moral authority. But garden ironwork such as Jencks himself has created inspired by "quantum waves" has no higher morality or deeper meaning than a cornstalk fence. Designs with randomized elements chosen on the basis of DNA sequences—a recent fashion in architecture schools—have no closer connection to life as a result. These phenomena are as good a basis for a stylistic idea as any, but no better.

The essential shallowness of this sort of fetish for science is apparent from the selection of ideas involved. For a start, they are not in fact "new sciences." It is a full century since the structure of the atom, quantum theory, and relativity were properly described. Even the theories of chaos and complexity originated more than forty years ago. If not novelty, then perhaps "weirdness" is what counts, especially weirdness involving richness and uncertainty. And yet long-standing weirdness is neglected. Quantum theory fires the imagination because it reintroduced something

William Ngan of Metaphorical.net. **Mandelbrot Set.** 2006. Java and Processing software

intrinsically mysterious and indeterminate to science just at the time when it seemed that all might soon be known for certain. Meanwhile, gravity remains fundamentally very odd, but because we live with it every day it is judged less worthy of artistic exploration. The second law of thermodynamics, the law of entropy, has likewise escaped much attention, perhaps because it lacks a convenient visual lexicon, or perhaps because its implication—that the universe must run down in ultimate disorder—is too depressing for the creative arts.

Mesoscale Mystery

Like Gulliver, we return from Lilliput and Brobdingnag only to find that some of the strangest goings-on are happening at the human scale. There is a case to be made that, for all their unanswered questions, it is the very large and the very small that are best understood by science. The middle of the range, the mesoscale, offers plenty of mysteries yet. There is much that we know, from Newton's laws to chemistry, but there are also the puzzles of the organization of life, the conscious mind, and the uncontrollable weather. You don't need to go down to the scale of the atom and Schrödinger's wave-in-a-box to be awed by the mysteries of waves. Mitsui Zosen's arrangement of wave generators in a circular tank in order to create standing waves of unwavelike shapes, such as letters of the alphabet, reminds us that they are strange enough in the everyday world. The mesoscale is where matter and energy behave in the ways intuitively familiar to us, where visualization is most relevant, and therefore where it is most likely that designers have a real contribution to make.

All of biology happens at this scale. When he wrote about technology as the extension of man, Marshall McLuhan did not explicitly invoke technologies based on biological systems, although that possibility is inherent in our conception of such powers—we speak of having eyes like a hawk or the hearing ability of a dog, we envy bats' radar and migrating birds' navigational skill. The huge progress in biological sciences during the twentieth century now dictates that designers should no longer consider only the mineral world as their raw material. Early work at this new boundary between science and design is both exciting and disturbing. Susana Soares uses the fact that bees can be "trained" to react to specific odors to harness them in a kind of olfactory appurtenance that could enable us to sense toxins or pheromones. The idea may seem bizarre now, but is it really any stranger in principle than an explosives-sniffing dog? It is beyond question that closer appreciation of biological systems of all kinds now raises the prospect of extending human capabilities in many ways.

If tissue cells can be cultured to emulate human parts for use in reconstructive surgery, some designers have reasoned, then they can also be made to follow entirely novel forms. It is a relatively straightforward matter to produce something faintly creepy using these techniques, as Oron Catts and Ionat Zurr

do in their long-running project, Tissue Culture & Art.
Their Pig Wings Project, wing shapes grown from pig
tissue, is an example of a semi-living object, one which,
by title and appearance, mocks the aspirations of the
very biotechnology it utilizes to achieve its result. It
is altogether harder, in these early days, to produce a
thing of beauty. However, Tobie Kerridge, Nikki Stott,
and Ian Thompson may have succeeded with Biojewellery,
a project that allows wedding rings to be exchanged
that are made of bone grown from each marriage
partner's bone cells.

Other designers are taking their ideas from nature
but executing them in artificial materials. Here is where
nanotechnology and biosciences—apparently so different
both in scale and in what one might call their romance—
actually overlap. James King's project Fossils from a
Nanotech Future continues a tradition that runs from
Gothic gargoyles to the Tiffany lamps and Blaschka
glassware inspired by contemporaneous drawings of
marine organisms by German biologist Ernst Haeckel. Such
objects are evidence of a shift away from the machine
and toward organism as cultural metaphor. This shift is
seen most unequivocally in Barry Trimmer's quest to
develop "soft-bodied" robots—automata as different
as can be from the clanking metallic monsters of classic
science fiction. The aim of such projects should be to
learn from nature's economy in both material and
energy. Joris Laarman's Bone Chair also exemplifies this
biomimetic approach, showing how a minimal structure
may be achieved by examining, in this case, the way that
bones sacrifice weight where it is not needed. Though
complex in shape, Laarman's resulting structure is highly
efficient—and very likely to be judged elegant because
of its "natural" appearance.

Taken a little further, the biomimetic argument
raises some challenging new questions. One of design's
greatest problems, often ignored completely, is that
of matching a product to its use not in the physical
three dimensions of space but over time. Some products
break before we have finished with them; others far
outlast any conceivable utility and are wastefully
dumped or destroyed. In nature, this problem is
deviously solved by death: An organism dies once it
ceases to have a use and ceases to have a use after
it dies. A prime goal for designers now has to be to
bring their objects' material existence and practical
utility into similar harmony. One might counter that
nature is wasteful in its own way, cruelly redundant in
its overproduction of species that merely become
another species' prey. But this is only wasteful from
the species' point of view: Nature's concern is for the
most economical management of the overall system.
A comprehensive biomimetic design philosophy will
require systems thinking a mile away from the designer's
traditional focus on the object.

This approach to design seeks to adapt specific
advantages observed in natural organisms into human
technology, but the polemical subtext of any design

above:
Stefan Sagmeister and Matthias
Ernstberger of Sagmeister Inc.
Seed Media Group Identity. 2005

right:
Jonathan Harris of Number 27.
Phylotaxis. 2005–ongoing. Perl,
MySQL, PHP, and Flash software

Seed's mission is to establish
science's position in culture, and
Stefan Sagmeister and Matthias
Ernstberger's adaptable logo is
based on the phyllotaxis structure,
a quintessentially organic algorithm.
Jonathan Harris took the logo as
a basis for a Web-based project
that symbolizes the space where
science meets culture.

November 18, 2005

inspired by nature is that we are in danger of losing touch with the natural world. It pleads for the biological, the technological, and the ethical to come together. This is the objective of "consilience," the term coined by biologist Edward O. Wilson for the reunification of the strands of intellectual inquiry artificially separated as a consequence of the growth of specialized disciplines in science and the humanities. In his book Consilience: The Unity of Knowledge, Wilson writes: "If the world really works in a way so as to encourage the consilience of knowledge, I believe the enterprise of culture will eventually fall out into science, by which I mean the natural sciences, and the humanities, particularly the creative arts."[5]

Charles Eames and Richard Feynman were consilient personalities, but their meeting never happened because the world didn't work in the right way. The question is: Does it now?

Notes
1.
Richard Feynman, "There's Plenty of Room at the Bottom" (lecture, December 1959). For a transcript of the lecture, see www.its.caltech.edu/~feynman/plenty.html.
2.
Josiah Wedgwood, letter to Thomas Bentley, quoted in Humphrey Jennings, Pandaemonium: The Coming of the Machine As Seen by Contemporary Observers (London: Macmillan, 1995), p. 63.
3.
Richard Feynman, Six Easy Pieces (London: Penguin, 1998), p. 117.
4.
Charles Jencks, The Architecture of the Jumping Universe (London: Academy Editions, 1995), p. 9.
5.
Edward O. Wilson, Consilience: The Unity of Knowledge (London: Little, Brown, 1998), p. 10.

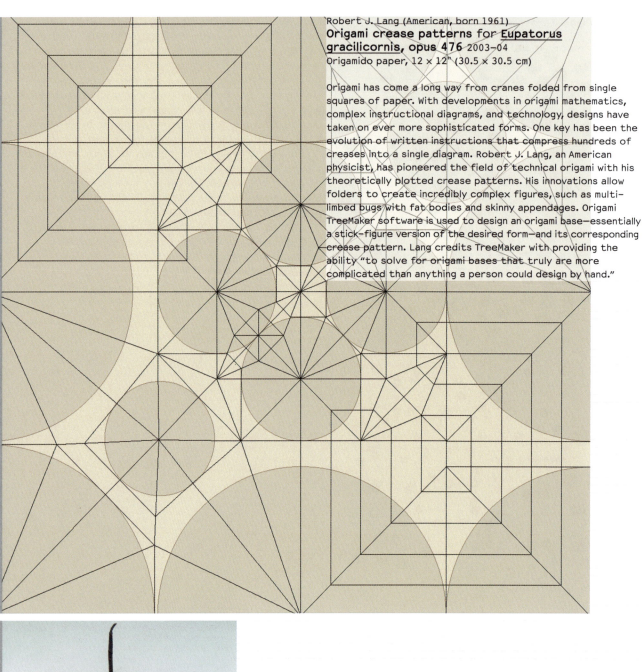

Robert J. Lang (American, born 1961)
Origami crease patterns for <u>Eupatorus gracilicornis</u>, opus 476 2003–04
Origamido paper, 12 × 12" (30.5 × 30.5 cm)

Origami has come a long way from cranes folded from single squares of paper. With developments in origami mathematics, complex instructional diagrams, and technology, designs have taken on ever more sophisticated forms. One key has been the evolution of written instructions that compress hundreds of creases into a single diagram. Robert J. Lang, an American physicist, has pioneered the field of technical origami with his theoretically plotted crease patterns. His innovations allow folders to create incredibly complex figures, such as multi-limbed bugs with fat bodies and skinny appendages. Origami TreeMaker software is used to design an origami base—essentially a stick-figure version of the desired form—and its corresponding crease pattern. Lang credits TreeMaker with providing the ability "to solve for origami bases that truly are more complicated than anything a person could design by hand."

Robert J. Lang (American, born 1961)
Scorpion varileg, opus 379 and its
Origami TreeMaker file 1990–2006
Origamido paper, 3 × 3 × 5" (7.6 × 7.6 × 12.7 cm)

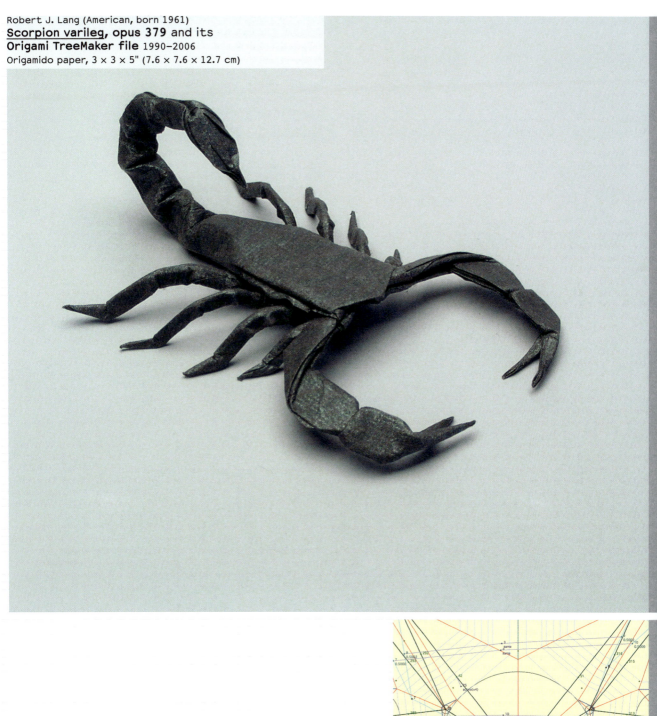

Robert J. Lang (American, born 1961)
Origami Simulation software 1990–92
THINK Pascal and THINK Class Library software

Origami Simulation, a program that Lang designed to simulate
the folding of paper on a computer screen, allows users
to experiment with various folds and easily undo or redo
a folding sequence with the click of a mouse.

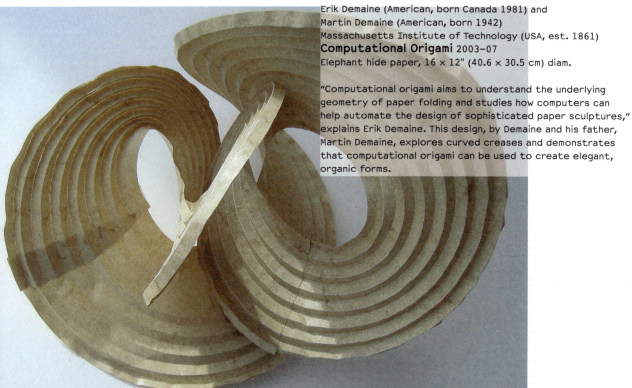

Erik Demaine (American, born Canada 1981) and
Martin Demaine (American, born 1942)
Massachusetts Institute of Technology (USA, est. 1861)
Computational Origami 2003–07
Elephant hide paper, 16 × 12" (40.6 × 30.5 cm) diam.

"Computational origami aims to understand the underlying
geometry of paper folding and studies how computers can
help automate the design of sophisticated paper sculptures,"
explains Erik Demaine. This design, by Demaine and his father,
Martin Demaine, explores curved creases and demonstrates
that computational origami can be used to create elegant,
organic forms.

Roderick Hyde (American, born 1952), Sham Dixit (American,
born 1955), and Robert J. Lang (American, born 1961)
Lawrence Livermore National Laboratory (USA, est. 1952)
Fresnel lens for the **Eyeglass Space Telescope**
Reduced-scale prototype. 1998–2005
Glass, aluminum, and steel, 16' 4 7/8" (500 cm) diam.

As origami has become more complex and adaptable to ad hoc
interventions, it has also become more useful, with applica-
tions for a wide range of devices. One such application is space
telescopes. The bigger a telescope's lens, the more light it can
gather, and with bigger apertures comes the ability to capture
objects deeper in space. Sending large glass lenses into orbit,
however, is difficult. The Fresnel lens for the planned Eyeglass
Space Telescope makes use of an origami-derived folding
concept that allows the lens to be tightly packed for launch
into space and then unfolded without suffering from unwanted
marks or creases—creating the possibility of building a lens
that will unfold to 100 meters; by contrast, the Hubble tele-
scope sports a lens with a diameter of 2.5 meters.

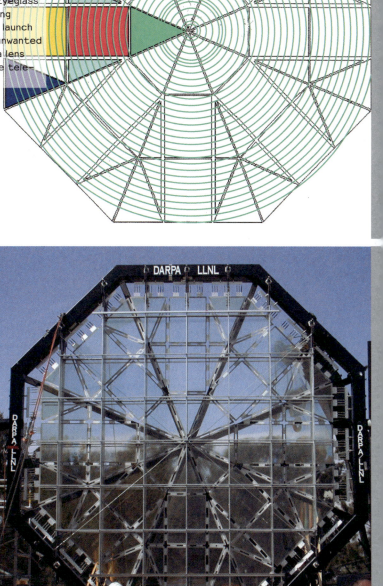

Jürg Lehni (Swiss, born 1978)
and Uli Franke (German, born 1978)
École cantonale d'art de Lausanne (écal) (Switzerland, est. 1821)
Hektor spray-paint output device Prototype.
2002-ongoing
Stepper motor, toothed belts, aluminum casing, spray-paint can, suitcase, custom-made electronics, and Scriptographer software, motor: 3 × 4 × 6 1/2" (7.5 × 10 × 16.5 cm); spray-paint can holder: 9 7/8 × 6 × 1 1/8" (25 × 15 × 3 cm)

In a publishing world dominated by paper and ink, Hektor—a computer-driven output device in which the human hand only clicks a button—allows for printing on a vertical surface with spray paint. The contraption commands a suspended spray-paint can that "prints" text written using Scriptographer, an Adobe Illustrator scripting plug-in designed by Jürg Lehni. The designers explain that "during operation, the mechanism sometimes trembles and wobbles and the paint often drips," creating a tension between low- and high-tech aspects of construction, application, and technology.

Philip Worthington (British, born 1977)
Design Interactions Department (est. 1989),
Royal College of Art (UK, est. 1837)
Shadow Monsters 2004–ongoing
Java, Processing, BlobDetection, SoNIA, and
Physics software

Monsters materializing from shadows cast on walls may sound
like something from a child's active imagination, but Philip
Worthington has made the playful concept a reality. Worthington's
Shadow Monsters project is an example of interactive design
based on custom-designed vision-recognition software. With
the support of a computer, a camera, a projector, and a light
box, fantastic creatures emerge from shadows of the hands
of participants as the software elaborates on their gestures
with sound and animation. Open and close your hands like a
mouth, and a wolf with razor-sharp teeth will surface and growl.
Tongues, eyes, and fins appear. Birds squawk and dinosaurs speak.
It's a magical experience that inspires the audience to play
with body posturing in order to create delightfully crazy stories.

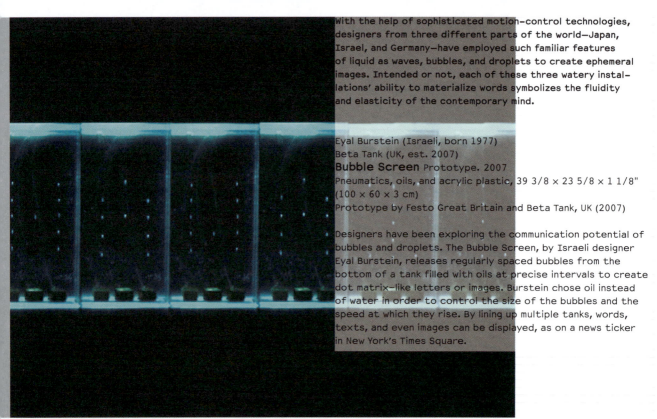

With the help of sophisticated motion-control technologies, designers from three different parts of the world—Japan, Israel, and Germany—have employed such familiar features of liquid as waves, bubbles, and droplets to create ephemeral images. Intended or not, each of these three watery installations' ability to materialize words symbolizes the fluidity and elasticity of the contemporary mind.

Eyal Burstein (Israeli, born 1977)
Beta Tank (UK, est. 2007)
Bubble Screen Prototype. 2007
Pneumatics, oils, and acrylic plastic, 39 3/8 × 23 5/8 × 1 1/8"
(100 × 60 × 3 cm)
Prototype by Festo Great Britain and Beta Tank, UK (2007)

Designers have been exploring the communication potential of bubbles and droplets. The Bubble Screen, by Israeli designer Eyal Burstein, releases regularly spaced bubbles from the bottom of a tank filled with oils at precise intervals to create dot matrix–like letters or images. Burstein chose oil instead of water in order to control the size of the bubbles and the speed at which they rise. By lining up multiple tanks, words, texts, and even images can be displayed, as on a news ticker in New York's Times Square.

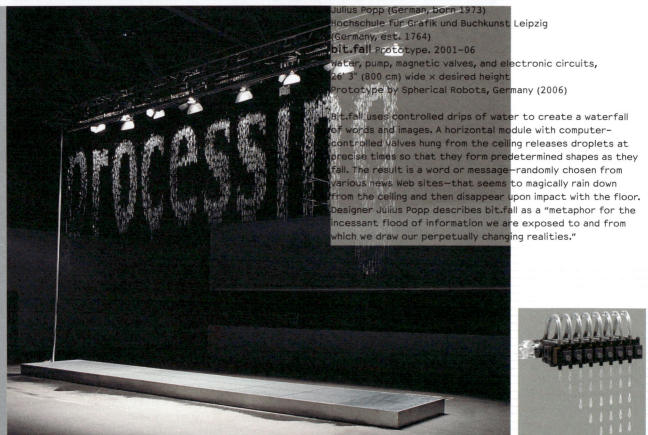

Julius Popp (German, born 1973)
Hochschule für Grafik und Buchkunst Leipzig
(Germany, est. 1764)
bit.fall Prototype. 2001–06
Water, pump, magnetic valves, and electronic circuits,
26' 3" (800 cm) wide × desired height
Prototype by Spherical Robots, Germany (2006)

Bit.fall uses controlled drips of water to create a waterfall of words and images. A horizontal module with computer-controlled valves hung from the ceiling releases droplets at precise times so that they form predetermined shapes as they fall. The result is a word or message—randomly chosen from various news Web sites—that seems to magically rain down from the ceiling and then disappear upon impact with the floor. Designer Julius Popp describes bit.fall as a "metaphor for the incessant flood of information we are exposed to and from which we draw our perpetually changing realities."

Shigeru Naito (Japanese, born 1944) of the Department of
Naval Architecture and Ocean Engineering, Osaka University
(Japan, est. 1931)
Etsuro Okuyama (Japanese, born 1977) of Akishima Laboratories
(Mitsui Zosen), Inc. (Japan, est. 1917)

**AMOEBA (Advanced Multiple Organized
Experimental Basin)** Prototype. 1997
Aluminum, acrylic plastic, and water, 11 3/4" × 9' 10" × 9' 10"
(30 × 300 × 300 cm)
Prototype by Akishima Laboratories (Mitsui Zosen), Inc.,
Japan (1997)

The AMOEBA, or Advanced Multiple Organized Experimental Basin,
was originally built to evaluate the effects of waves on ship
designs. It is a circular basin about the size of an inflatable
children's pool. Using fifty plungerlike mechanical units installed
along its rim, AMOEBA can produce a variety of wave conditions
and then calm the water's surface on command. One of Shigeru
Naito's students found an unintended use for this equipment:
creating the alphabet on the water's surface. When waves in
various frequencies converge, the water's surface rises at
specific points; by connecting these points, lines and shapes
can be drawn. In 2002, Etsuro Okuyama of Mitsui Zosen's Akishima
Laboratories was asked to further develop this theory.

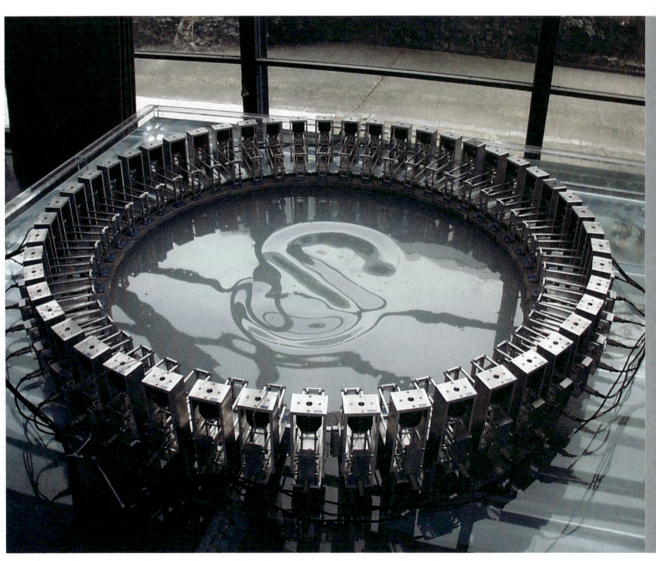

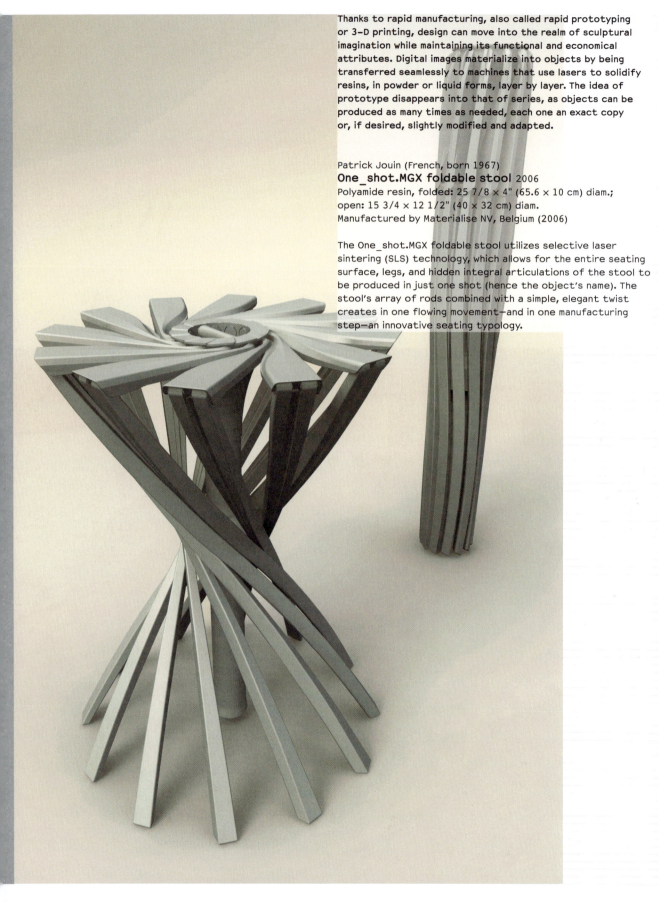

Thanks to rapid manufacturing, also called rapid prototyping or 3-D printing, design can move into the realm of sculptural imagination while maintaining its functional and economical attributes. Digital images materialize into objects by being transferred seamlessly to machines that use lasers to solidify resins, in powder or liquid forms, layer by layer. The idea of prototype disappears into that of series, as objects can be produced as many times as needed, each one an exact copy or, if desired, slightly modified and adapted.

Patrick Jouin (French, born 1967)
One_shot.MGX foldable stool 2006
Polyamide resin, folded: 25 7/8 × 4" (65.6 × 10 cm) diam.;
open: 15 3/4 × 12 1/2" (40 × 32 cm) diam.
Manufactured by Materialise NV, Belgium (2006)

The One_shot.MGX foldable stool utilizes selective laser sintering (SLS) technology, which allows for the entire seating surface, legs, and hidden integral articulations of the stool to be produced in just one shot (hence the object's name). The stool's array of rods combined with a simple, elegant twist creates in one flowing movement—and in one manufacturing step—an innovative seating typology.

Sofia Lagerkvist (Swedish, born 1976), Charlotte von der Lancken (Swedish, born 1978), Anna Lindgren (Swedish, born 1977), and Katja Sävström (Swedish, born 1976) of Front Design (Sweden, est. 2004)
Sketch Furniture 2005
Polyamide resin, chair: 31 1/2 × 15 3/4 × 15 3/4" (80 × 40 × 40 cm); floor lamp: 55 1/8 × 15 3/4" (140 × 40 cm) diam.; table: 28 3/8 × 17 3/4" (72 × 45 cm) diam.
Prototypes by Acron Formservice AB, Sweden (2005)
Motion capture by Crescent, Japan (2006)

The Front Design team has developed a unique method by which freehand sketches materialize into form. Strokes made in the air are recorded with motion-capture video technology and are then digitized into a 3-D computer model. The digital files are then sent to a rapid manufacturing machine that uses computer-controlled lasers to print the objects in plastic, resulting in furniture that is a clear translation of drawing into object.

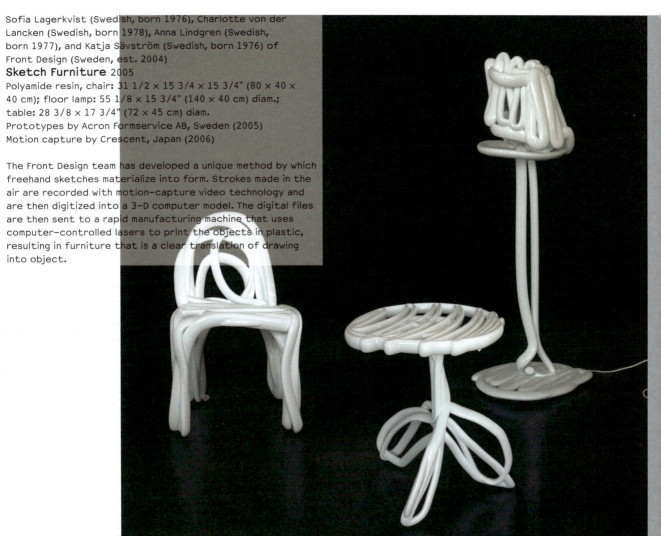

Janne Kyttänen (Finnish, born 1974)
Freedom Of Creation (FOC) (The Netherlands, est. 2000)
Macedonia fruit bowl 2007
Quartz sand with epoxy infiltration, 1 3/4 × 12 1/2"
(4.6 × 32 cm) diam.
Manufactured by Freedom Of Creation, The Netherlands (2007)

In Italian and Spanish, the word macedonia means fruit salad;
the original etymology of the term harks back to the
heterogeneous composition of the people of the Balkan region
of Macedonia. Janne Kyttänen designed this fruit bowl inspired
by the formation and structures of soap bubbles. Kyttänen
printed it using sand mixed with resin, proving that even when
employing the most advanced technique and an innovative form,
a conventional material can restore a balance between novelty
and tradition.

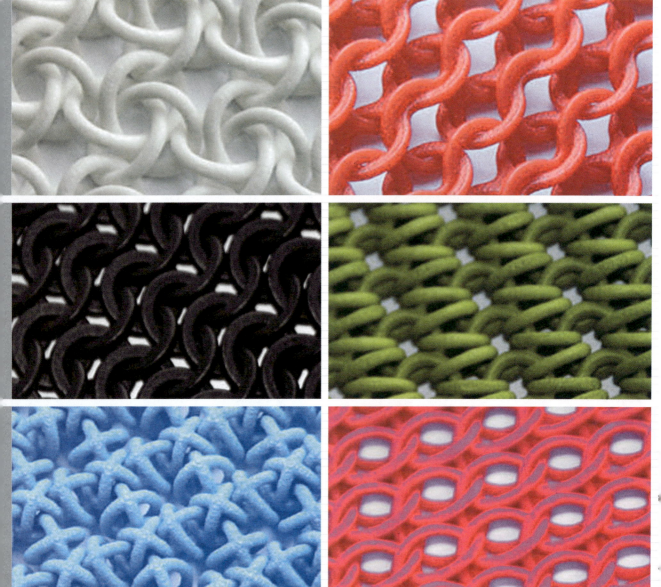

Janne Kyttänen (Finnish, born 1974) and
Jiri Evenhuis (Dutch, born 1973)
Freedom Of Creation (FOC) (The Netherlands, est. 2000)

page 68, bottom:
Laser-sintered textiles 2000–06
Polyamide resin, dimensions variable
Manufactured by Freedom Of Creation, The Netherlands
(2000–06)

below:
Punchbag handbag 2005
Polyamide resin, 11 3/4 × 11 × 5/8" (30 × 28 × 1.7 cm)
Manufactured by Freedom Of Creation, The Netherlands (2005)

Freedom Of Creation designers Janne Kyttänen and Jiri Evenhuis
have taken the concept of rapid manufacturing to the realm
of textiles. Rather than the traditional method of weaving
materials and then cutting and sewing them together, laser-
sintered textiles are built tridimensionally, layer by layer.
Because the textile is first created on a computer, its
threads digitally interwoven, the fabric is easily customizable
in various patterns, sizes, and colors.

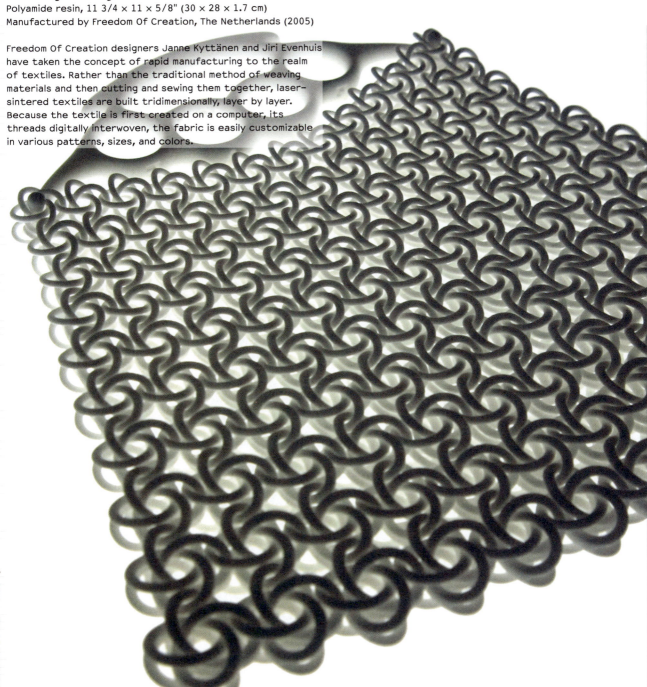

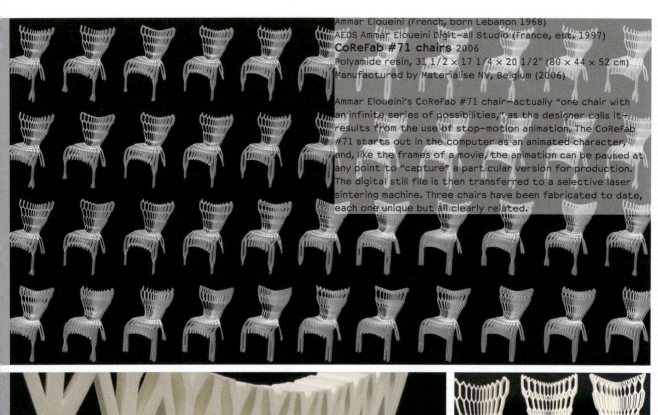

Ammar Eloueini (French, born Lebanon 1968)
AEDS Ammar Eloueini Digit-all Studio (France, est. 1997)
CoReFab #71 chairs 2006
Polyamide resin, 31 1/2 × 17 1/4 × 20 1/2" (80 × 44 × 52 cm)
Manufactured by Materialise NV, Belgium (2006)

Ammar Eloueini's CoReFab #71 chair—actually "one chair with an infinite series of possibilities," as the designer calls it—results from the use of stop-motion animation. The CoReFab #71 starts out in the computer as an animated character, and, like the frames of a movie, the animation can be paused at any point to "capture" a particular version for production. The digital still file is then transferred to a selective laser sintering machine. Three chairs have been fabricated to date, each one unique but all clearly related.

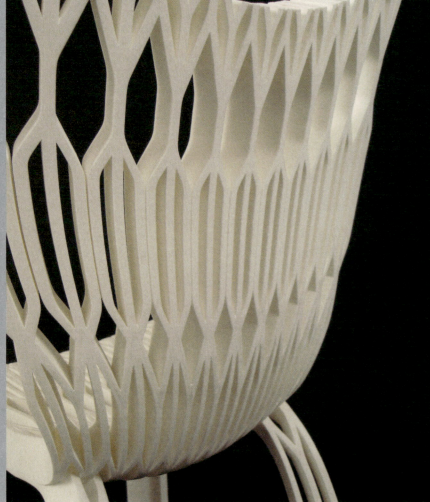

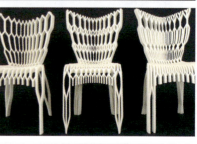

Design and the Elastic Mind

right:
Joris Laarman (Dutch, born 1979)
Bone Chair 2006
Aluminum, 29 3/4 × 29 7/8 × 17 1/2" (75.6 × 75.8 × 44.5 cm)
Manufactured by Joris Laarman Studio, The Netherlands (2007)

below:
Lothar Harzheim (German, born 1956)
Adam Opel GmbH (Germany, est. 1862)
Engine mount production component 1998
Aluminum, 1 × 3/4 × 5/8" (2.5 × 2 × 1.5 cm)
Manufactured by Adam Opel GmbH, Germany (1998)

The International Development Center at Adam Opel GmbH, General Motors' German subsidiary, has developed 3-D optimization software that mimics biological growth and applies its rules to objects of all kinds. Originally designed for automotive chassis components and called SKO (Soft Kill Option), the software has been applied by designer Joris Laarman to the design of furniture. The transfer of technology between the natural world and synthetic constructs is at the heart of Laarman's Bone Chair, which is based on the generative process of bones. As bones grow, areas not exposed to high stress develop less mass while areas that bear more stress develop added mass for strength. Doing away with the superfluous results in an optimized structure that performs with the least amount of material. Using 3-D optimization software to generate form rather than applying the software to a preexisting structure, Laarman's Bone Chair moves beyond imitation of a biological structure to emphasize the implementation of a natural building process, suggesting that nature is the ultimate form giver.

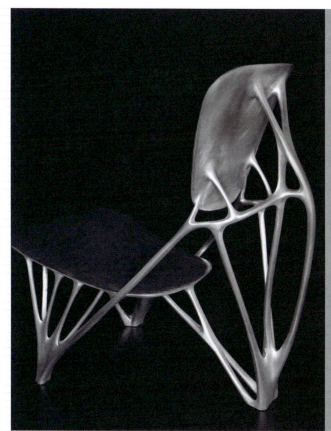

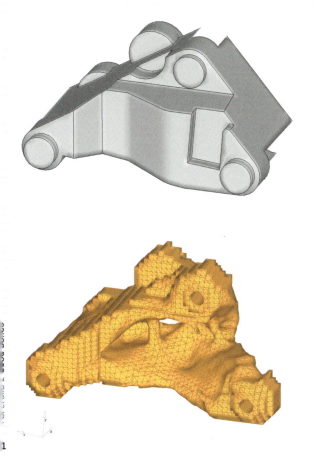

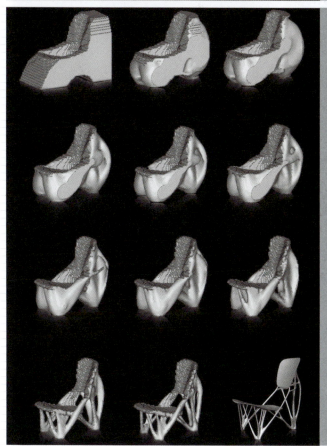

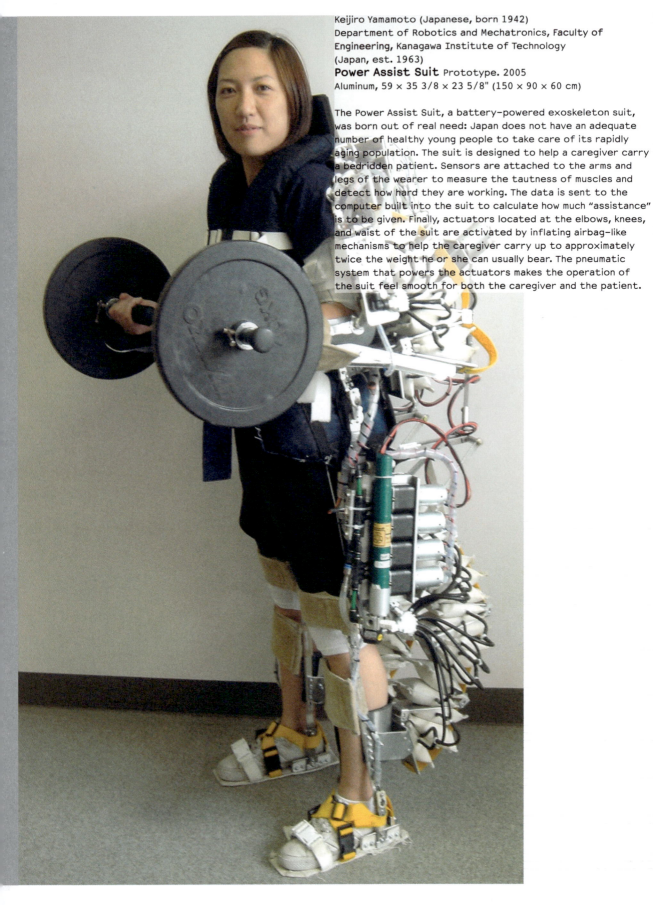

Keijiro Yamamoto (Japanese, born 1942)
Department of Robotics and Mechatronics, Faculty of
Engineering, Kanagawa Institute of Technology
(Japan, est. 1963)

Power Assist Suit Prototype. 2005
Aluminum, 59 × 35 3/8 × 23 5/8" (150 × 90 × 60 cm)

The Power Assist Suit, a battery-powered exoskeleton suit,
was born out of real need: Japan does not have an adequate
number of healthy young people to take care of its rapidly
aging population. The suit is designed to help a caregiver carry
a bedridden patient. Sensors are attached to the arms and
legs of the wearer to measure the tautness of muscles and
detect how hard they are working. The data is sent to the
computer built into the suit to calculate how much "assistance"
is to be given. Finally, actuators located at the elbows, knees,
and waist of the suit are activated by inflating airbag-like
mechanisms to help the caregiver carry up to approximately
twice the weight he or she can usually bear. The pneumatic
system that powers the actuators makes the operation of
the suit feel smooth for both the caregiver and the patient.

Hugh Herr (American, born 1964), Jeff Weber (American, born 1969), and Bruce Deffenbaugh (American, born 1946)
Biomechatronics Group (est. 2004), Massachusetts Institute of Technology (USA, est. 1861)
iWalk, Inc. (USA, est. 2006)
Powered Ankle-Foot Prosthesis Prototype. 2005–07
Titanium, aluminum, carbon composite, and polyurethane, 7 × 3 × 10 1/2" (17.8 × 7.6 × 26.7 cm)
Prototype by iWalk, Inc., USA (2007)

Most of today's prostheses cannot equal actual limbs. A conventional ankle-foot prosthesis, for example, requires the amputee to exert thirty percent more energy when walking than a biological ankle does. This is because the biological ankle and foot provide energy for walking beyond that which can be stored from the spring of the foot alone. Hugh Herr and his Biomechatronics Group at MIT have developed an artificial ankle-foot that can mimic the real thing. Instead of muscle and tendon, a battery-powered motor and multiple springs are used to make walking easier and a person's gait more natural.

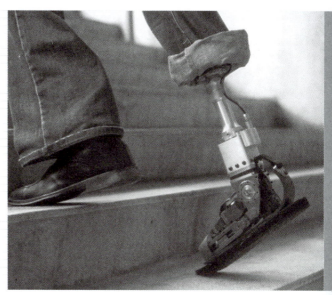

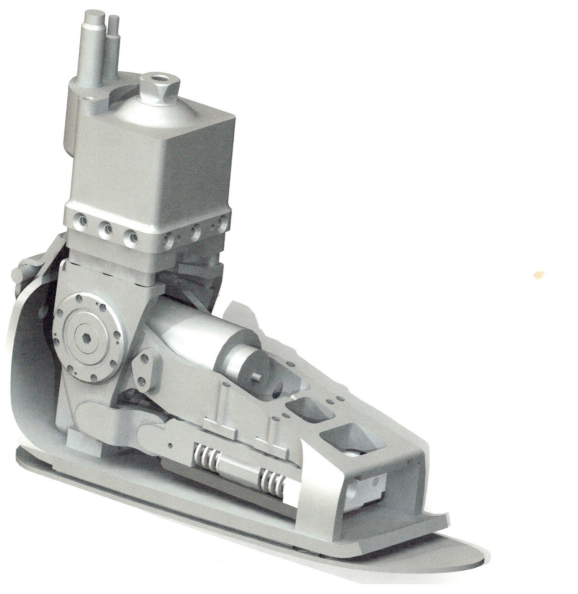

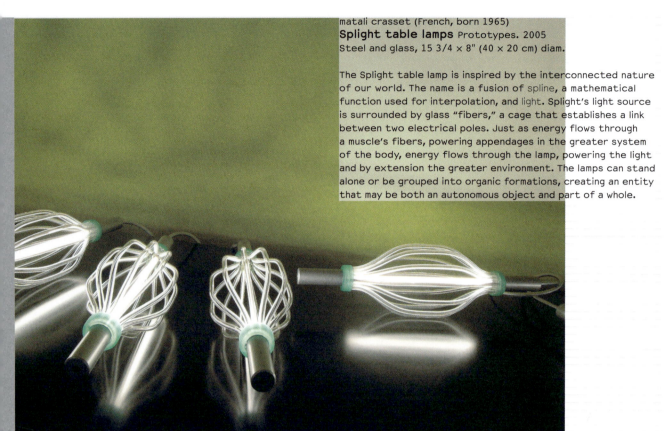

matali crasset (French, born 1965)
Splight table lamps Prototypes. 2005
Steel and glass, 15 3/4 × 8" (40 × 20 cm) diam.

The Splight table lamp is inspired by the interconnected nature of our world. The name is a fusion of spline, a mathematical function used for interpolation, and light. Splight's light source is surrounded by glass "fibers," a cage that establishes a link between two electrical poles. Just as energy flows through a muscle's fibers, powering appendages in the greater system of the body, energy flows through the lamp, powering the light and by extension the greater environment. The lamps can stand alone or be grouped into organic formations, creating an entity that may be both an autonomous object and part of a whole.

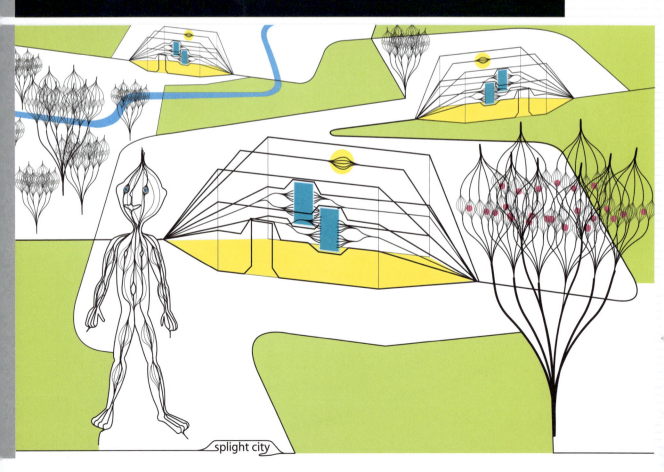

splight city

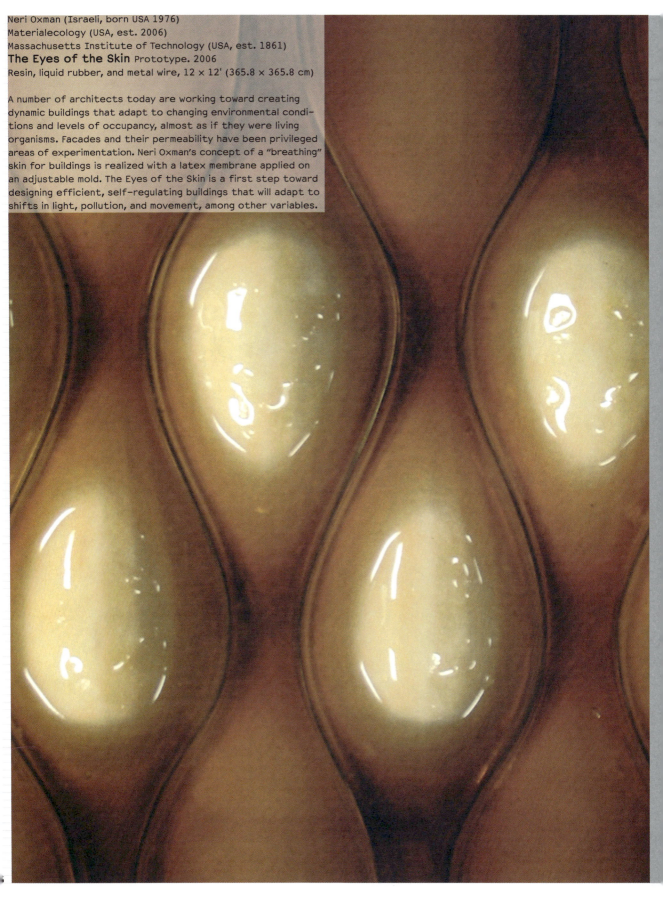

Neri Oxman (Israeli, born USA 1976)
Materialecology (USA, est. 2006)
Massachusetts Institute of Technology (USA, est. 1861)
The Eyes of the Skin Prototype. 2006
Resin, liquid rubber, and metal wire, 12 × 12' (365.8 × 365.8 cm)

A number of architects today are working toward creating
dynamic buildings that adapt to changing environmental condi-
tions and levels of occupancy, almost as if they were living
organisms. Facades and their permeability have been privileged
areas of experimentation. Neri Oxman's concept of a "breathing"
skin for buildings is realized with a latex membrane applied on
an adjustable mold. The Eyes of the Skin is a first step toward
designing efficient, self-regulating buildings that will adapt to
shifts in light, pollution, and movement, among other variables.

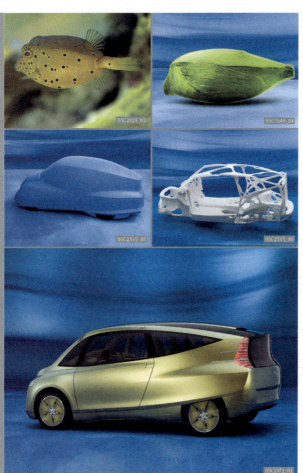

Peter Pfeiffer (German, born 1943)
Daimler AG/Mercedes-Benz Design (Germany, est. 1998/1926)
Mercedes-Benz bionic car Concept. 2005

With billions of years of research and development under its belt, it's no wonder that nature has achieved the optimal solutions for the toughest design problems—and sometimes the best solution is surprisingly counterintuitive. When Daimler engineers were searching for an aerodynamic form for a new lightweight, fuel-efficient car, they turned away from the prevailing teardrop shape and looked instead to the boxfish. Angular yet elegant, the boxfish is unexpectedly streamlined for easy maneuverability, while its skin, consisting of hexagonal bony plates, provides protection with minimal weight. Using bionic modeling, the engineers developed a concept for a vehicle that benefits from a low drag coefficient, high engine performance, and a safe, rigid construction.

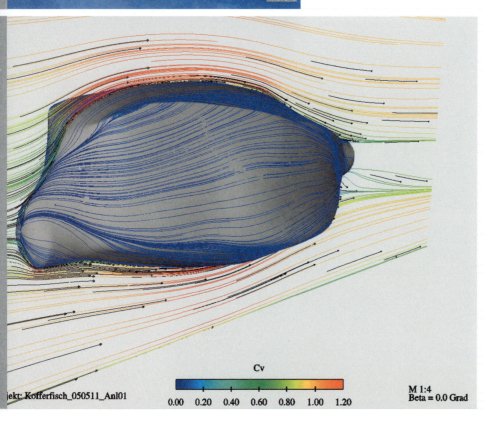

jekt: Kofferfisch_050511_Anl01

Cv

0.00 0.20 0.40 0.60 0.80 1.00 1.20

M 1:4
Beta = 0.0 Grad

Jayden D. Harman (Australian, born 1949)
PAX Scientific, Inc. (USA, est. 1997)
Lily Impeller 1996
Stainless steel, 7 1/2 × 4 1/4" (19 × 10.8 cm) diam.
Manufactured by PAX Water Technologies, Inc., USA (2002)

Biomimicry is the strategy that designers and engineers use
to observe and learn from nature's sophisticated designs and
then implement these lessons in artificial objects. The Lily
Impeller is a mixer "designed using the elegant and effective
geometries found in natural fluid flow," explains its designer.
Its shape, based on the logarithmic curve known as the Fibonacci
spiral and found in such objects as nautilus shells and whirlpools,
allows liquids to flow centripetally through it with little friction.
As a result the device is capable of circulating millions of gallons
of water with a minimal amount of energy. Used in municipal
reservoir tanks, the mixer prevents drinking water from stag-
nating, reducing the need for disinfectant additives.

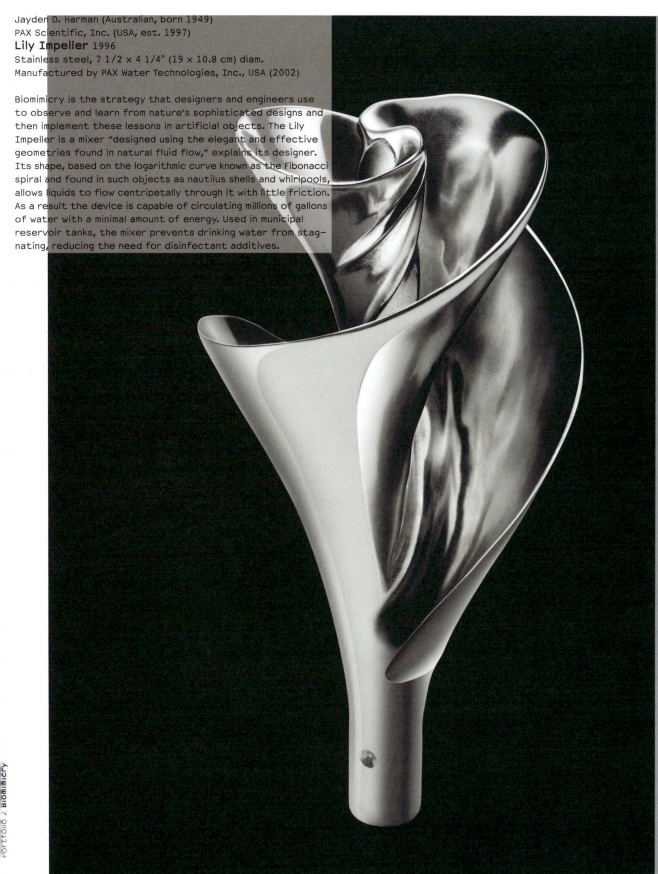

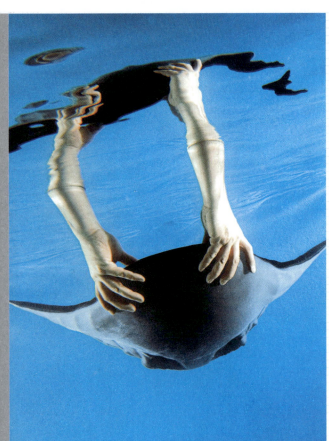

Rudolf Bannasch (German, born 1952) and Leif Kniese (German, born 1968) of EvoLogics GmbH (Germany, est. 2000)
Markus Fischer (German, born 1966) of Festo AG & Co. KG Corporate Design (Germany, est. 1925)
Aqua_ray Prototype. 2007
Fiberglass-reinforced plastic, CURV polypropylene sheet, polyamide resin with elastane skin, and Torcman brushless motor, 5 3/4 × 37 7/8 × 24 1/4" (14.5 × 96 × 61.5 cm)
Prototype by EvoLogics GmbH, Germany (2007)

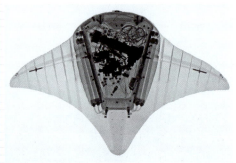

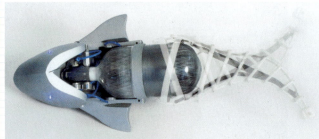

Elias Maria Knubben (German, born 1975) and Markus Fischer (German, born 1966) of Festo AG & Co. KG Corporate Design (Germany, est. 1925)
Airacuda Prototype. 2006
Polyamide and silicone, 17 3/4 × 11 × 39 3/8" (45 × 28 × 100 cm)
Prototype by Festo AG & Co. KG, Germany (2006)

The Aqua_ray and the Airacuda biomimetic robots are remote-controlled, pneumatically driven fish whose form and kinematics are modelled on the creatures that inspire their names. Flowing movements, achieved by the dynamic flapping of a wing, allow the Aqua_ray to be maneuvered precisely and efficiently. The Airacuda also moves easily through the water, balanced by an air bladder. The robots can be used in a wide range of oceanography applications without disrupting the natural environment. Translated from biological operating principles, both feature a key technology—a pneumatic "muscle" whose dynamics are similar to a real muscle, only operated using compressed air. The muscle consists of a hollow tube; when the tube is inflated its diameter expands as its length contracts, generating power. A pair of these pneumatic muscles, alternately pressurized and depressurized, causes the robot's fin or tail to move, propelling it through the water.

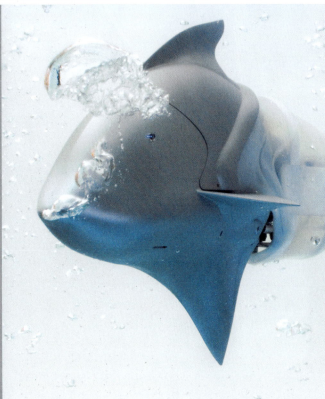

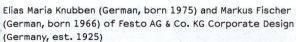

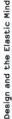

Barry Trimmer (British, born 1958)
Biomimetic Devices Laboratory (est. 2005), Tufts University
(USA, est. 1852)
SoftBot from the **Biomimetic Soft-Bodied Robots
project** Prototype. 2005–07
Silicone elastomer and nitinol shape-memory alloy, 9 1/2 ×
1 5/8" (24 × 4 cm) diam.

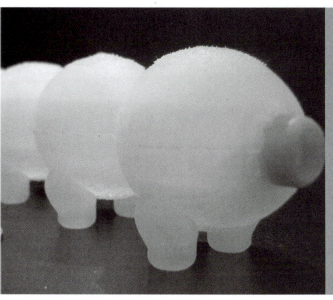

The Biomimetic Devices Laboratory at Tufts University is
working on robots that will lead to a new approach to motion
control, based on biological materials and the adaptive
mechanisms of animal movement. The SoftBot, which takes its
inspiration from the tobacco hornworm caterpillar, was built
to test ideas about controlling movements using very simple
commands. Silicone rubber segments, which form the body, are
lined with shape-memory alloy wires that contract when a
current passes through, causing the rubber to bunch up. When
the current is switched off, the rubber returns to its original
shape, moving the robot forward. According to its inventor,
the SoftBot "will have direct applications in robotics—such as
manufacturing, emergency search and retrieval, and repair and
maintenance of equipment in space—and in medical diagnosis
and treatment, including endoscopy and remote surgery."

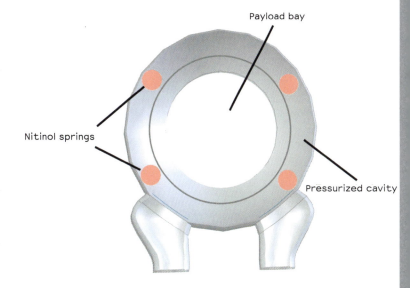

Payload bay

Nitinol springs

Pressurized cavity

Nanotechnology: Design in the Quantum Vernacular
Ted Sargent

The values of design and the aspirations of nanotechnology are one: Each strives to mold matter with an eye to function. Nanotechnologists fashion materials and construct edifices from the smallest of building blocks—atoms and molecules. We build designer molecular beacons that help visualize cancers before they run amok within us; create lightweight, wearable "power suits" to store and deliver electrical energy; and build new camera chips that sense colors to which we ourselves are blind.

In many respects, little changes when one enters into the realm of the small. When we jump down the rabbit hole into Alice's Wonderland, things often behave much as they did in the macroscopic universe. If teacups and teapots are scaled down to the same degree, and if tea pours as it did aboveground, then—were we ourselves proportionately shrunken—we would be hard-pressed to say whether length had been rescaled or not. We call this idea—the indistinguishability of small from big if all is commensurately shrunken—scale invariance. It is a powerful idea. It means that all of our ideas and imaginings from the daily world serve us well, even when we craft materials smaller than we can see.

What makes nanotechnology more powerful is that while our visual imagination remains useful, scale invariance does not, in fact, apply. The world of the nanometer is not simply the same card game with smaller cards and smaller players. This world is instead governed by a different set of rules—ones recorded not by Newton but by Einstein. The rules that emerge in the realm of the nanometer brighten the spectrum of aesthetic and functional possibilities.

The Nanoscale Alphabet

Nanotechnologists endeavor to showcase the best of human-centered design, but at the scale of the nanometer—one billionth of a meter. This is the size of the cloud of electrons that orbits an atom's inner core, its nucleus. A typical molecule, such as a protein, is only a few nanometers in size. Before we explore design at the nanoscale, however, we must first ask two sets of questions. Is the discreteness of atoms too limiting? In other words, with only about one hundred building blocks in our atomic palette, will our range of expression be too confined? And is nanoscale architecture too sensitive to flaws? Would minor molecular mistakes—analogous to defects in a building material—make a nanoscale edifice crumble where its human-scale counterpart would stand?

We can answer the first two questions empirically, observing the world around us. Nature builds all matter—including all life—from the nanoscale; it is restricted to the same atomic building blocks as are we, yet

Samuel Cabot Cochran. SMIT Sustainably Minded Interactive Technology, LLC. **GROW**. Prototype. 2005–ongoing. Aluminum, flexible photovoltaic, piezoelectric device, steel wire rope, and copper wire, 8' × 4' × 7" (243.8 × 121.9 × 17.8 cm)

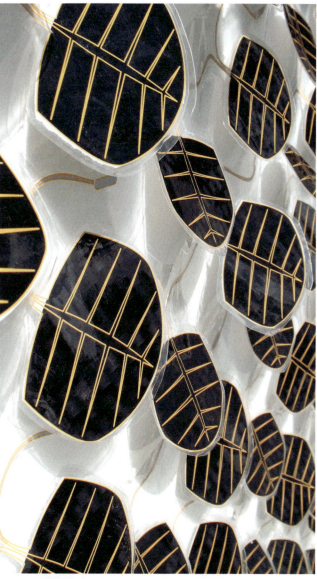

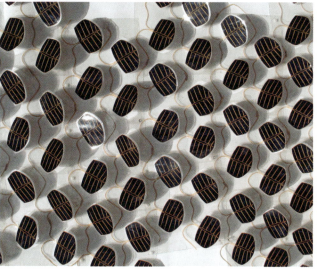

creates infinitely variegated materials and motifs. Nature's nanometer-narrow DNA molecules program the composition of proteins, and the laws of physics and chemistry determine how these linear chains fold into complex three-dimensional forms. As for the latter questions, even with such a well-perfected set of design principles, nature is tolerant: Countless methods of molecular error-checking and correction ensure that stochastic processes yield robust structures and functions.

Nature builds masterpieces, beginning at the nanometer and finishing with us. Nanotechnologists seek to learn and then to begin to emulate her craft. As aspiring nanoscale designers, scientist need to ask one more question about the realism of our own aspirations. Does our inability to see nanometer-sized structures with our own eyes prevent us from designing creatively and compellingly? No: It is through the exploration, and exploitation, of both the analogies and disanalogies between the macroscale and the nanoscale worlds of design that nanotechnologists find their groove.

Engineering Form for Function

One of the greatest threats to our way of life is our dependence on a frighteningly finite legacy of fossil fuels. Our addiction to oil has negative ramifications across the environmental, economic, and geopolitical landscape. Nanotechnologists can play an important role in the quest to find alternative sources of energy, one of the most promising being striving to capture the sun's clean energy efficiently and to turn it into electrical power for direct use or storage.

For decades, conventional solar panels have made this conversion between two forms of energy—optical and electrical—quite effectively. However, solar cells are far from ubiquitous. Our electrical energy is largely delivered in a centralized fashion today, originating from hydroelectric, nuclear, and fossil fuel sources and then distributed to its many destinations. Solar energy, in contrast, is already a distributed resource. Why are we not harvesting pristine photons when they land on our roofs, our tents, our hats, and our roadways? Is the problem that the sun is too weak? Bright enough to illuminate but not powerful enough to heat our homes or energize our laptops? No. It is well documented that solar energy reaching the earth's surface in one hour is sufficient to power the whole of the world's energy needs for one year; solar energy striking the earth over one month corresponds to the total energy stored in all known fossil fuel reserves on the planet.

The lack of solar adoption at present is circumstantial, not fundamental. Existing solar cells are made from pure, perfect crystals of the semiconductor silicon. These wafers of crystal have to be fashioned under highly controlled conditions. The requirements of purity and perfection make today's

solar cells expensive, and the cells' rigidity mandates large, inflexible panels. To create low-cost, light-weight, flexible solar cells ranks high among nano-technologists' ambitions. Our approach has been to work not with rigid semiconductors but with nanometer-sized clusters of atoms designed specifically to have light-harvesting ability, and to consider fresh appli-cations for gathering solar energy. Could we weave flexible light-harvesting materials into fabrics? Make plastic sheets that could be rolled out? Or even produce a paint that absorbs light, extracting the energetic electrons generated when photons strike its surface?

So far we have made such solar cells about one-quarter as efficient as conventional silicon. We do not know of a fundamental—nor even of a practical—reason why we cannot engineer nanoparticle-based solar cells to be as efficient as silicon, or even more so. In fact, recently, by capturing the sun's invisible infrared wavelengths as well as its visible colors, we have started to catch within our nanoscale solar net those photons to which silicon is permeable.

What would solar capture as a guiding principle mean for design? It might mean buildings aligned to maximize incidence of the sun's rays, or the use of parabolic reflective surfaces that could concentrate the sun's power. At the other extreme, choosing the right solar material could become simply mundane: a functional item, commoditized like window caulking, necessary but given little thought.

Fundamentals Are Our Beacon

Just as design is built on a foundation of understanding—both of function and aesthetics—nanotechnology, too, relies on a deep appreciation of underlying principles. Nanoscientists seek to systematize the grammar that atoms, molecules, and supramolecular structures obey.

The foundations of the nanoworld are well under-stood. Physics gives us a detailed knowledge of the atom, and even of its constituents—from the quantum theory of particles and their interactions via forces. Chemistry explores and exploits the behavior of the known cast of characters, raising to the next level of abstraction the propensities of each atomic element: sulfur and metals adore one another; chlorine and its cousins are highly reactive; atoms orbited by four outer electrons love forming beautiful, perfect crystals—diamond and silicon chips are the most famous—in which each atom has four nearest neighbors.

Such tropes are well known—some have been for centuries; others are more recently learned. Nano-technologists, on the other hand, seek to exploit interactions at the next step in the hierarchy of length scales: to investigate, for example, how small or long molecules assemble into larger shapes. One striking example is the work of Paul Rothemund. The Caltech scientist sought to understand the

Paul W. K. Rothemund. California Institute of Technology. **DNA origami.** Prototype. 2004–05. Natural and synthetic DNA molecules, 100 nanometers diam. Synthetic DNA manufactured by Integrated DNA Technologies, USA (2004–05)

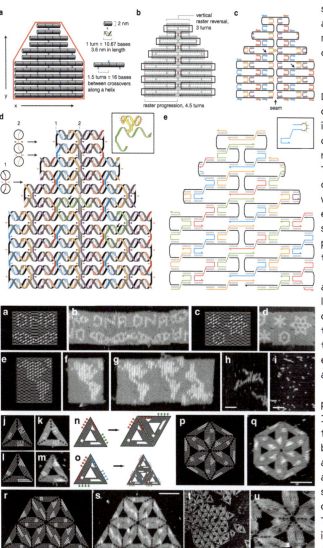

self-organization of a particular class of engineerable molecules so well as to be able to redesign the molecules and thereby determine how they fold. He calls his beautiful work DNA origami.

Scale Bar = 100 nm.
DNA is an appealing molecule to work with for a number of reasons. It is famous; it is the basis of life; and it is sufficiently important that chemical biologists have developed an entire class of technologies that have rendered the programming of DNA sequence routine. This itself is remarkable: that we understand the chemistry of DNA's bases' pairings and affinities so well that we can build millions of identical custom molecules to order. The instrument of choice is the DNA synthesizer; as with its musical counterpart, the artist programs in her choice of notes, and the resulting tune is entirely deterministic and replayable at will.

Rothemund's molecular vocabulary—of "scaffolds" and "staple strands"—emphasizes our reliance on analogy. It is by forging such connections that we empower our imaginations. Rothemund's genius is in rendering this analogy robust through a deep understanding of the true nature of his scaffolds and staples, and then exploiting it in the extreme—building original shapes, and even a map of the world, using DNA.

The power of Rothemund's findings lies in the potential for molecules' controlled self-assembly. Imagine—instead at the macroscale now—a factory, fully automated, that does nothing but produce two-by-fours of a specific length and then attach one of a few different varieties of Velcro at various points along the wood beams. The various Velcro patches are sticky only to their complementary mates: red sticks only to orange, blue sticks only to green, and so on. The beams would then be delivered to the construction site. No need to hire a crew and take years to assemble the complex mass, though. Instead just add water, shake, and stir, and the building assembles itself, programmed through beam lengths and Velcro pairings.

At the length scale of a skyscraper, the idea seems unlikely. At the nanometer length scale, however, working with water-soluble molecules that at room temperature bounce off one another very frequently—red Velcro gets to sample orange millions of times every second, checking for a compatible match—Rothemund made the idea work.

Of course, we already knew that such self-assembly was possible—we are its greatest triumph. DNA programs proteins to self-assemble into cell walls, differentiated cells form communities that produce functional organs, and organs work together to constitute people. All this is programmed by a string of 3.2 billion base pairs on our DNA and more than thirty thousand genes. Rothemund's triumph is to show that nature—our inspiration, the ultimate in sophisticated molecular design—is not the only agent capable of design for self-assembly.

The Quantum Vernacular

In the examples above, design at the nanometer length scale benefits from quantitative rather than qualitative differences compared to what happens at macroscopic dimensions. More striking, however, is when rules break down and new ones emerge—when we enter a new length scale. It is then that new possibilities emerge. This is indeed the case when we design on the scale of the nanometer—the quantum length scale.

Though the world we experience every day is built of atoms, we rarely see direct evidence of the discreteness of matter's constituents. And we observe interactions between objects—their statics and dynamics—that Sir Isaac Newton, in his famous Principia Mathematica, described succinctly in 1687. Science has since discovered—with the aid of Max Planck, Albert Einstein, Erwin Schrödinger, and Werner Heisenberg in the early decades of the twentieth century—that, at the length scale of a few nanometers, there is another layer of logic lying beneath what we see in the world around us. The elucidation of the grammar of quantum physics led to a powerful new understanding of electrons, too, and photons and other quantum particles. Einstein won his Nobel Prize by explaining, for the first time, why it was that the electric current emitted from a metal depended not only on the brightness but also on the color of light impinging on it. This photoelectric effect was explainable only if we posited that light was made not only of waves, but also of discrete bundles—quanta—of energy.

Quantum mechanics also tells us that electrons, too, are simultaneously particles and waves. An electron's characteristic wavelength is short enough—a few nanometers—that, in our daily lives, we rarely experience directly the "softness" of an electron. In fact, we know that even the hardest rock is made up of fuzzy clouds of constituent particles—particles that are soft, but only at the scale of a nanometer.

When nanotechnologists build nanometer-sized particles, though, we trap electrons into cages sized on the order of their wavelengths. From the world of classical physics we know the implications of confining waves: changing the length of a guitar string, for example, changes the selection of waves that can be suspended across it; changing the tension in a tympani drum changes its resonances.

Phenomena wherein electrons' dual nature as both wave and particle is manifest are constantly at play within the materials that surround us—including those from which we ourselves are built. We seldom see their effects directly, though, because they are apparent only when we look for them with an acuity corresponding to electrons' characteristic wavelength of a few nanometers.

Through structure, waves can be readily tuned. One way, observable by human eyes, in which quantum structures' tunabilities are manifest is through the colors of light these materials absorb and emit.

Microscope images showing scientists' and engineers' ability to form matter on the scale of the micrometer, one thousandth of a meter.

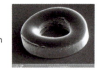

Philips Research Laboratories. FEI Company. **Micro-molded part from a deep-etched silicon mold.** 2007. Polymer, 1,250x magnification on a FEI NovaNanoSEM600 microscope. Horizontal field width: 250 microns

The donut shape shows an incomplete replication due to premature vitrification of the thermoplastic polymer.

Philips Research Laboratories. FEI Company. **Titanium oxide crystallite during the deposition of a wet-chemical layer.** 2002. 2,500x magnification on a FEI scanning electron microscope. Horizontal field width: 125 microns

The amount of TiO_2-procursor was too high and these tagliatelle-like crystallites were formed on the surface.

Philips Research Laboratories. FEI Company. **Bad adhesion of metallization.** 2007. Metal thin film on silicon, 40.000x magnification on a FEI NovaNanoSEM600 microscope. Horizontal field width: 7.5 microns

Metal thin film deposition is commonly used in the manufacturing of semiconductor devices. In this example, internal stress makes the film curve upward to outline a metal wave.

Philips Research Laboratories. FEI Company. **Plasma etching done by SF6 plasma in the so-called Bosch process.** 2006. Silicon, 20.000x magnification on a Philips XL40FEG microscope Horizontal field width: 24 microns

The so-called Bosch process is generally used for making Micro-electromechanical Systems (MEMS), 3-D high-density storage capacitors, and other devices. Successive etching of silicon using the Bosch process resulted in this skyline pattern.

Quantitatively, while foot-long guitar strings tune harmonics in the hundreds and the thousands of Hertz—the oscillation frequencies of acoustic waves—nanometer-long quantum dots tune harmonics in the trillions of Hertz, corresponding to light waves.

Such tunability opens new avenues of freedom in expression. For a given material—say silicon or another semiconductor—the degree of chromatic expression is no longer circumscribed by the medium's god-given color. Instead, we can build bespoke matter simply by controlling particle size. It is as if we have discovered that each letter of the alphabet has an infinite variety of tones, and that new poetry, new songs, and new puns have become possible as a result of this expanded palette. The solar cells discussed above benefit from this tunability. The sun's rays are intensely polychromatic—they span not only the visible colors but also stretch into the ultraviolet and the infrared. Indeed, over half of the sun's light lies in these chromatic regimes invisible to our eyes.

Solar cells are most efficient if they collect photons of different colors—different energies—into neatly sorted piles, and harvest the maximum energy of each slice of the spectrum. In the past this has meant searching for new materials—a different semi-conductor for each pile. But with the capacity to tune materials' colors using the quantum size-effect, collecting a particular slice of spectrum is as simple as making a bunch of nanoparticles of a particular size and thereby tuned to a particular frequency. Is building same-sized nanoparticles to order a simple matter? No, but it is now a known art. Self-organization—materials chemistry—has been the key. Nanotechnologists can now build particles—spheres, cubes, rods, and even tetrapods and ribbons—that are identical in their key quantized direction to within a few percent.

To Visualize the Invisible

While what we have built so far at the nanoscale is remarkable, it barely scratches the surface of possibility. Even the simplest living organisms are richer and more complex than what nanotechnologists have so far sought to grow from the bottom up. A virus uses a highly compact genetic code to build a set of proteins that form a protective capsid, a delivery system into its host, and a strategy for self-replication. And this is one of the simplest living entities we can imagine.

We debate whether a brain can ever understand itself. We need not resolve this debate to believe that we can understand so much more about designing custom structures and properties from the smallest constituents. And thus we should imagine the limits of possibility: Will we program the growth of living solar cells that build themselves, trained to expand only across otherwise unused land, and connect inductively into an electrical grid? Will regenerative medicine, a fast-moving field, succeed in generating banks of

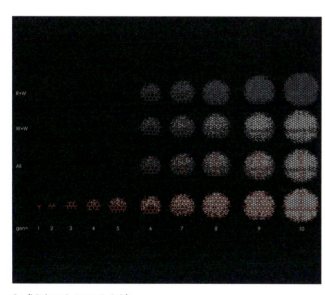

Cecil Balmond, Jenny E. Sabin,
Seonhee Yoon, David B. LeFevre,
Firas Hnoosh, and Huayou Li.
University of Pennsylvania School
of Design. **Abstract Branching Model
for new Nanotechnology Facility.**
Concept. 2007

Three-dimensional digital model
generated by a branching algorithm.

healthy organs available for transplantation so that we each have a spare? Will we succeed in measuring expression levels of genes in our bodies so sensitively and so cost-effectively that we can perceive, warn of, and act against cancers as soon as they first strike?

To get there we will depend, as we always have, on the human imagination. Breakthroughs will continue to come from a union of two distinct human capacities. The first is to imagine a world identical in its underlying rules of behavior but simply scaled down in spatial dimensions to the world we touch and see each day. The second is to picture potentiality within a world that is more than scaled—it is altered, built from quantized clouds of probability. Much hope lies in finding new possibility in strangeness.

Benjamin Aranda and Chris Lasch of Aranda/Lasch.

QuasiCrystal packing study. 2006.
Rhino 3-D software

Woven Rope. 2005.
Rhino 3-D software

Weaving study collection. 2005.
Generative Components software

7 Agata Jaworska. Design Academy
Eindhoven. **Mushroom Growth
Packaging** from **Made in Transit,**
a concept for sustained growth
within the supply chain. Concept.
2007

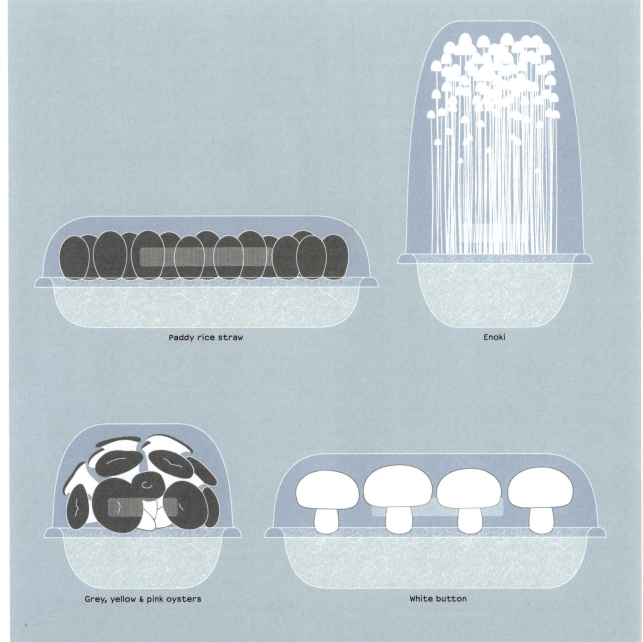

Paddy rice straw

Enoki

Grey, yellow & pink oysters

White button

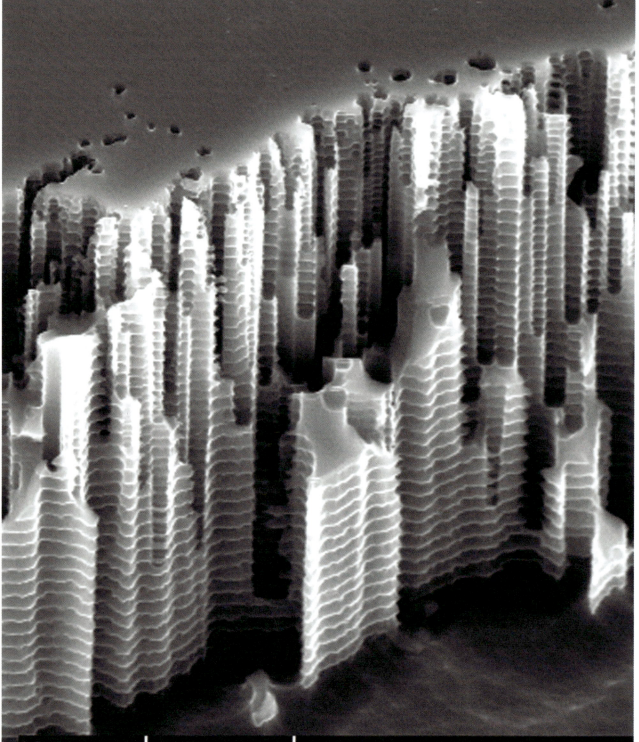

Magn 2 μm
20000x PHILIPS XL40FEG

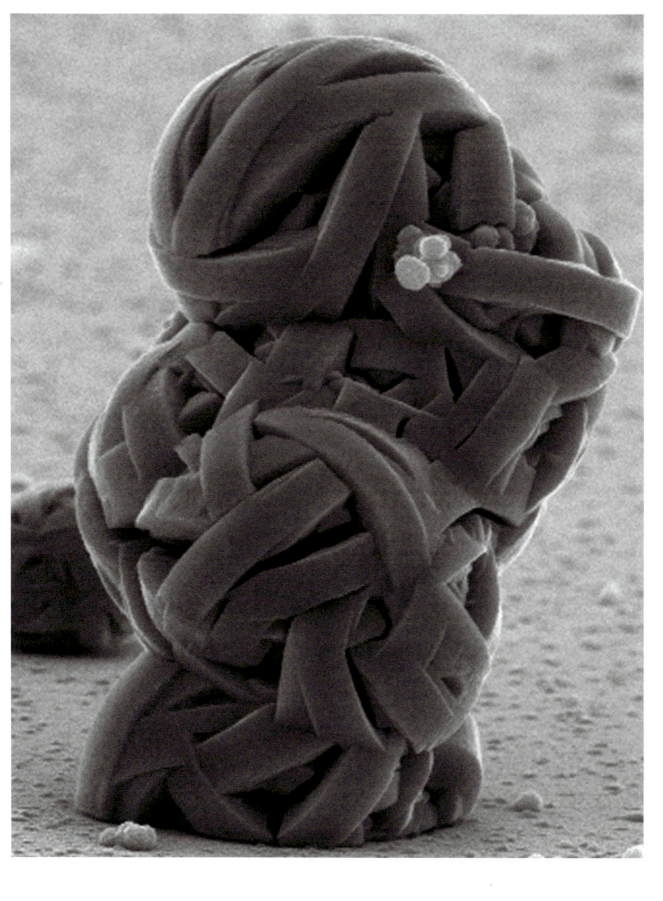

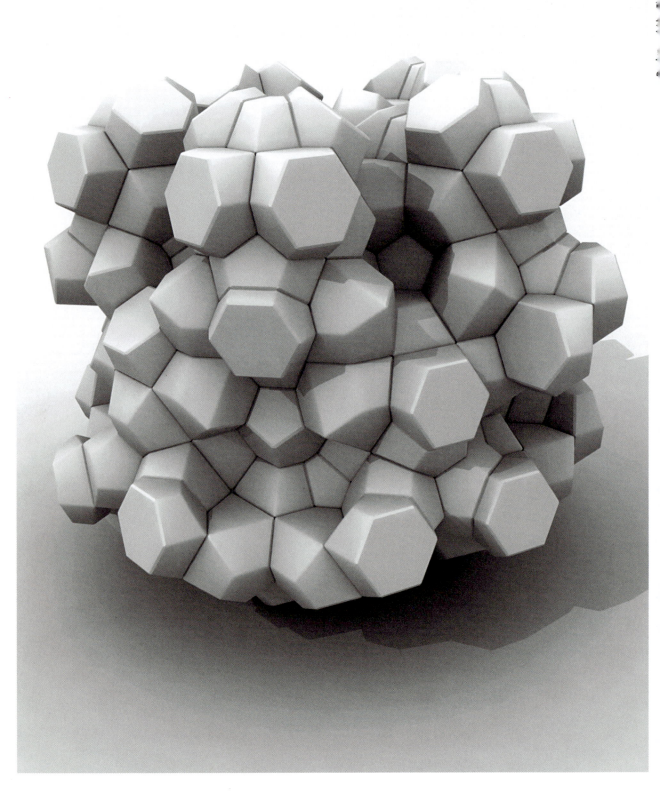

Designers and scientists unite in the exploration of the possibilities of nanotechnology. At the nanoscale (one nanometer is one billionth of a meter) molecules can be used to construct larger entities either by allowing them to come together chemically according to the laws of molecular recognition or by assembling them in a top-down process more like traditional engineering. Scientists are acting as designers and tinkering with nano objects with abandonment, while designers are irresistibly attracted to the possibility of building new objects that will respond to their circumstances in an autonomous and novel fashion, almost having lives of their own.

Keith Schwab (American, born 1968) of the Department of Physics, Cornell University (USA, est. 1865)
Michael Roukes (American, born 1952) of the Department of Physics, California Institute of Technology (USA, est. 1891)
Measurement of the Quantum of Thermal Conductance 1996–2000
Nanofabricated from submicron-thin films of silicon nitride, gold, niobium, and silicon oxide, field of view: 20 microns; central square: 4 microns

Keith Schwab's focus is "the study of fundamental quantum behavior of small mechanical structures" and to understand what happens to them at the atomic scale. In this particular experiment, Schwab and Michael Roukes "explore heat flow through nanoscale structures at ultra-low temperatures." Their work is an example of scientists tinkering with new ideas and projects to see how they will translate to the nanoscale.

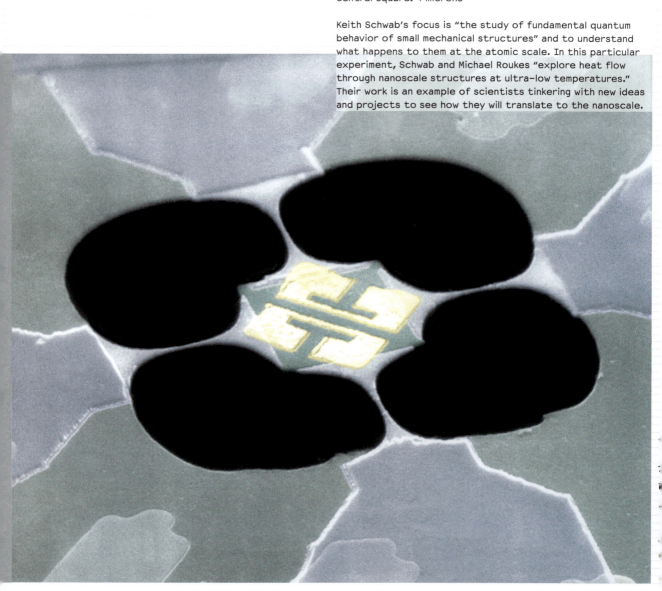

Felice Frankel (American, born 1945) of Harvard University (USA, est. 1636)
Microphotography 2007
Nanotubes: 1 nanometer
Block copolymers (48 hours): 3/8" (1 cm) diam.

Felice Frankel is a science photographer whose rigorous manipulation of images is akin to a design gesture. By tweaking colors and backgrounds in order to exalt the scientific focus of her images, she achieves a level of clarity and beauty that highlights the sublime design that can be found in science in general, and more specifically at the nanoscale. These two images serve as a visual introduction to the world of nano-physics. The first is an optical rendition of nanotubes—among the most promising structures in nanotechnology. Because no camera exists that is able to photograph at the nanoscale, Frankel had to construct her own image: "I imprinted a pattern on acetate, made the latter into a cylinder, scanned the material on a flatbed scanner, played with the image in Photo-shop through a series of steps." The second image shows the magnified detail of a gel-like structure made of polymers over forty-eight hours. Because her images are frequently accom-panied by statements that detail her process and explain exactly what she has done to manipulate them, Frankel sees her work as an example of designing to communicate information.

Institute of Bioengineering and Nanotechnology
(Singapore, est. 2003)
Blue Beetle Design (Singapore, est. 2003)
Nano-Bio Kits 2003–06

Biological Fuel Cell Kit
Acrylic fuel cell cartridge, proprietary nanostructured
catalyst-immobilized electrodes, polymer membrane, resistors,
wires, and steel, 9 1/2 × 7 × 2 3/8" (24.1 × 17.8 × 6.1 cm)

Thermo-responsive Hydrogel Kit
Thermo-responsive hydrogel polymer in powder form, reagents,
and polystyrene plastic, 9 1/2 × 7 × 2 3/8" (24.1 × 17.8 × 6.1 cm)

Dielectrophoresis Chip Kit
Glass slides etched with microchannels, glass slides coated with
electrode metal layer and photoresist film, yeast cells, acrylic
plastic, and aluminum, 9 1/2 × 7 × 2 3/8" (24.1 × 17.8 × 6.1 cm)
Manufactured by the Institute of Bioengineering and
Nanotechnology, Singapore (2006)

These three Nano-Bio Kits, individualized science curricula
offering hands-on learning tools for students between the
ages of fifteen and nineteen, are the first in a planned series
designed to introduce students to professional lab experi-
ences in the field of biomedical technologies. Highlighting the
science behind alternative "green" energy, the Biological Fuel
Cell Kit explores how electricity can be generated from such
a mundane household item as sugar with the help of enzymes
fixed on nanoparticles. The Thermo-responsive Hydrogel Kit
shows how a temperature-sensitive material is made and how
the rate of diffusion of particles within that material is
affected by different temperatures; this experiment helps
students understand how medical drugs can be delivered at
different body temperatures from a hydrogel drug carrier
embedded into a patient. The Dielectrophoresis Chip Kit
shows how individual cells behave during a phenomenon called
dielectrophoresis (DEP), the movement of an object in a non-
uniform electrical field. Making their own DEP chips and then
observing the movement of yeast cells, which are included in
the kit, students gain hands-on experience with a cutting-
edge technique, which may be used to diagnose diseases at
the cellular level and invent new drugs in the near future.

Thomas G. Mason (American, born 1968) and
Carlos J. Hernandez (American, born 1979)
Department of Chemistry and Biochemistry and the California
NanoSystems Institute (est. 2000), University of California,
Los Angeles (USA, est. 1919)

LithoParticle Dispersions:
Colloidal Alphabet Soup 2006
Polymer microparticles containing fluorescent dyes and
dispersed in water, 4 × 4 3/4" (10 × 12 cm)
Manufactured by UCLA in conjunction with Colloidia LLC,
USA (2006)

Scientists at UCLA have designed and mass-produced billions
of fluorescent lithographic particles in the shapes of all
twenty-six letters in the English alphabet. Dispersed in a liquid
solution, each particle has a custom-designed shape achieved
with the same lithographic technology used in computer elec-
tronics. They can customize the font style of these particles
and, according to Thomas G. Mason and Carlos J. Hernandez,
even "pick up the letters and reposition them in a microscale
version of the game Scrabble." Mason and Hernandez anticipate
that their LithoParticles will have significant technological and
scientific uses, such as marking individual cells with particular
letters in order to identify them. The two have also designed
different shapes, including triangles, crosses, and donuts, as
well as complex three-dimensional forms. "The research could
lead to the creation of tiny pumps, engines, or containers for
medical applications," the two explain. As scientists continue
to hone their skills in working with these tiny forms, which in
the future will become the bricks from which functional micro-
devices will be produced, they will be able to assemble them
into more complex structures.

Oded Ezer (Israeli, born 1972)
Typosperma Concept. 2007
Macromedia FreeHand and Rhino software

Typosperma, the second experimental project in Oded Ezer's
Biotypography series, are cloned sperm with typographic infor-
mation implanted into their DNA. These fantastical creatures
literally embody the dream of design and science coming
together. Ezer, a typographer trained at the Bezalel Academy
in Jerusalem, appears on his Web site wearing a white lab coat
and contemplating a vial, surrounded by tools not found in a
typical design office. As he explains it, "The term Biotypography
refers to any application that uses biological systems, living
organisms, or derivatives thereof to create or modify
typographical phenomena. The main purpose of the Typosperma
project was to create some sort of new transgenic creatures,
half (human) sperm, half letter."

Under Anthony Dunne's direction, the Royal College of Art's Design Interactions Department has been focusing on design's possible implementation of the most cutting-edge scientific and technological innovations, from bioengineering to nanophysics. Several of the projects presented in this book come from that department's students and professors, most often in the form of artifacts accompanied by scenarios described by videos, books, and other narratives.

Christopher Woebken (German, born 1980)
Design Interactions Department (est. 1989),
Royal College of Art (UK, est. 1837)
New Sensual Interfaces Concept. 2007
Linseeds, 1 1/2 × 4 1/2 × 20" (3.8 × 11.4 × 50.8 cm)

Christopher Woebken's project explores innovative ways of interacting with information. By using nanotechnology—starting with molecules and counting on their self-assembly tendencies—Woebken proposes a way to build devices from the bottom up. Mimicking organic behaviors, natural systems, and microbiological processes, these devices will behave like body cells, made of a network of micro- or nano-sized elements. Since each element of these new modular and moldable products contains the same basic information, similar to DNA in living organisms, it will be possible to break these devices apart in order to change their functions or share them with friends, redefining the very essence of a product.

James King (British, born 1982)
Design Interactions Department (est. 1989),
Royal College of Art (UK, est. 1837)
Fossils from a Nanotech Future Models. 2006

The Flower
Polyamide resin, 8 × 11 3/4" (20 × 30 cm)

The Chalk
Chalk, 3/8 × 1 3/4" (1 × 4.5 cm)

The Comb
Cardboard, 11 3/4 × 9 7/8" (30 × 25 cm)

James King's project Fossils from a Nanotech Future documents the findings of a team of future anthropologists as they examine a collection of fossils believed to originate from the year 2025. One of the artifacts, which the team calls The Flower, seems to be a breathing apparatus, almost certainly man-made, with a slender stem forming a mouthpiece. It comes apart in two halves to reveal something resembling a seedpod. They think this might be either a filter to clean the air or, alternatively, some sort of medical device that adds particles to the inhaled air. Another artifact is a small stick of what looks like chalk; observation under an electron microscope shows an amalgam of loosely packed particles, each measuring a few hundred nanometers. To get a better idea of its properties, the stick is broken up into fine powder, thereby freeing the particles and increasing their active surface area. The futurologists also find a small container of what they call "smart dust"—dust is commonly associated with nanomaterials—and discover that if they sprinkle it onto a flat surface, an intricate pattern appears. Another found object, The Comb, is a tool for manipulating the dust.

In trying to decipher the objects, the team discusses nanotechnology as it may be experienced in daily life in a world transformed by the advances in the field. The possibility of a nanotech future seems very real, and imagining the kinds of objects that might appear can help us envision the actual impact of such advances. As King states: "Some technologists believe that this science will one day allow us to cure all diseases, reverse ecological damage, and even halt the aging process. Skeptics argue that nanotechnology will do nothing of the sort, though it might provide us with faster computers, self-cleaning windows, and wrinkle-free trousers."

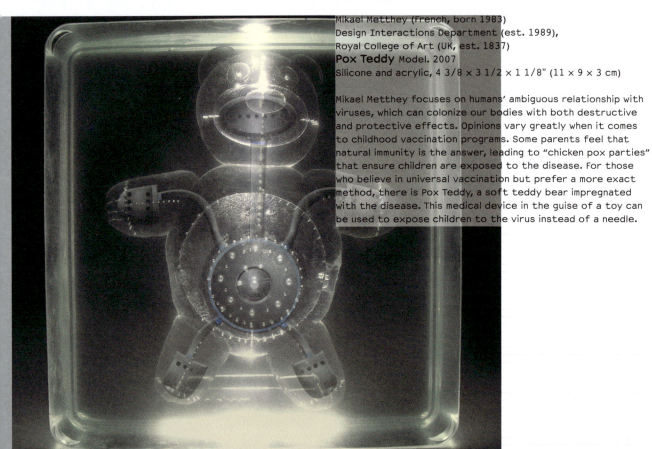

Mikael Metthey (French, born 1983)
Design Interactions Department (est. 1989),
Royal College of Art (UK, est. 1837)
Pox Teddy Model. 2007
Silicone and acrylic, 4 3/8 × 3 1/2 × 1 1/8" (11 × 9 × 3 cm)

Mikael Metthey focuses on humans' ambiguous relationship with viruses, which can colonize our bodies with both destructive and protective effects. Opinions vary greatly when it comes to childhood vaccination programs. Some parents feel that natural immunity is the answer, leading to "chicken pox parties" that ensure children are exposed to the disease. For those who believe in universal vaccination but prefer a more exact method, there is Pox Teddy, a soft teddy bear impregnated with the disease. This medical device in the guise of a toy can be used to expose children to the virus instead of a needle.

Mikael Metthey (French, 1983)
Design Interactions Department (est. 1989),
Royal College of Art (UK, est. 1837)
The Minutine Space Concept. 2006

In Mikael Metthey's utopian vision, the future holds a world
where all illness has been eradicated by progress in medical
diagnostics and treatment. When the efficacy of nanomedicine
is perfected, sickness will not hold the same connotations as
in our present world. Rather, the anxiety associated with
disease will be replaced by a recreational approach to illness
in which potential patients check into a "counter-spa" where
they will be infected by engineered viruses designed to mimic
the experience of having a particular malady. The space is
"designed to emphasize the social implications of illness," the
designer explains. "It is composed of a viral area where the
virus can be chosen, facilities to rest and suffer collectively,
and a 'central sick pit' where people can vomit. Once they have
had enough, visitors can leave through the 'minutine' zone,"
where nano-antidotes remove all harmful organisms from their
bodies in one minute instead of a typical course of treatment.

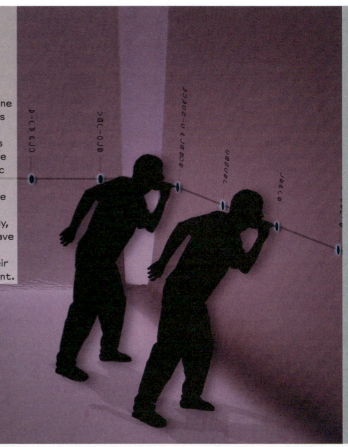

James King (British, born 1982)
Design Interactions Department (est. 1989),
Royal College of Art (UK, est. 1837)
Dressing the Meat of Tomorrow Model. 2006
Plastisol (fiberglass-reinforced polyester), 5 1/2 × 7 1/2"
(14 × 19 cm)

Scientists at the University of Western Australia have coined
the term "disembodied cuisine" to refer to a new tissue-
engineering technique that makes it possible to grow edible
meat in a laboratory from sample cells. The artificial pro-
duction of meat, also called in vitro-cultured meat production,
offers many advantages, such as avoiding the tremendous out-
put of resources and the generation of organic waste and
pollutants that come with raising livestock. It also raises
complex issues about our relationship to animals, nature, and
food, to name just a few of the mainstays of our existence
shaken by this innovation.

In addition to the philosophical issues raised, there are
a number of practical ones as well. What should this meat look
like? What flavor should it have? How should it be served?
James King describes his approach to the first of these
questions: "A mobile animal MRI (Magnetic Resonance Imaging)
unit scours the countryside looking for the most beautiful
examples of livestock. The selected specimen is scanned from
head to toe and accurate cross-sectional images of its inner
organs are generated. The most aesthetically pleasing exam-
ples of anatomy will be used as templates to create molds for
the in vitro meat. We wouldn't necessarily choose to eat the
same parts that we eat today. However, we might still want
to recreate a familiar shape to better remind us where the
'artificial' meat came from."

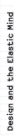

Design and the Elastic Mind

1

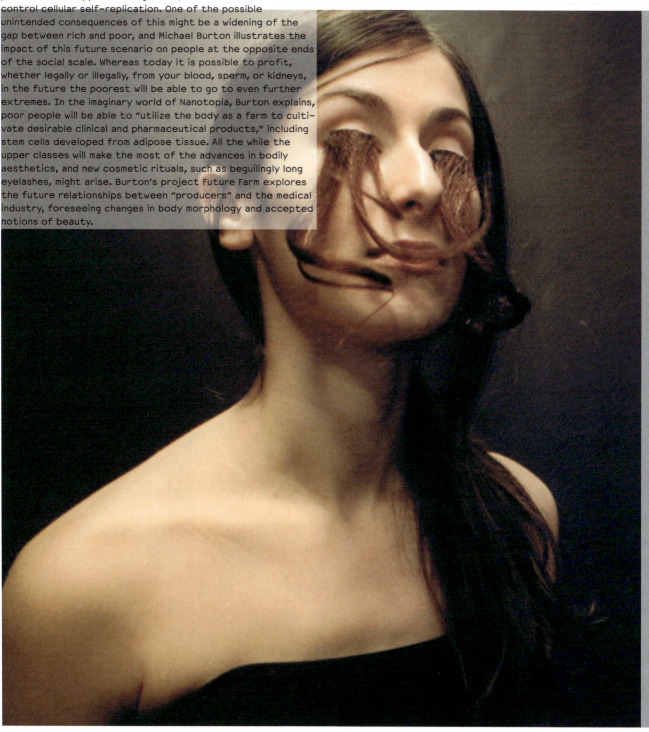

Michael Burton (British, 1977)
Design Interactions Department (est. 1989), Royal College
of Art (UK, est. 1837)
Nanotopia from the **Future Farm project**
Concept. 2006–07
Human hair and prosthetics, 1 1/4 × 6 1/2" (3.2 × 16.5 cm)

The promise of nanotechnology invites utopian imaginings, but
it could have a darker, dystopian side as well. Many believe that
nanotechnology will reach its true imaginative and creative
potential when applied to organisms, where it can stimulate and
control cellular self-replication. One of the possible
unintended consequences of this might be a widening of the
gap between rich and poor, and Michael Burton illustrates the
impact of this future scenario on people at the opposite ends
of the social scale. Whereas today it is possible to profit,
whether legally or illegally, from your blood, sperm, or kidneys,
in the future the poorest will be able to go to even further
extremes. In the imaginary world of Nanotopia, Burton explains,
poor people will be able to "utilize the body as a farm to culti-
vate desirable clinical and pharmaceutical products," including
stem cells developed from adipose tissue. All the while the
upper classes will make the most of the advances in bodily
aesthetics, and new cosmetic rituals, such as beguilingly long
eyelashes, might arise. Burton's project Future Farm explores
the future relationships between "producers" and the medical
industry, foreseeing changes in body morphology and accepted
notions of beauty.

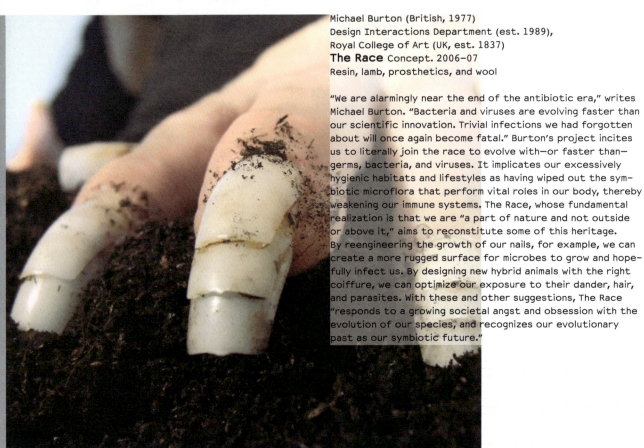

Michael Burton (British, 1977)
Design Interactions Department (est. 1989),
Royal College of Art (UK, est. 1837)
The Race Concept. 2006–07
Resin, lamb, prosthetics, and wool

"We are alarmingly near the end of the antibiotic era," writes
Michael Burton. "Bacteria and viruses are evolving faster than
our scientific innovation. Trivial infections we had forgotten
about will once again become fatal." Burton's project incites
us to literally join the race to evolve with—or faster than—
germs, bacteria, and viruses. It implicates our excessively
hygienic habitats and lifestyles as having wiped out the sym-
biotic microflora that perform vital roles in our body, thereby
weakening our immune systems. The Race, whose fundamental
realization is that we are "a part of nature and not outside
or above it," aims to reconstitute some of this heritage.
By reengineering the growth of our nails, for example, we can
create a more rugged surface for microbes to grow and hope-
fully infect us. By designing new hybrid animals with the right
coiffure, we can optimize our exposure to their dander, hair,
and parasites. With these and other suggestions, The Race
"responds to a growing societal angst and obsession with the
evolution of our species, and recognizes our evolutionary
past as our symbiotic future."

Michiko Nitta (Japanese, born 1978)
Design Interactions Department (est. 1989), Royal College
of Art (UK, est. 1837)
Body Modification for Love project Concept. 2005
Latex and acrylic paint, 1/8 × 3/8" (0.3 × 0.9 cm) diam.

Body Modification for Love takes previous research on in vitro—
cultured meat production technologies into the realm of
memories and emotions. Michiko Nitta's project envisions
a technique for genetically growing selected body parts on
your skin, allowing you to sport your partner's favorite mole
on your shoulder, your ex-girlfriend's nipple close to your
pelvic bone, or a patch of living hair on your arm to remind
you of your mother. This is a long-term commitment, of course,
as the mole and nipple will grow and demand care and the hair
patch will need to be cut and groomed. By embedding our
emotional background into our own bodies, we would create
a "growing memory" to keep our recollections alive.

Susana Soares (Portuguese, born 1977)
Design Interactions Department (est. 1989),
Royal College of Art (UK, est. 1837)

Genetic Trace: New Organs of Perception
Concept. 2006
Acrylic nails and feathers

Genetic Trace, Part Two: Sniffing Others
Concept. 2007

Genetic Trace imagines a future in which people are equipped
with specially designed organs that act as perception enhanc-
ers, allowing them to collect genetic material from those
they encounter. The need for such "complementary sensors,"
according to Susana Soares, stems from the belief that
"advances in genetics, biotechnology, and nanotechnology are
changing our very nature and that our evolution now relies
on genetic technology rather than natural selection." Cilia in
the nails could scrape dead cells from others when shaking
hands, while whiskers grown in eyebrows will increase the signals
we pick up from the environment. These innovations could allow
genetic siblings who may not have met identify each other,
for example, and help people collect information to be used
as a tool for selective mating. Sniffing Others explores the
development of new tools that will allow us to "sniff" other
people's genetic codes.

Tobie Kerridge (British, born 1975), Nikki Stott (British, born 1977), and Ian Thompson (British, born 1975)
Design Interactions Department (est. 1989),
Royal College of Art (UK, est. 1837)
Biojewellery Prototype. 2003–07
Cow bone and silver, 1/8 × 1" (0.4 × 2.4 cm)
Prototype by Nikki Stott, UK (2003)

Biojewellery uses design to engage the general public with the processes and technologies of tissue engineering. It redirects this emerging medical technique to provide couples with what its designers call "a unique symbol of their love for one another." A team from the Royal College of Art and scientific researchers at King's College London worked together to create rings for several couples that donated bone cells. The bone tissue was cultured in a laboratory and then seeded onto a bioactive ceramic that acted as a scaffold for the growing cells. When cells began to divide and grow rapidly, they took on the form of the scaffold. The final bone tissue was taken to the designers' studio and combined with precious metals to finish the rings. Each participant received a ring made with the tissue of his or her partner, making it possible for them to literally wear their loved ones on their hands.

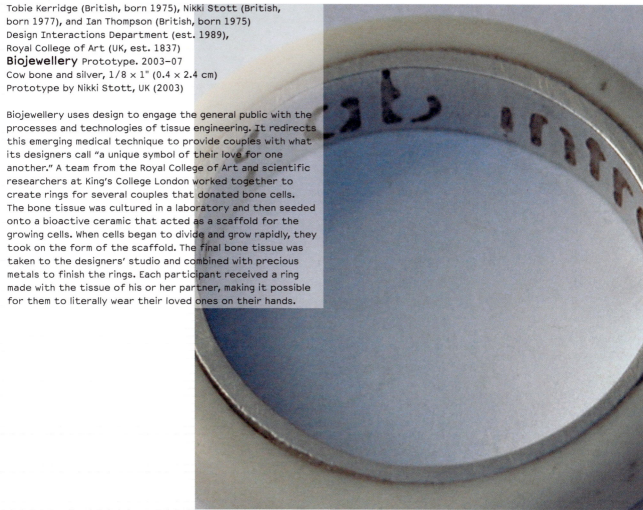

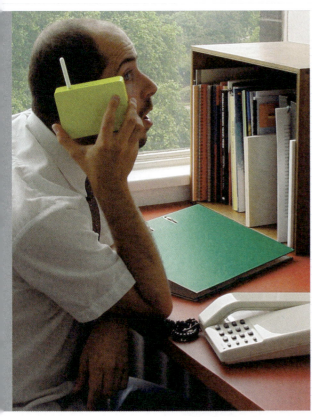

Elio Caccavale (Italian, born 1975)
Utility Pets Prototypes. 2003

Smoke Eater
Polypropylene, 8 5/8 × 6 1/4 × 11" (22 × 16 × 28 cm)

Toy Communicator
Polypropylene and rubber, radio receiver: 1 × 7 1/8 × 3 3/8"
(2.5 × 18 × 8.5 cm); communicator: 8" (20 cm) diam.

Memento Service
Polyurethane and pig snout, 3 1/2 × 4 × 2 3/8"
(9 × 10 × 6 cm)

Comforting Device
Polypropylene and pig snout, 1 5/8 × 3 3/8 × 10 5/8"
(4 × 8.5 × 27 cm)

Elio Caccavale's project Utility Pets addresses the various
effects that xenotransplantation (interspecies organ trans-
plantation) might have on our lives in the not-so-distant
future. Caccavale has imagined a scenario in which the organ
recipient maintains a close relationship with the organ donor.
Instead of suffering the cruelty of factory farming, the
donor, in this case a pig, is taken home and given an enjoyable
existence while waiting for the day of the organ replacement.
From the unique relationship between an owner and his or her
utility pet, a new typology of objects emerges. The Smoke
Eater, for example, is a smoke-filtering device that allows the
user to smoke at home while protecting the pig from second-
hand smoke that could damage its health. The Toy Communicator,
a pig toy with a microphone and a radio handset, creates an
open channel between animal and human when they are not in
the same room. The Memento Service preserves the snout
of the utility pet in a clear cast box to be kept as a remem-
brance, while the Comforting Device, made from the snout
of the sacrificed pig, helps people come to terms with the
psychological apprehension and contradictory feelings of
having a foreign body inside them.

Oron Catts (Australian, born Finland 1967), Ionat Zurr (Australian, born UK 1970), and Guy Ben-Ary (Australian, born USA 1967)
The Tissue Culture & Art Project hosted by SymbioticA, The Art and Science Collaborative Research Laboratory, School of Anatomy and Human Biology, University of Western Australia (Australia, est. 1996)

The Pig Wings Project Prototypes 2000–01
Pig mesenchymal cells (bone marrow stem cells) and PGA and P4HB biodegradable, bioabsorbable polymers, 1/4 × 3/4 × 1 5/8" (0.5 × 2 × 4 cm)

Thanks to their genetic closeness to humans and to advances in biomedical technologies, pigs could one day become precious repositories whose body parts can be easily grown and exchanged with our own. Since 1996, The Tissue Culture & Art Project has used tissue engineering as a medium for artistic expression. The artists create what they call semi-living entities, a new type of object/being artificially designed using living and nonliving biological materials—cells or tissues from a complex organism grown onto synthetic scaffolds and kept alive with technological intervention. Oron Catts, Ionat Zurr, and Guy Ben-Ary employed this technology to answer the whimsical question, "If pigs could fly, what shape would their wings take?" Using tissue engineering and stem cell technologies, the trio grew pig bone tissue in the shapes of wings. They chose to emulate the wings of the Plerosaur, the first vertebrate to evolve for flight, those of a bat, and those of an angel. As such technologies progress, these and other entities will undoubtedly raise questions about the cultural and aesthetic implications of biotechnology's ability to manipulate living systems for human-centered purposes.

Oron Catts (Australian, born Finland 1967) and
Ionat Zurr (Australian, born UK 1970)
The Tissue Culture & Art Project hosted by SymbioticA,
The Art and Science Collaborative Research Laboratory,
School of Anatomy and Human Biology, University of Western
Australia (Australia, est. 1996)
Victimless Leather Prototype. 2004
Biodegradable polymer, connective and bone cells, nutrient
media, glassware, and peristaltic pump, coat: 2 × 1 1/8 × 1/8"
(5 × 3 × 0.4 cm)

Victimless Leather is the small-scale prototype of a "leather"
jacket grown in vitro. Like all in vitro tissue, it is a living layer
supported by a biodegradable polymer matrix, only in this case
that matrix is shaped like a miniature coat. As Oron Catts and
Ionat Zurr, the artists behind the project, explain, "The grown
garment confronts people with the moral implications of
wearing parts of dead animals for protection, aesthetics,
or expression of identity and social class." Victimless Leather,
on the other hand, offers the possibility of wearing leather
without directly killing an animal as "a starting point for cultural
debate." Catts and Zurr believe that "biotechnological research
occurs within a particular social and political system, which will
inevitably focus on manipulating nature for profit and economic
gain." They argue that if the things we surround ourselves with
every day can be both manufactured and living, growing entities,
"we will begin to take a more responsible attitude toward our
environment and curb our destructive consumerism."

Stuart Karten (American, born 1957), Steve Piorek
(American, born 1974), and Simon Sollberger
(Swiss, born 1973)
Stuart Karten Design (USA, est. 1984)
Epidermits Interactive Pet from the
Cautionary Visions project Concept. 2006
Living engineered human tissue, 3 × 3 × 4" (7.6 × 7.6 × 10.2 cm)

Following the popularity of Tamagotchis, digital devices endowed
with biological and emotional needs that enslaved children all
over the world when they were released about ten years ago,
come Epidermits. Still only a provocative concept, they are,
according to their designers, "fully functioning organisms
resulting from advances in tissue engineering, electronics, and
fuel cell research. They don't feel pain, they don't think, they
just follow a complex set of algorithms. They require minimal
maintenance and can be stored in a state of forced hibernation
in a standard refrigerator." Users can customize their Epidermits
with different body, skin, and hair selections, and further
personalize them through tanning, tattooing, and piercing.
Epidermits are part of Stuart Karten Design's project Caution-
ary Visions, which considers humorous aberrations that could
stem from future technological advances. "In a world where
boundaries between real and artificial are increasingly blurred,
comes the toy that will truly confuse kids and rob them of any
remaining sense of what is natural," the designers say.

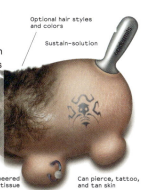

Optional hair styles
and colors

Sustain-solution

Engineered
human tissue

Can pierce, tattoo,
and tan skin

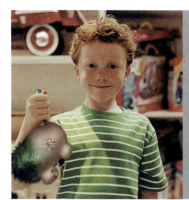

0:00 0:05 0:11 0:20 0:2

0:55 0:59 1:03 1:13 1:1

1:42 1:48 1:52 2:1

2:35 2:41 2:45 2:48 2:55

3:17 3:27 3:30 3:33 3:38 3:42 3:5

4:09 4:10 4:17 4:27

Viktor Zykov (Russian, born 1979), Stathis Mytilinaios (Greek, born 1980), and Hod Lipson (Israeli, born 1967)
Computational Synthesis Lab (est. 2001), Cornell University (USA, est. 1865)

Molecubes functional robots 2003–04
Somos 9120 epoxy photopolymer, 4 × 4 × 4" (10 × 10 × 10 cm)
Manufactured by ProtoCall, LCC, USA (2004)

The creators of Molecubes aim to use advances in nanotechnology to transpose the very basic biological process of self-reproduction to inorganic objects. "Self-reproduction," they explain, "is a process whereby a physical system is capable of producing an autonomous, functional copy of itself. The copy, by definition, should also be capable of self-reproduction." This principle is central to biological life but had yet to be exploited in machine design. "Long-term physical survivability in robotics is achieved through durable hardware," continue the Cornell scientists. "In contrast, most biological systems are not made of robust materials; sustainability and adaptation are provided through processes of self-repair and, ultimately, self-reproduction."

The Computational Synthesis Lab has built a set of eight functional modular robots called Molecubes, "composed of actuated modules equipped with electromagnets to selectively control the morphology of the robotic assembly," in order to demonstrate artificial self-reproduction. The stop-motion sequence seen here shows autonomous self-reproduction of a four-module robot: the top three rows show the first generation of self-reproduction, while the bottom three rows show the second generation. This feat could have an application in self-sustaining robotic systems used in space exploration and other hazardous environments, where conventional approaches to long-term maintenance are not feasible.

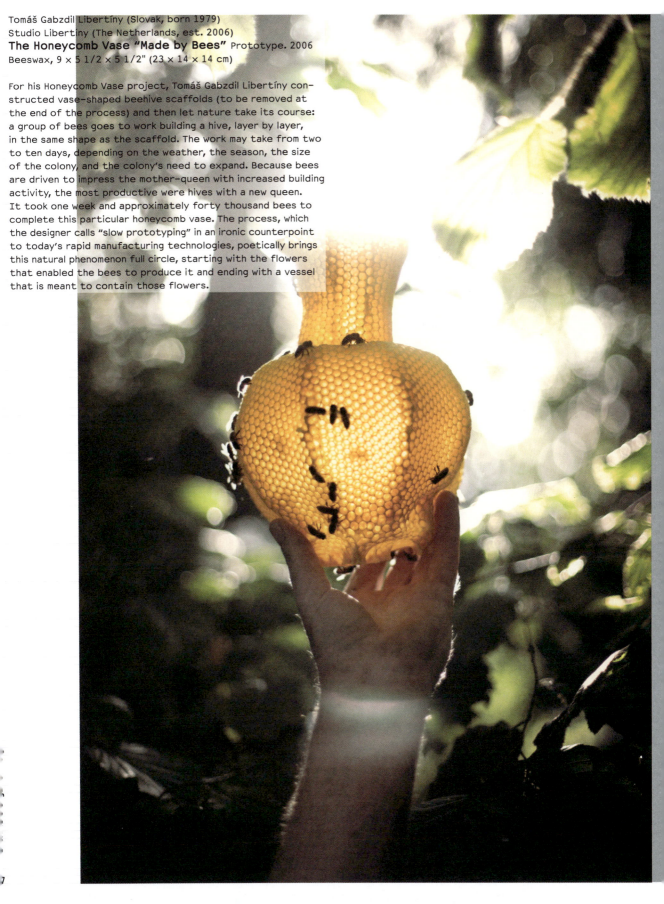

Tomáš Gabzdil Libertíny (Slovak, born 1979)
Studio Libertíny (The Netherlands, est. 2006)
The Honeycomb Vase "Made by Bees" Prototype. 2006
Beeswax, 9 × 5 1/2 × 5 1/2" (23 × 14 × 14 cm)

For his Honeycomb Vase project, Tomáš Gabzdil Libertíny con-
structed vase-shaped beehive scaffolds (to be removed at
the end of the process) and then let nature take its course:
a group of bees goes to work building a hive, layer by layer,
in the same shape as the scaffold. The work may take from two
to ten days, depending on the weather, the season, the size
of the colony, and the colony's need to expand. Because bees
are driven to impress the mother-queen with increased building
activity, the most productive were hives with a new queen.
It took one week and approximately forty thousand bees to
complete this particular honeycomb vase. The process, which
the designer calls "slow prototyping" in an ironic counterpoint
to today's rapid manufacturing technologies, poetically brings
this natural phenomenon full circle, starting with the flowers
that enabled the bees to produce it and ending with a vessel
that is meant to contain those flowers.

Lightweeds · Simon Heijdens

A living digital organism growing onto an indoor space, through which the space regains the natural timeline that it has walled out. Uniquely generated plant families that grow up, move and behave closely depending on actual sunshine, rainfall and wind as measured live outside. On passing human traffic they bend, loose their seeds and pollenate to other walls throughout the space, to make up a constantly evolving wallpaper that reveals the character of the space and it's use.

Growth

Silhouettes of plants growing onto several walls throughout a space.

Plant generation

Each plant is uniquely generated of hundreds of parts, that form and behave affected by genetical data and current outdoor weather conditions, creating families that never have the same appearance.

Movement

Each of the parts that the plant is built up from is individually connected to the live measurings of the windsensor outdoor, and has its own sensitivity and elasticity. Together they create a hyper-real, continuously live generated movement that changes throughout the day and year.

Human traffic

The plants slightly bend and hang over when someone passes, tracing the path of human traffic.

Pollenation

After several passages, the plant loses its seeds which then travel to another wall to make a new plant grow there. The plants pollenate in the same direction as the traffic, therefor the increasing amount of flora reveals how the space has been used throughout the day.

Simon Heijdens (Dutch, born 1978)
Lightweeds wall installation 2006
Self-developed software, dimensions variable

As we spend most of the day in fixed spaces with regulated climates and artificial lighting, nature is becoming more and more scarce in our daily lives. Simon Heijdens's Lightweeds is a "living digital organism" that "grows" onto the walls and floors of an indoor space, restoring a natural cycle. The projected silhouettes of uniquely generated plant families grow, move, and behave according to current weather conditions and the way the space is used. Each plant is made of hundreds of parts, each with its own sensitivity and elasticity and individually connected to a live sensor outdoors that measures variables such as rainfall and sunshine. All parts together create a continuously evolving wallpaper that changes throughout the day and the seasons. The plants also trace the path of human traffic; they slightly bend and lose their seeds when someone passes, pollinating nearby walls in the direction of the movement and the breeze it generates. Over time, the proliferation of flora reveals how the space has been used, keeping track of our everyday activities and biorhythms.

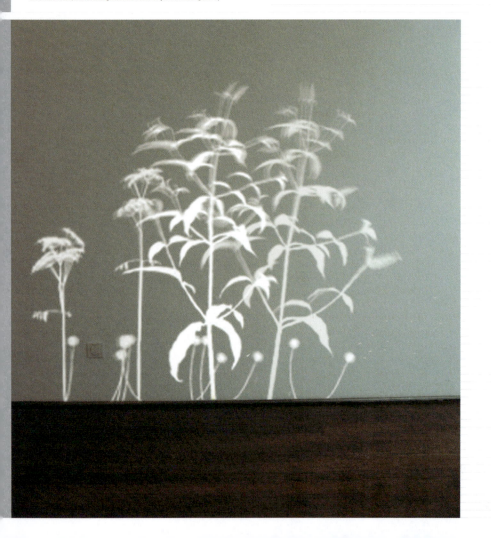

Rachel Wingfield (British, born 1978) and
Mathias Gmachl (Austrian, born 1974)
Loop.pH (UK, est. 2003)
Biowall Prototype. 2006
Fiberglass and plants, dimensions variable

Biowall is a woven scaffold that can become a partition wall
when colonized by living plants. In their attempt to create a
modular building system based on structures found in nature,
designers Rachel Wingfield and Mathias Gmachl looked at several
geometries, such as Penrose tiles (pairs of shapes that tile
the plane only aperiodically) and Synetic structures (an airy
and lacelike basketry of thin arcs patterned in curvilinear
triangulation). They finally opted for a dodecahedron weave
of twelve small circles made of one-millimeter fiberglass rods,
around which plants grow and creep. The designers explain that
the curved elements "are tangentially joined, so that forces
are distributed in a near continuous manner. The construction
is based on the principle of self-similarity, translating a
biological construction from the nanoscale to the macroscale.
It can be seen in our natural environment in the formation of
bubbles, living cells, and water molecules." Loop.pH uses tech-
nology to create objects "inspired by botanical life that
reflect and communicate environmental changes. As it becomes
increasingly difficult to read the signs of our natural environ-
ment in urban, built landscapes," the designers resort to
plants "as the most sophisticated of sensors."

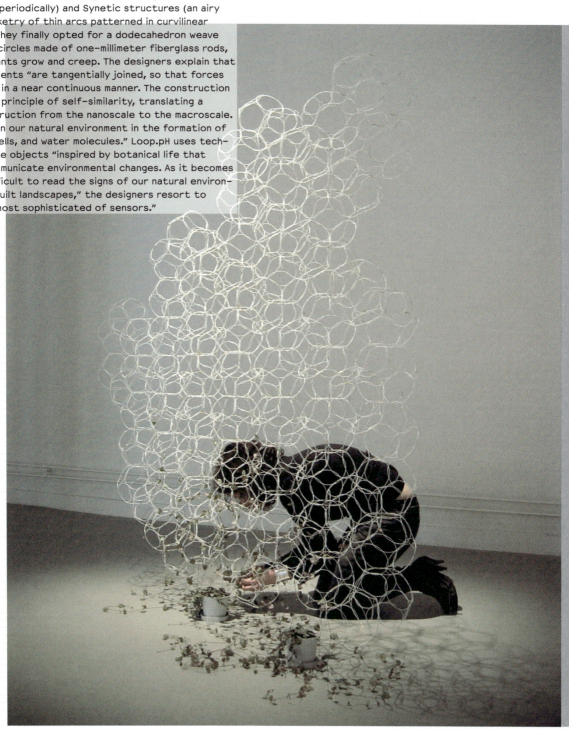

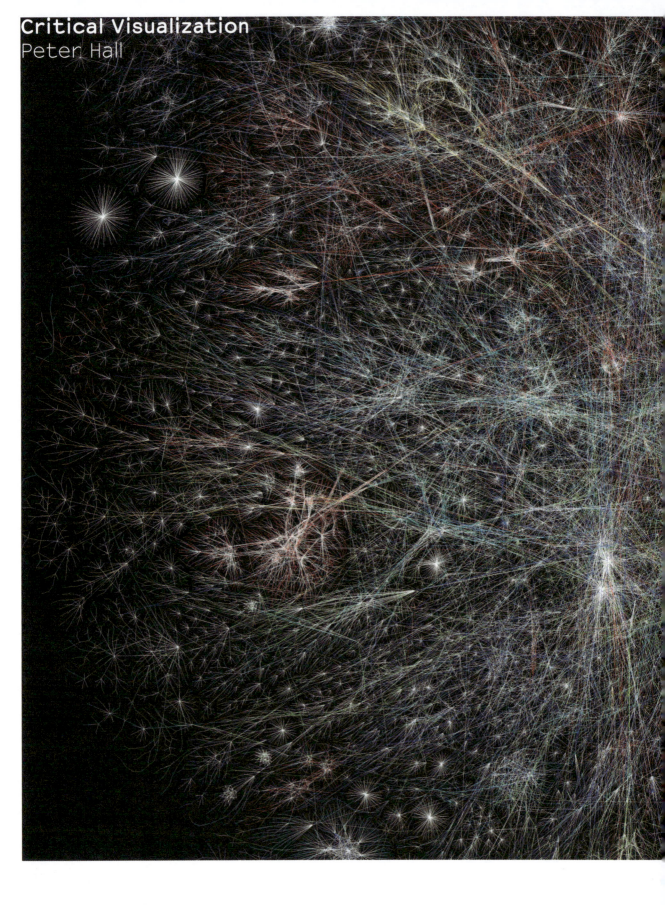

Critical Visualization
Peter Hall

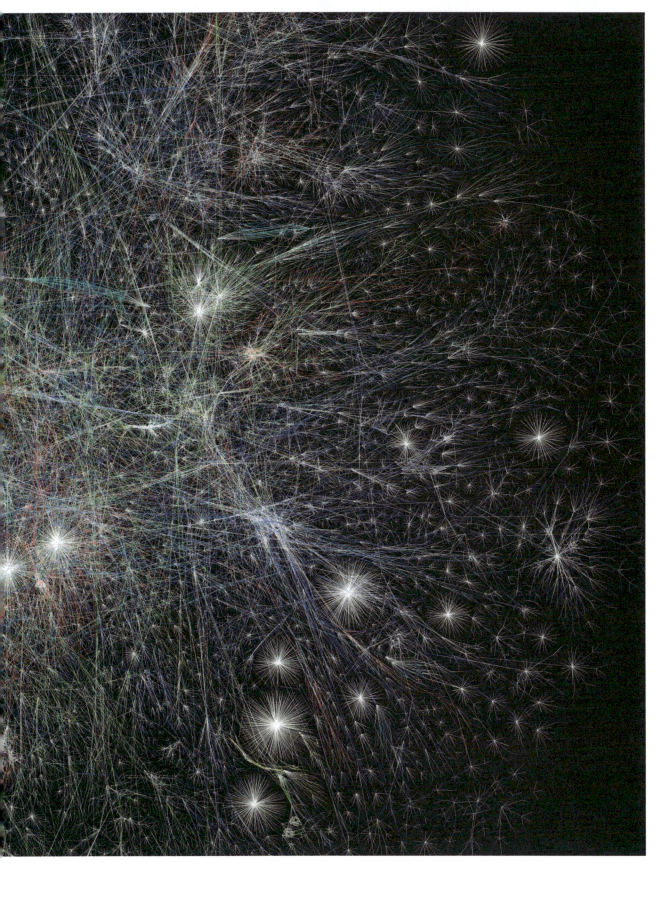

In an age when information is more prolific and more widely available than ever before, diagrams, maps, and visualization tools offer a means to filter and make sense of it. We live amid a deluge of data—gathered by sensors, arrayed by software, and dispersed via ever-proliferating networks—and to visualize it is to understand it, or so we hope. Colin Ware, a researcher in human perception, notes that we acquire more information through vision than through all of the other senses combined: the twenty billion neurons in the brain that help us analyze visual information provide a pattern-finding mechanism that is a "fundamental component in much of our cognitive activity." Ware makes a five-point case for the advantages of visualization: it helps us comprehend huge amounts of data; it allows us to perceive emergent properties we might not have anticipated; it can reveal problems with the data itself; it facilitates our understanding of large-scale and small-scale features; and it helps us form hypotheses.[1]

Yet, at the same time, the data explosion has brought about an aestheticizing of information, to the point that it has become difficult to sort function from creative expression. Information graphics adorn advertisements, architecture, magazines, textbooks, TV shows, and political campaigns.[2] Cascading veils of information, as famously depicted in the binary code of the 1999 film <u>The Matrix</u>, have become a definitive signifier of our age. As Arthur Robinson's history of early thematic mapping reveals, the line between visualization as a mode of scientific inquiry and as a form of figurative expression has long been blurred. Medieval mappae mundi eschewed geographic knowledge in favor of a Christian view of the earth divided into three continents, as repopulated by the descendents of Noah, with a greatly enlarged Holy Land at the center.[3] Even the flurry of scientific disease and morbidity maps of the nineteenth century, which reflected a growing concern with social conditions resulting from the movement of populations into cities, were rife with creative projections, such as E. H. Michaelis's map investigating a relationship between elevation and incidences of cretinism.[4]

By extension, early maps of the Internet seem equally wishful. With the benefit of a few years' hindsight, the graphics that purported to reveal the structure and activity of the Internet are perhaps better understood as mappae mundi of the digital age, expressions of a prevailing mythology of an emerging utopia known as cyberspace. In the popular imagination, the Internet was a discrete place we entered through portals, a place detached from the "meatspace" of the physical world; hanging in empty space, the early maps, resembling 3-D baubles or elaborate Tinker Toy constructions, reflected that sense of a discrete utopia.[5] Today we tend to think of the Internet as something that enhances or augments the physical world, something we encounter everywhere we go.

previous page:
Barrett Lyon. The Opte Project.
Mapping the Internet. 2003.
Opte software

John Snow. **Cholera Map of London.**
1855. Original map: 16 1/2 × 17 1/2"
(41.9 × 44.5 cm)

The Value of Visualization: Three Views

How, then, do we gauge the value of a visualization? Some maps, graphics, and diagrams seem to obfuscate or distort information or bewilder readers, while others have a profound effect on society, changing the course of government policy, scientific research, funding, and public opinion. This vast terrain of imagery —of network diagrams, 3-D mappings, charts, graphics, and browsers—presents something of a navigation problem in itself. Is it an art or a science? In an effort to take stock of the current state of the field, Jarke van Wijk, a math and computer science researcher at Eindhoven Technical University, The Netherlands, identifies three prevailing views of visualization: as a technology, as a science, and as an art.

As a technology, information visualization is theoretically aimed at developing new solutions and selecting the best ones, according to the criterion of usefulness. A benchmark of usefulness cited by van Wijk is one of the best-known information graphics in history, physician John Snow's 1854 map charting the location of eighty-three deaths from an outbreak of cholera in central London. Snow revealed that fatalities occurred in a cluster around the water pump at Broad Street, and argued—against prevailing wisdom that cholera was an airborne disease—that the pump was contaminated and should be shut down. Both Robinson and Edward Tufte, the writer and publisher of four well-known books on information design, wax lyrical about this graphic, which arguably changed the course of epidemiology and information design. Its apparent efficiency is stunning.

Visualization as an empirical science can be dated to the 1987 publication of an influential paper, "Visualization in Scientific Computing,"[6] and is perhaps best characterized by Ware's textbook Information Visualization, which uses psychological principles of human perception to build a set of rules governing the effective presentation of information. Ware provides a foundation for this view by first tackling the argument that something so arbitrary as the manipulation of images to represent concepts can ever be systematized, making a case for those conventions that are so entrenched in our brains that they have become hardwired.

As we shall see, both the technological and scientific approaches have some limitations. The third view, visualization as an art form, is given the least credibility by van Wijk, who characterizes its goals as the production of images that have "clear aesthetic value" and the pursuit of simple, elegant solutions that provide "intellectual and aesthetic satisfaction."[7] He quickly counters that this is not a line of defense that can "help us to convince our prospective users and sponsors."[8] Such a diminutive account of art might be expected from the computer sciences, but outside the world of peer-reviewed papers and industry-backed research, the art of visualization can be seen

as an important critical counterpoint to the tech-
nological and scientific views. As a practice, it might
even open up the field.

Technological Determinism?

The canonization of Snow's map is a good starting
point for examining the technological view, which
places a great deal of emphasis on technique and the
integrity, efficiency, and effectiveness of visualiza-
tions. Tufte focuses on the notion of graphic
integrity, frequently redrawing "deceptive" graphics
to illustrate how to avoid distorting data in the
representation. Revisiting Snow's map in Visual
Explanations, he gives an intriguing lesson on how
different time-series representations of Snow's data
can be used to support a sensationalist version of
the tale, which states that immediately following
Snow's report the Broad Street pump handle was
removed and the cholera outbreak subsided. As Tufte
reveals with his chart of the day-to-day chronology
of deaths, the decline had begun before the handle
was removed, most likely because Londoners were
fleeing the area. Simply reorganizing the death rates
by weekly intervals shows a sudden dramatic decline in
death rates immediately following the handle's removal.

By drawing attention to the possibility that the
removal of the water pump was unrelated to the
decline in cholera in the area, Tufte seems to point
to a problem in the very myth he is weaving around
Snow's map. Is the graphic important because it is a
technical paradigm of visual clarity and integrity, or
because it is inextricably linked in our minds to the
progress of epidemiology? Clearly, if Snow had been
wrong about cholera and water, the map would not be
a benchmark today. It certainly was not a technical
innovation. Medical maps were common in the mid-
1800s, and plotting deaths with dots was not a Snow
invention.[9] The backbone of the case for cholera as
waterborne was Snow's detective work, as revealed
in his prize-winning essay on the subject, to which
the map was simply an accompaniment. To canonize the
map through association is to risk invoking a kind of
technological determinism, which suggests that Snow's
map alone changed the way we view disease. If in the
future Snow were proven to be wrong about cholera,
one suspects his map would be quietly dropped from
the "infoviz" canon.

A more recent example of putting undue emphasis
on an information graphic can be found in the brouhaha
that greeted the "hockey stick" graph showing tem-
perature change over the last one thousand years.
First published in the magazine Nature in 1998, the
graph was included in the United Nations Intergovern-
mental Panel on Climate Change Third Assessment
Report, in 2001, and writ large in Al Gore's 2006 film,
An Inconvenient Truth. It earned its nickname from its
shape, depicting relatively level temperatures for nine
hundred years followed by a sharp upturn in the last

Michael E. Mann of Pennsylvania
State University. Raymond S. Bradley
of University of Massachusetts.
Malcolm K. Hughes of University
of Arizona. **Patterns of Organized
Climatic Variability: Spatio-Temporal
Analysis of Globally Distributed
Climate Proxy Records and Long-
term Model Integrations.**
1998–2000

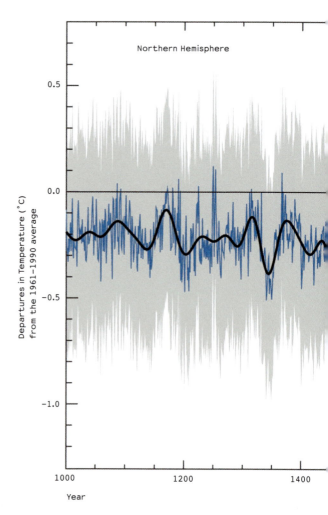

ninety years.[10] Based on proxy evidence from tree rings, ice cores, coral, historical records, and instrumental data, the graph points the finger squarely at human activity as the cause of global warming. Opponents of this argument contend, however, that the visualization was derived by using a particular statistical convention that favored production of the hockey stick form. By focusing on one decontextualized graphic, and side-stepping the overwhelming body of evidence linking human behavior with climate change, right-wing critics were able to muddy the waters of the argument. (Incidentally, this tactic effectively overshadowed other statistical conventions that achieved the same hockey stick shape. A paper published in <u>Nature</u> in 2005, to cite one example, found—using proxy evidence from stalagmites and lake sediment—the latter part of the twentieth century to be the warmest period in two thousand years.)[11]

Effectiveness, a barometer of the technological view, is also an unreliable test of visualization. Consider a set of graphics produced by the <u>New York Times</u> to accompany a report in April 2002 on the vulnerability of New Orleans's flood-control system (pp. 126–27).[12] A shaded relief map using a twenty-fold vertical exaggeration (albeit a Tufte no-no) effectively shows the changes in terrain around New Orleans, highlighting the critical role of the levees in protecting land (shaded red) at sea level or below. A cross section of the same area reveals the water levels of the Mississippi River and ocean in relation to the land. An aerial view shows the potential path of a "worst-case hurricane." And, finally, three flooding scenarios show the city in various states of submersion. Although the case for preventive measures was clearly and efficiently spelled out, the visualizations, like others published ahead of Hurricane Katrina, had little or no effect on policy. Its value is contingent on hindsight, as a vivid artifact of an institutional failure to heed well-documented warnings.

The Science of Visualization

For Ben Fry, who worked at MIT and Harvard University's Broad Institute developing dynamic visualization tools for genomics researchers, the chief oversight of Tufte's approach is its failure to address situations in which data is complex and undergoing continuous change—a situation that often calls for the user to interact with the data.[13] Fry finds certain advantages in the scientific empirical approach laid out by Ware, specifically as a strategic counter to the current impulse to begin a visualization with the data itself. With vast data sets like the human genome, it becomes crucial for research teams to ask themselves, before the visualization stage, what they are trying to show. "Storytelling winds up being the crux of this stuff," says Fry. "Most often I work with people coming from the engineering or science side, and there's a

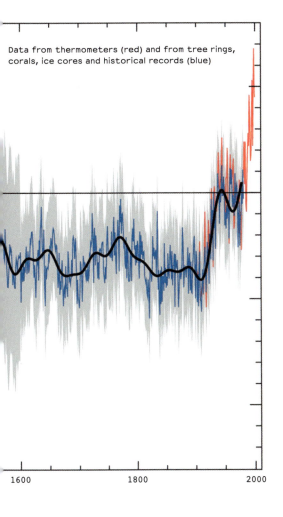

Data from thermometers (red) and from tree rings, corals, ice cores and historical records (blue)

1600 1800 2000

tendency for them to say 'I have a whole bunch of information and data—what do I do with it?' Their starting point is a pile of stuff that they want to make something interesting and clear out of. But it winds up being the opposite. I'm much more interested in getting people to think about what kind of story they want to tell, or what kind of narrative they're trying to pull out, and working backwards from that, back to the data."[14]

Fry's efforts to simplify and enhance standard genome representations with interactivity played a part in speeding the research behind two scientific papers: one that compared the catalogue of all known human genes with that of closely related species, with a view to eliminating aberrations and reducing the overall gene count (humans are estimated to have between twenty- and twenty-five thousand genes); and another aimed at simplifying how researchers identify across several species the areas around the genes linked to diseases like cystic fibrosis or conditions like lactose intolerance.[15] As Fry sees it, Ware's perception-based approach unpacks techniques that graphic designers might consider intuitive, such as a hierarchy of visual modes for attracting the eye, with motion at the top followed by color, size, and shape. "Knowing things like that is important," says Fry, who observes that the first impulse of someone producing a visualization might be to want to match categories of data with colors. Color, however, is one of the first things the eye picks up. According to Fry, "You have to ask yourself whether the categories are the most interesting thing about this data, because if they're color-coded it's what's going to attract the most attention."

Visualization becomes a more slippery science when we peer closer at Ware's distinction between hardwired and culturally learned conventions. The hardwired, or "sensory," aspects of visualizations, he argues, derive their power from being well designed to stimulate the visual sensory system (such as pattern recognition); "arbitrary" conventions derive their power from how well they are learned. Ware admits, however, that the two aspects are closely intertwined, and the boundary between them is fuzzy: "For any given example we must be careful to determine which aspects of the visual coding belong in each category."[16] This is easier said than done: The use of red to symbolize danger, for example, might seem for some to be hardwired, but in Ware's own example, an Asian student working on a system for visualizing a hard disk chose green for deleted entities and red for new entities, reasoning that in Asian culture green symbolizes death and red equals good luck. Similar discrepancies led information designer W. Bradford Paley to treat with caution the close adherence to general principles of perception. In an equities valuation tool he was creating in 1989 for the global finance firm Lehman Brothers, Paley initially used a standard scientific heat map (black =

William E. McNulty and Bill Marsh.
Graphics produced for "Nothing's Easy for New Orleans Flood Control."
Science Times, <u>New York Times</u>, April 30, 2002

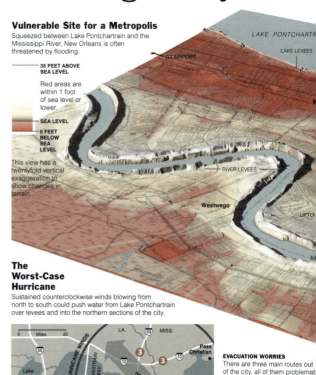

Scien

The

Nothing's Easy for N

Vulnerable Site for a Metropolis
Squeezed between Lake Pontchartrain and the Mississippi River, New Orleans is often threatened by flooding.

LAKE PONTCHARTRA
LAKE LEVEES
TO AIRPORT

35 FEET ABOVE SEA LEVEL
Red areas are within 1 foot of sea level or lower.
SEA LEVEL
6 FEET BELOW SEA LEVEL

This view has a twentyfold vertical exaggeration to show changes in terrain.

RIVER LEVEES

Westwego

UPTO

The Worst-Case Hurricane
Sustained counterclockwise winds blowing from north to south could push water from Lake Pontchartrain over levees and into the northern sections of the city.

Miles 20
LA. MISS.
55
Pass Christian
Lake Maurepas
Lake Pontchartrain
New Orleans
Lake Borgne
Mississippi River
HURRICANE WINDS
LAKE PONTCHARTRAIN CAUSEWAY
HURRICANE PATH

EVACUATION WORRIES
There are three main routes out of the city, all of them problemat

1 Interstate 10 is prone to flooding where it passes over a corner of the lake.

2 The 24-mile Lake Pontchartrain Causeway is closed when winds exceed 50 m.p.h.

3

By JON NORDHEIMER

NEW ORLEANS — Caught between the Mississippi and the long shoreline of Lake Pontchartrain, this low-lying city has long depended on levees and luck.

Now engineers say those are not enough to protect New Orleans, much of it below sea level, from a devastating flood that could threaten it if a storm surge from a powerful hurricane out of the Gulf of Mexico propelled a wall of water into the lake and the city.

That event could place vast sections under 20 feet or more of water, engineers and scientists say, with worst-case computer predictions showing death tolls in the tens of thousands with many more people trapped by high water that has no natural drainage outlets.

"There's no way to minimize the amount of devastation that could take place under such circumstances," warned Walter S. Maestri, director of emergency management of Jefferson Parish, a suburban region with 455,000 residents on the city's western and southern sides.

Perhaps the surest protection is building up the coastal marshes that lie between New Orleans and the sea and that have been eroding at high rates. But restoration will require time, a huge effort and prohibitive sums of money, perhaps $14 billion, according to a study by a panel from federal and state agencies, universi-

ties and business.

Engineers are consider ways to protect the heart and provide an island of re French Quarter and g centers. Though such are less expensive, they their own problems. One volves walling off an area water. But where would built and who would benef

Many residents give litt to such matters, countin knowledge that New Orlea caped hurricane disaster i

The most nervous people paid to worry about such t Dr. Joseph N. Suhayda, the Louisiana Water Rese search Institute at Louis University. Like other c

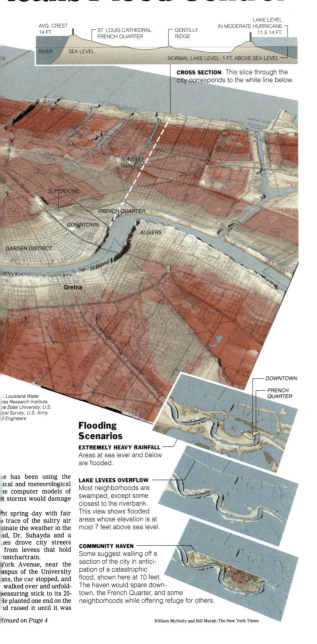

...leans Flood Control

AVG. CREST 14 FT. ST. LOUIS CATHEDRAL, FRENCH QUARTER GENTILLY RIDGE LAKE LEVEL IN MODERATE HURRICANE 11.5 14 FT.

RIVER SEA LEVEL NORMAL LAKE LEVEL: 1 FT. ABOVE SEA LEVEL

CROSS SECTION This slice through the city corresponds to the white line below.

GENTILLY RIDGE

SUPERDOME

FRENCH QUARTER

DOWNTOWN ALGIERS

GARDEN DISTRICT

Gretna

DOWNTOWN

FRENCH QUARTER

Flooding Scenarios

EXTREMELY HEAVY RAINFALL Areas at sea level and below are flooded.

LAKE LEVEES OVERFLOW Most neighborhoods are swamped, except some closest to the riverbank. This view shows flooded areas whose elevation is at most 7 feet above sea level.

COMMUNITY HAVEN Some suggest walling off a section of the city in anticipation of a catastrophic flood, shown here at 10 feet. The haven would spare downtown, the French Quarter, and some neighborhoods while offering refuge for others.

: Louisiana Water
es Research Institute,
a State University; U.S.
cal Survey; U.S. Army
f Engineers

e has been using the
ical and meteorological
e computer models of
t storms would damage

ht spring day with fair
trace of the sultry air
inate the weather in the
d, Dr. Suhayda and a
es drove city streets
from levees that hold
ontchartrain.
ork Avenue, near the
mpus of the University
ns, the car stopped, and
walked over and unfoldeasuring stick to its 25-
e planted one end on the
d raised it until it was

tinued on Page 4

William McNulty and Bill Marsh/The New York Times

cool = low, red = hot = high). He quickly realized a crucial cultural difference between the sciences and the trading floor when his client said, "Now let me understand this: Being in the red is good?"

The ease with which data can be visualized, Paley argues, has led to a proliferation of initially impressive but ultimately useless tools. "Ironically, some tools are difficult to use for the very reason their designers think they are good: generality. If datasets as different as a thesaurus, a museum, and a list of popular songs look identical, that means you're only seeing the structural variation they share—not where they differ. And the interesting structure is often in the idiosyncrasies." He adds, "There's no simple, consistent translation from data to visuals because every mature problem domain has its own metaphors, its own interpretation frame—making one tool fit all impoverishes its expressive range, and you lose both resolving power and ease of interpretation."[17]

Such issues seem to stunt the growth of network mapping tools like Thinkmap and Inxight's Vizserver, which, while offering to make sense of complex information—such as the knowledge assets in a corporation—end up revealing little about the relations between the nodes on the networks they render. A simple comparison of Thinkmap's Visual Thesaurus, which arrays synonyms in a dynamic network map, with the rich word-usage history of the Oxford English Dictionary quickly reveals to any writer that the former is a reductive tool that closes down meaning while the latter opens up expressive possibilities within language.

Fry has noted that the quality of visual design is generally neglected in the scientific approach to information visualization, perhaps because in its efforts to quantify the practice the field has come to perceive the business of making things attractive as too subjective. Yet those "cosmetic tweaks" on a simple diagram become extremely important when applied to a complex data set of thousands of elements, as Fry notes: "Minor problems in the diagram of a smaller data set are vastly magnified in a larger one." Singling out by way of example the TreeMap software introduced by Ben Shneiderman's Human Computer Interaction Laboratory at the University of Maryland in 2002, Fry critiques its layout, noting the visual noise caused by frames, borders, labels, and the use of valuable screen real estate for sliders and dead space at the cost of providing more space for the data.[18] Indeed, while Tufte's books are chiefly concerned with quality and technique, Ware's is strikingly devoid of beauty.

Finally, as van Wijk and other scholars within the field have observed, visualization as a scientific discipline has some doubts about its own validity. "There seems to be a growing gap between the research community and its prospective users," writes van Wijk, noting that, after the flourishing of diverse ideas in the 1990s, the field today has become more

specialized, with submitted work often consisting of incremental progress. "It is not always clear that these incremental contributions have merit, and reviewers are getting more and more critical."[19]

The Art of "Viz" as Critical Practice

Perhaps fallow ground and incremental progress are indicators that a discipline has argued itself into a corner. An expansive science would surely allow for alternative theoretical approaches, just as a technological approach benefits from a meta-perspective. Here, van Wijk's characterization of art as the production of self-rationalized aesthetic objects that bring intellectual delight merits a little rethinking. If instead we align the art of visualization with the art of urban planning and architecture, we open up a potentially fruitful comparison. Both urban planners and architects aim at the production of spaces with clear aesthetic value, yet this is only part of the reason that their users and sponsors are convinced, to use van Wijk's wording. Their services are enlisted in order to take part in a process, to "reformulate what already exists," as landscape architect James Corner argues in his essay "The Agency of Mapping": "What already exists is more than just the physical attributes of a terrain (topography, rivers, roads, buildings) but includes also the various hidden forces that underlie the workings of a given place."[20] Among these, Corner lists several forces indicated in the exploration of the canonic visualizations above: historical events, local stories, economic and legislative conditions, and political interests.

If we follow Corner's lead and imagine the art of visualization as a creative process concerned with not just the finished artifact but the framing, gathering, connecting, and arraying of data, then we can also imagine it as a critical practice: sizing up and reformulating a terrain of knowledge as well as experimenting with new and alternative forms.[21] Drawing from Gilles Deleuze and Felix Guattari, Corner uses the motifs of the rhizome and the burrow for their nonhierarchical and expansive way of connecting points from the middle rather than the beginning or end. Corner finds a paradigm of such "rhizomatic" mapping in a project also lauded by Tufte: Charles Joseph Minard's narrative diagram of Napoleon's ill-fated march on Russia during the winter of 1812–13. The map elegantly brings together facts such as the diminishing size of the French army, its movement, the terrain, locations and times of battles, weather, and the passage of time in one predigital "datascape," printed in 1885. "More than telling a story," writes Corner, "the map conditions how places on the land have come to exist in new relationships precisely through the vector of an event."[22] But he qualifies his praise by noting that the Minard map is a "closed system" that invites only a linear read. According to Corner, a rhizomatic map would be more multivariate

Terraswarm and Natalie Jeremijenko. **OneTrees Project Map.** 2003. ESRI GIS, USGS Landsat 7 satellite photo, and Rhino 3-D software, 22 × 11" (56 × 28 cm)

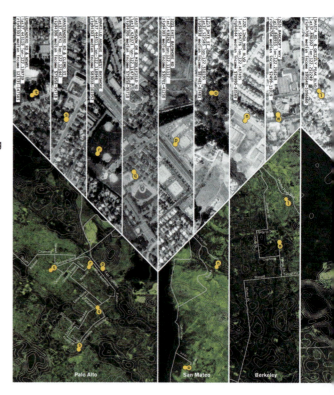

and open: "Indeed such a map might not 'represent' any one thing at all; rather it might simply array a complex combination of things that provides a framework for many different uses."[23]

Such rhetoric risks encouraging data-driven rather than story-driven visualizations. But it also provides for radical experimentation of the sort practiced by Natalie Jeremijenko, a design engineer and "techno-artist." Jeremijenko's OneTrees project, for example, reimagines cloned trees as environmental sensors. In 2003 she and two San Francisco–based nonprofit groups planted cloned pairs of Paradox trees around the Bay Area in order to register the different social and environmental conditions in the various locations. A map of OneTrees locations, produced with experimental architecture practice Terraswarm, juxtaposes a U.S. Geological Survey Landsat 7 aerial image of the Bay Area with "lay knowledge," such as the locations of bike trails, common hawk flight paths, and the habitat of the endemic song sparrow. The implicit critique is of culturally entrenched hierarchies of information, which, for example, prioritize satellite views and expert, institutional knowledge over the knowledge of ordinary people.[24]

Jeremijenko's provocations attempt to call into question the legitimacy of the entire barrage of scientific procedures, presenting disruptive juxta-positions and very unscientific instruments (such as trees or toy robotic dogs). A more conventional project—though a potentially more disruptive one—was begun by architect and artist Laura Kurgan at the Columbia University Spatial Information Design Lab in 2006. Working with the Justice Mapping Center, Kurgan and Columbia graduate students have been mapping data from the criminal justice system. They have been looking not at where crimes were committed, as is common, but at the home addresses of the people incarcerated as a result of the crimes. Coining the term "million dollar blocks," the research collaborative revealed in their maps how a disproportionate number of prisoners come from a very few neighborhoods in the country's largest cities, to the extent that some states are spending in excess of a million dollars a year to incarcerate the residents of single city blocks. A description of the project, named Architecture and Justice, concludes with a discussion of its implications: "Guided by the maps of Million Dollar Blocks, urban planners, designers, and policy makers can identify those areas in our cities where, without acknowledging it, we have allowed the criminal justice system to replace and displace a whole host of other public institutions and civic infrastructures....What if we sought to undo this shift, to refocus public spending on community infrastructures that are the real foundation of everyday safety, rather than criminal justice institutions of prison migration?"[25]

Potentially, Architecture and Justice does offer a new kind of benchmark for critical visualization.

Hot or Not? Vegetation & Heat Maps
Derived from Landsat Thematic Mapper
Veg.: Band 3 & 4 (wavelength .63-.90um) Red & Near Infrared
Heat: Band 6 (wavelength 10.4-12.5um) Thermal Infrared

San Francisco

It utilizes many of the principles espoused by Tufte and Ware, efficiently and effectively conveying a clear, succinct story. As a critical mapping, it challenges current thinking by reformulating what already exists. It uses the master's tools—the aerial view, the crime map, and crime data—to reveal a street-level view of the city: not a crime epidemic but a view of civic infrastructure that necessitates the inclusion of a distant exostructure—prisons and jails.

In his first book, Tufte introduced a guideline with which to judge statistical representations that he called the "lie factor": the ratio of the size of an effect shown in the visualization to the size of the effect in the data.[26] But as the Architecture and Justice project reminds us, the data itself is never neutral; it is collected for a reason, and processed and presented for specific purposes. In other words, "There is no such thing as raw data."[27] Cartography historian Denis Cosgrove once advised attendees at a mapping conference to "always make maps; always question maps."[28] The same should be said of information visualization.

Laura Kurgan, Eric Cadora, David Reinfurt, and Sarah Williams. Spatial Information Design Lab, Graduate School of Architecture, Planning and Preservation, Columbia University. **Architecture and Justice from the Million Dollar Blocks project.** 2006. ESRI ArcGIS (Geographic Information System) software

Notes

1.
Colin Ware, Information Visualization: Perception for Design, 2nd ed. (San Francisco: Morgan Kaufmann, 2004), pp. 2–3.

2.
For example, the Move Our Money campaign of 1999–2000, featuring inflatable pie charts and bar charts designed by Stefan Sagmeister. Peter Hall and Stefan Sagmeister, Sagmeister: Made You Look (London: Booth Clibborn, 2001), pp. 169–73.

3.
Arthur Robinson, Early Thematic Mapping in the History of Cartography (Chicago: University of Chicago Press, 1982), pp. 9–11.

4.
Ibid., pp. 174–76.

5.
See, for example, www.cybergeography.org/atlas.

6.
"Visualization in Scientific Computing," in Computer Graphics 21, vol. 6, ed. Bruce H. McCormick, Thomas A. DeFanti, and Maxine D. Brown, ACM Siggraph, New York, November 1987.

7.
Jarke J. van Wijk, "The Value of Visualization," in Proceedings of the IEEE Visualization Conference 2005, ed. C. Silva, E. Groeller, H. Rushmeier, p. 85.

8.
Ibid.

9.
The practice of using spot maps to depict mortality and disease rates can be traced back to the eighteenth century in the United States.

10.
Paul Rincon, "Row Over Climate 'Hockey Stick,'" BBC News, March 16, 2005, news.bbc.co.uk/2/hi/science/nature/4349133.stm.

11.
See David Womack, "Seeing Is Believing: Information Visualization and the Debate Over Global Warming," Think Tank, www.adobe.com/designcenter/thinktank/womack.html.

12.
Jon Nordheimer, "Nothing's Easy for New Orleans Flood Control," New York Times, April 30, 2002. Graphics by William McNulty and Bill Marsh/The New York Times.

13.
Ben Fry, "Computational Information Design" (PhD thesis, MIT Media Laboratory, 2004), p. 39.

14.
Ben Fry, telephone interview, May 29, 2007. Unless otherwise noted, all subsequent quotations from Fry come from this interview.

15.
See Janet Abrams, "Geneography," in Else/Where: Mapping. New Cartographies of Networks and Territories, ed. Abrams and Peter Hall (Minneapolis: University of Minnesota Design Institute, 2006).

16.
Ware, Information Visualization, p. 17.

17.
W. Bradford Paley, e-mail to author, June 14, 2007.

18.
Fry, "Computational Information Design," pp. 40–41.

19.
Van Wijk, "The Value of Visualization," p. 80.

20.
James Corner, "The Agency of Mapping," in Mappings, ed. Denis Cosgrove (London: Routledge, 1999), pp. 213–52.

21.
Ibid., p. 214.

22.
Ibid., p. 245.

23.
Ibid., p. 246

24.
Alice Twemlow, "Bark to Bytes," in Else/Where: Mapping, pp. 254–56.

25.
Eric Cadora and Laura Kurgan, "Architecture and Justice" (exhibition brochure), The Architectural League of New York, September 15–October 28, 2006. See www.spatialinformationdesignlab.org/publications.php?id=38.

26.
Edward Tufte, The Visual Display of Quantitative Information, 2nd ed. (Cheshire, Conn.: Graphics Press, 2001), p. 57.

27.
Cadora and Kurgan, "Architecture and Justice."

28.
Denis Cosgrove, "Cartography in the Age of Digital Media" (symposium, Yale University School of Architecture, April 2002). See also Rebecca Ross, "Digital Cartography," The Knowledge Circuit, design.umn.edu/go/knowledge Circuit/smr02.3.Ross.

Edward Marcotte (American, born 1967) and
Alex Adai (American, born 1976)
Center for Systems and Synthetic Biology (est. 2003),
The University of Texas at Austin (USA, est. 1883)
Protein Homology Graph 2004
bioinformatics.icmb.utexas.edu/lgl/#gallery
Large Graph Layout (LGL) software

The sequencing of a genome is central to molecular biologists'
understanding of the basic makeup of every living organism.
The goal is to appreciate how this information comes together
to constitute a uniquely characteristic being, whether a
human, a plant, an animal, a bacterium, or a virus. The calculus
necessary to compile and interpret this enormous quantity
of data can be supported only by ever-increasing computer
capabilities, which become much more effective when coupled
with good visualization design. The Protein Homology Graph is
one example of this. To measure homology—the similarities
between genes in different organisms that are so strong they
point to a common evolutionary ancestor—Edward Marcotte
and Alex Adai compared the sequences of 140,000 known genes;
after nearly 21 billion comparisons were performed, 1.9 million
homologies were established. Marcotte and Adai then used
software to present this data as an immense web of relation-
ships in which each point represents a single gene and genes
in the same family are connected by lines. Genes that share
homologies are placed near each other, creating constellations
of points. Larger groupings designate larger gene families,
and often point to fundamental building blocks critical to many
organisms; smaller groupings represent genes common to only
a few organisms. Establishing such blueprints of genetic
information provides important clues as to how genes affect
cells, tissues, and organs, which can lead to innovations in,
for example, understanding and treating disease.

When it comes to visualizing great amounts of data, the Internet is an irresistible subject of study. As it has grown, so has the challenge of accurate measurement and modeling of its topology. Numerous Internet maps exist, some strictly functional and diagnostic (such as the Internet Mapping Project initiated by Bell Labs in 1998), others more "atmospheric," meant as dynamic snapshots of a universe in continuous expansion.

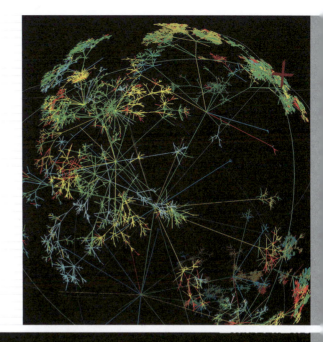

Young Hyun (American, born 1973)
Cooperative Association for Internet Data Analysis, San Diego Supercomputer Center (est. 1997), University of California, San Diego (USA, est. 1960)
Walrus graph visualization tool 2001–02
Java and Java3D software

In mathematics and computer science, a graph is a set of points or nodes connected by lines that can be considered equivalent in either direction (from A to B equals from B to A). In a directed graph, or digraph, each direction is instead considered distinct and called a direct arc or link. Digraph analysis has a wide set of applications as a deductive tool, especially in the social sciences, where points often stand for individuals and arcs as relationships between them. Walrus clearly illustrates the results of a digraph analysis for particularly large amounts of data, optimally with a few hundred thousand nodes.

Applied to the Internet, these visualizations allow us to appreciate the complex world of Internet connectivity. By sending probes to several hundred thousand IP addresses every day, researchers can actively measure both topology and average round-trip time (RTT)—the time interval between the moment a probe is sent and the moment a response is received—across a wide cross-section of the Internet. The graph shown here depicts a single cycle of measurements originating on February 2, 2002. Different colors identify each link's RTT, with cyan being the fastest and red being the slowest (and likely showing poor or problematic connectivity).

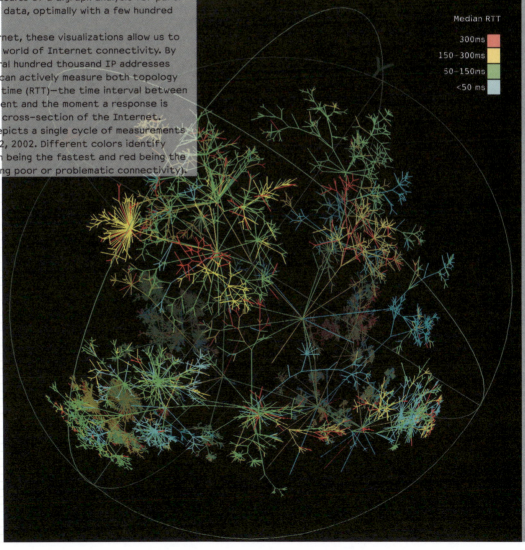

Median RTT
300ms
150–300ms
50–150ms
<50 ms

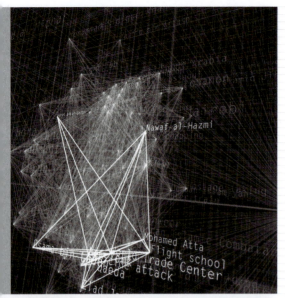

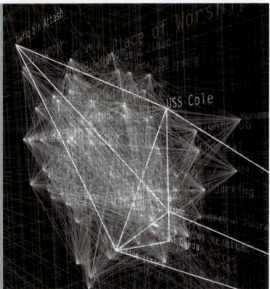

Lisa Strausfeld (American, born 1964) and
James Nick Sears (American, born 1980)
Pentagram (UK and USA, est. 1972)

"Rewiring the Spy" illustrations/applet for
the <u>New York Times Magazine</u> December 3, 2006
jamesnsears.com/applets/spies
Illustrator, Acrobat, and Processing software

Understanding connections in the vast landscape of infor-
mation often requires a new way of looking. On December 3,
2006, the lead story for the <u>New York Times Magazine</u>, penned
by Clive Thompson, discussed the challenge of analyzing and
interpreting information about terrorism and coordinating its
exchange among various intelligence organizations. For the
article, information designers Lisa Strausfeld and James Nick
Sears programmed an applet in which keywords—in this case
names of terrorists or terrorist events—are connected by
springlike links, which become stronger and more animated with
the frequency of the words' interconnection in a database.
The resulting visualizations can be rotated in three dimensions
to reveal new viewpoints. While for the purpose of the story
the designers used the Internet as the source database,
the model could also be adapted by government agencies
using their own classified databases.

Aaron Koblin (American, born 1982)
Department of Design | Media Arts (est. 1994), School of
the Arts and Architecture, University of California,
Los Angeles (USA, est. 1966)
Flight Patterns 2005
users.design.ucla.edu/~akoblin/work/faa
Processing, Maya, and After Effects software

Celestial Mechanics, a project launched in 2005, visualizes the
arresting patterns of the myriad flying objects—satellites,
aircraft, balloons—that are at any time hovering around the
earth. The work, which combines science, statistics, and art,
was meant to be shown in a planetarium. Flight Patterns is
a "flat" corollary to the project, one which also shows the
informative and aesthetic potential of this type of visuali-
zation. As Aaron Koblin explains it, "Aircraft data collected by
the Federal Aviation Administration was parsed and plotted
to create animations of North American travel paths. Through
visual traces of airplanes, one gets at any moment a sense
of the changing dynamics of traffic in the skies above, as well
as insight into the geographies and superstructures guiding
the network."

GustavoG (anonymous)
**The FlickrVerse: A Graph Depicting the Social
Network of the Flickr Community** April 2005

Flickr, the photo-sharing Web site and online community, allows
users not only to share personal photos but also to cate-
gorize their photos with keywords and to organize them into
sets that can easily be searched. Users can add contacts to
their profiles, creating a vast network. The "universe" made
up of this group and its photos was explored in FlickrVerse,
a now inactive blog. One day in 2005, one Flickr user, the elusive
GustavoG, designed an image showing the social landscape of
FlickrVerse. The graph depicts a network of 2,367 Flickr members,
demonstrating the connections and relationships of this
unique community at a particular moment.

The FlickrVerse, April 2005
A graph depicting the social network of the Flickr community.
Visit www.krazydad.com/gustavog for more information.

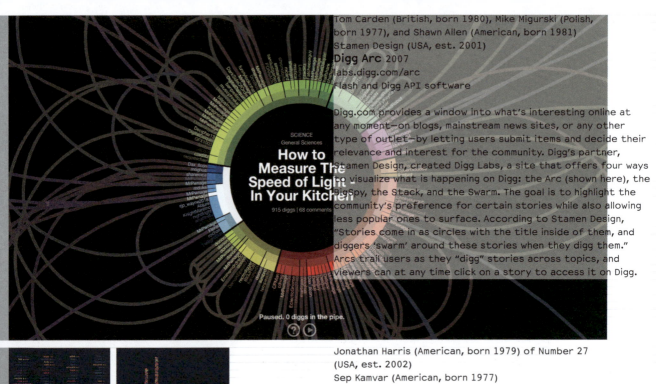

Tom Carden (British, born 1980), Mike Migurski (Polish, born 1977), and Shawn Allen (American, born 1981)
Stamen Design (USA, est. 2001)
Digg Arc 2007
labs.digg.com/arc
Flash and Digg API software

Digg.com provides a window into what's interesting online at any moment—on blogs, mainstream news sites, or any other type of outlet—by letting users submit items and decide their relevance and interest for the community. Digg's partner, Stamen Design, created Digg Labs, a site that offers four ways to visualize what is happening on Digg: the Arc (shown here), the BigSpy, the Stack, and the Swarm. The goal is to highlight the community's preference for certain stories while also allowing less popular ones to surface. According to Stamen Design, "Stories come in as circles with the title inside of them, and diggers 'swarm' around these stories when they digg them." Arcs trail users as they "digg" stories across topics, and viewers can at any time click on a story to access it on Digg.

Jonathan Harris (American, born 1979) of Number 27 (USA, est. 2002)
Sep Kamvar (American, born 1977)
We Feel Fine: An Exploration of Human Emotion in Six Movements 2005
wefeelfine.org
Perl, MySQL, Java, PHP, and Processing software

People often use the Internet to express and share emotions and to connect with others. The Web site We Feel Fine has been harvesting human feelings from blogs since 2005. Every few minutes, the system searches the world's newly posted blog entries for occurrences of the phrases "I feel" and "I am feeling." When it finds such a phrase, it records the full sentence and tags the feeling expressed in that sentence. The site can also extract the age, gender, and geographical location of the author, as well as the local weather conditions at the time the sentence was written, resulting in a database of several million feelings (increasing by about fifteen to twenty thousand new feelings each day). The site's designers have experimented with six visualization systems, which they call "movements," each one with its own efficacy and beauty.

Golan Levin (American, born 1972) of Carnegie Mellon University (USA, est. 1900)
Kamal Nigam (American, born 1972) of Google (USA, est. 1998)
Jonathan Feinberg (American, born 1972) of IBM Research (USA, est. 1914)
The Dumpster (Valentine's Day) 2006
artport.whitney.org/commissions/thedumpster
Java software

The pain of a relationship ending mixed with the anguish of adolescence is requisite material for pop songs, movies, and magazines. Building on the idea that the Web holds an amazing repository of humanity, The Dumpster, an interactive visualization Web site, uses real-life examples from the lives of American teenagers drawn from the Internet to provide a snapshot into the romantic lives of teens in 2005. The site—launched on Valentine's Day, 2006—uses postings extracted from millions of blogs in which the phrases "broke up" or "dumped me" appeared.

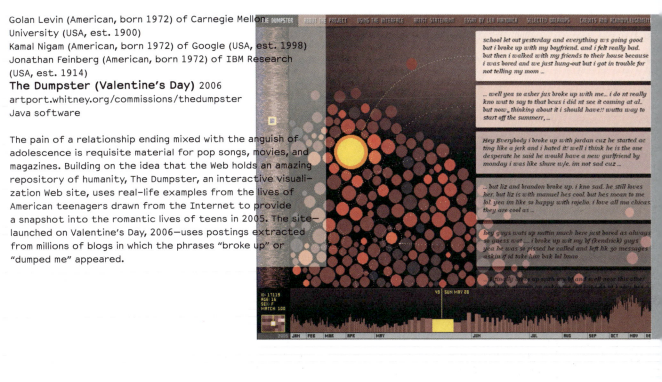

W. Bradford Paley (American, born 1958)
Digital Image Design Incorporated (USA, est. 1982)
TextArc 2001
www.textarc.org
Java software

One of the main characteristics of visualization design is its capacity to use beauty and elegance as a path to clarity and analysis. W. Bradford Paley is one of the foremost experts in the communication of great amounts of data, and his renowned tool TextArc is used to conduct structuralist analyses of text. Every line of text from a book (in this case, Alice in Wonderland) is plotted in a circle. TextArc's function is to provide an analysis of the text unencumbered by its interpretation. As Paley explains, it is "a tool designed to help people discover patterns and concepts in any text by leveraging a powerful, underused resource: human visual processing. TextArc exposes the nature and style of a document's content....It taps into our pre-attentive ability to scan for brighter (here, more frequent) words, compare them, and let the eye read those words....The eye and mind scan for ideas, then follow the ideas down to where and how they appear in the text." TextArc has several features and visualization options, one of which is shown here.

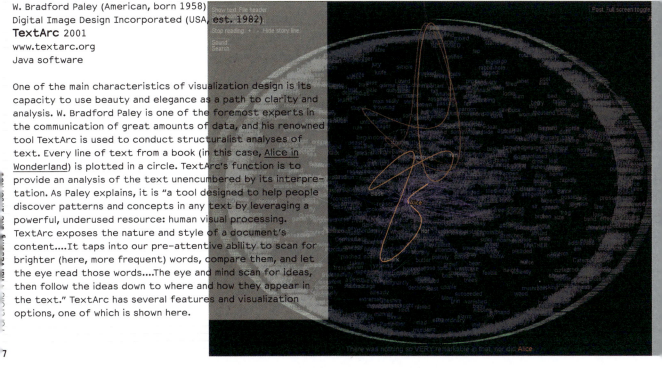

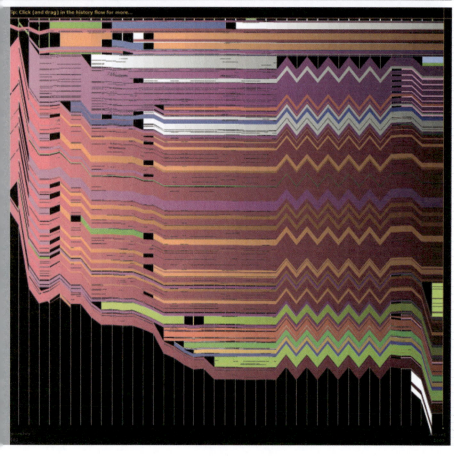

Fernanda Bertini Viégas (Brazilian, born 1971) and
Martin Wattenberg (American, born 1970)
IBM Thomas J. Watson Research Center (USA, est. 1961)
History Flow 2003
www.research.ibm.com/visual/projects/history_flow
Java software

History Flow presents visualizations of the flow of editing
that takes place on all Wikipedia entries. Taking advantage of
Wikipedia's free access to the complex layers of every entry's
contributing history, History Flow maps the entire sequence
of versions of the same entry, providing a chronicle of a not-
always-harmonious collaborative process. The examples shown
here refer to the history of a highly controversial entry—
abortion—on top, and of a very popular one—chocolate—below,
as of 2003. Each color corresponds to a different contributor.
Each vertical line, called a "revision line," corresponds to the
beginning of changed or updated text, while a line's length
indicates the length of the text. The immediate visual reading
of this flow can render with relative precision the level of
debate and controversy surrounding a topic. A deeper reading
using various parameters, such as time, can push the analysis
further, into surprising detail.

Designed by Casey Reas and Ben Fry, formerly of the Aesthetics + Computation Group at the MIT Media Lab, Processing is an open source "programming language and integrated development environment (IDE) built for the electronic arts and visual design communities" based on Java language. Simple enough to be picked up by nonprogrammers and yet sophisticated enough to be used for high-level design, architecture, visualization, and animation projects, Processing has already had a significant impact as a powerful and inspiring design tool. Presented here are only a few of the many new experiments that Processing has sparked.

Demetrie Tyler (American, born 1973)
Interactive Telecommunications Program (est. 1979),
Tisch School of the Arts, New York University (USA, est. 1965)
Hypothetical Drawings about the End of the World 2006
www.demetrietyler.com/hypotheticaldrawings
Processing software

Demetrie Tyler's Hypothetical Drawings about the End of the World are large-format social landscapes inspired by online conversations that contain argumentative and divisive language. These exchanges were found all over the Web by using a Bayesian filter similar to that employed to identify spam e-mail. The images were created using a set of algorithms based on the designer's drawings. The purpose of the work, in the designer's words, is to investigate "the idea that as communities continue to become defined more by common ideologies than common geographies and as ideological contrasts become further exaggerated as a result, we become less able to identify with each other….In other words, the more we choose to spend our time conversing with people who are interested (or worried) about exactly the same things that we are, in relatively tiny but globally dispersed communities, the more we feel like the rest of the world is just plain crazy."

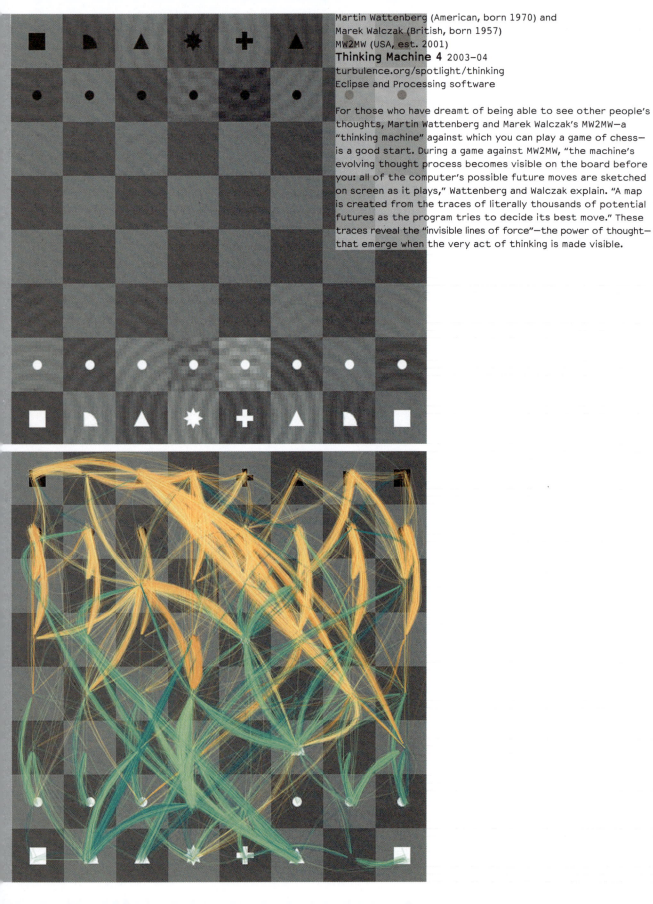

Martin Wattenberg (American, born 1970) and
Marek Walczak (British, born 1957)
MW2MW (USA, est. 2001)
Thinking Machine 4 2003–04
turbulence.org/spotlight/thinking
Eclipse and Processing software

For those who have dreamt of being able to see other people's
thoughts, Martin Wattenberg and Marek Walczak's MW2MW—a
"thinking machine" against which you can play a game of chess—
is a good start. During a game against MW2MW, "the machine's
evolving thought process becomes visible on the board before
you: all of the computer's possible future moves are sketched
on screen as it plays," Wattenberg and Walczak explain. "A map
is created from the traces of literally thousands of potential
futures as the program tries to decide its best move." These
traces reveal the "invisible lines of force"—the power of thought—
that emerge when the very act of thinking is made visible.

Ben Fry (American, born 1975)

Distellamap (Pac-Man) 2004

benfry.com/distellamap

Processing software

Ben Fry's Distellamap is a visualization of the code and data
found in a Pac-Man Atari 2600 cartridge. Fry began "showing"
code with his Dismap project of 2003, in which he rendered
graphically both the executable code of some early computer
games and the data sections that are used to store images
or game scenarios, highlighting not only the mathematical
instructions, but also the commands that would direct jumps
to different locations in the program. In Distellamap, Fry
explains, the code is listed as "columns of assembly language,
most of it either math or conditional statements (if x is true,
go to y). Each time there is a 'go to' instruction, a curve is
drawn from that point to its destination. When a byte of data
(as opposed to code) is found in the cartridge, it is shown as
an orange row: a solid block for a '1' or a dot for a '0.'" With
both Dismap and Distellamap, Fry's intent is not to analyze
the software but rather to celebrate its elegance with an
equally graceful portrait of it.

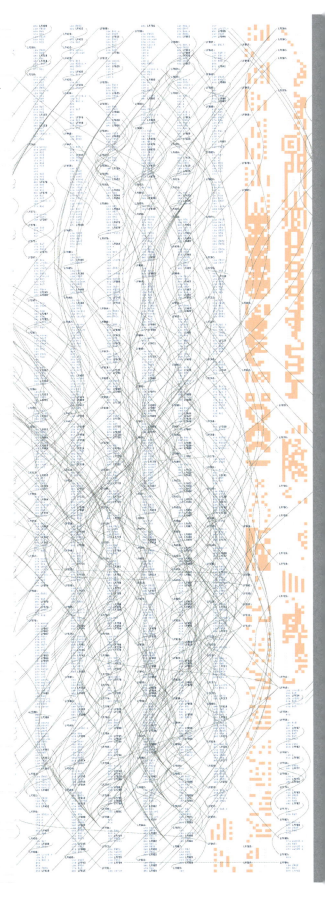

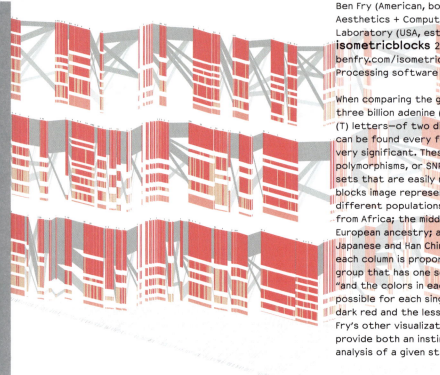

Ben Fry (American, born 1975)
Aesthetics + Computation Group (est. 1996), MIT Media
Laboratory (USA, est. 1980)
isometricblocks 2002/2004–05
benfry.com/isometricblocks
Processing software

When comparing the genomes—and thus the exact order of the
three billion adenine (A), cytosine (C), guanine (G), and thymine
(T) letters—of two different organisms, single letter changes
can be found every few thousand letters and are at times
very significant. These variations are called single nucleotide
polymorphisms, or SNPs, and are often found in consecutive
sets that are easily rendered in blocks. Ben Fry's isometric-
blocks image represents blocks in the genetic profile of three
different populations: the top row shows a group of Yorubans
from Africa; the middle row depicts groups with Western
European ancestry; and the bottom row represents a group of
Japanese and Han Chinese individuals. "The vertical height of
each column is proportional to the number of people in each
group that has one set of changes or another," Fry explains,
"and the colors in each row depict one of (only) two variations
possible for each single letter change, the most common in
dark red and the less common in a paler color." As in many of
Fry's other visualization experiments, diagrams are used to
provide both an instinctive gauge and a progressive in-depth
analysis of a given statistical topic.

Ben Fry (American, born 1975)
Humans vs. Chimps 2005
Processing software

Just how closely related are humans and chimpanzees? It is
widely known that humans and chimpanzees have a common
ancestor, but when the first analytical comparison of human
and chimpanzee genomes was released in 2005, it became official:
Humans are 98.77 percent chimpanzee. Ben Fry's image Humans vs.
Chimps accompanied an article about these findings in Seed
magazine in 2005. In his visualization, Fry shows specifically how
the gene FOXP2 differs in humans and chimps. The gene, a part
of that 1.23 percent difference and believed to be one of the
primary distinctions between humans and chimpanzees, has been
linked to language. All of the nearly seventy-five thousand
letters of the gene are depicted; nine letters—shown with
red dots—indicate the only significant differences.

Brendan Dawes (British, born 1966)
magneticNorth (UK, est. 2000)
Cinema Redux: <u>Serpico</u> 2004
brendandawes.com/sketches/redux
Processing software

Cinema Redux explores the idea of distilling an entire film down
to a single image. Processing software is employed to sample
every second of a movie, and generate an eight-by-six-pixel
image of the frame at that moment. The process is continued
for the whole film, with each row in the visualization represen-
ting one minute of film time. The result is a unique fingerprint
for that film—a visual DNA showing the film's colors and pacing,
as well as the rhythm of the editing process.

Matt Pyke (British, born 1975) of Universal Everything
(UK, est. 2004)
Karsten Schmidt (German, born 1975) of toxi (UK, est. 2000)
Lovebytes 2007 identity generator 2007
festival2007.lovebytes.org.uk/monsters.php
Processing software

The 2007 edition of Lovebytes, an annual international digital
arts festival in Sheffield, England, was devoted to the idea of
process. This theme inspired the Lovebytes identity—a popu-
lation of unique characters, which appeared across all festival
literature. Using a rule-based design system, Matt Pyke and
Karsten Schmidt created "an automated process with the
potential to output an infinite number of designs: A self-
contained 'seed' grows into a multitude of design solutions
automatically, within an environment defined by ranges of
parameters such as hair color, hair length, head shape, eye
shape, and name."

Michiko Nitta (Japanese, born 1978)
Design Interactions Department (est. 1989),
Royal College of Art (UK, est. 1837)
Animal Messaging Service from the **Extreme
Green Guerrillas project** Concept. 2006–07
Paper, ink, and acrylic, 27 × 19 5/8" (68.6 × 49.4 cm)

As the environment becomes a worldwide concern, there is
a lot of pressure on individuals to initiate change. Extreme
Green Guerillas, Michiko Nitta's fictional project, is a community
that proposes radical solutions to these preoccupations. It
acts against both the Internet and wireless communication—
tied as they are to big corporations—and against conventional
postal systems, which leave an immense carbon footprint.
Instead, Extreme Green Guerrillas proposes to send digital
messages by "hacking" into the radio-frequency identification
tags placed by environmental protection agencies on migrating
animals, and turning them into an animal postal service.

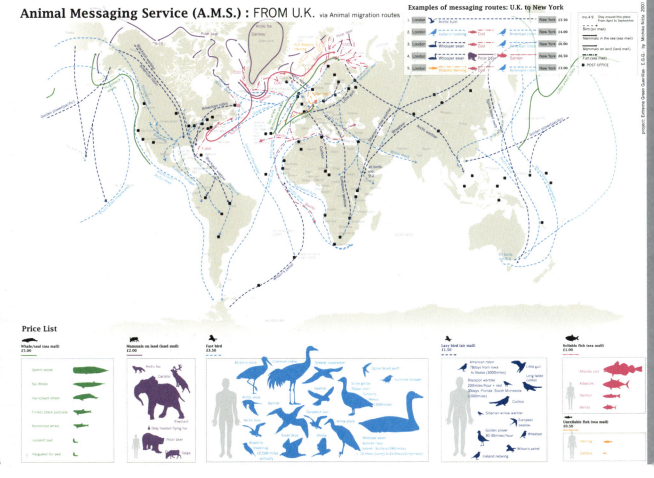

Gavin Jancke (British, born 1970)
Microsoft Research (USA, est. 1991)
Microsoft High Capacity Color Barcode
Prototype. 2004–ongoing

The mapping and tagging of information rely on the increasing capacity and decreasing size of computer chips and other data reservoirs. The High Capacity Color Barcode, developed by Microsoft Research engineering director Gavin Jancke, is a new barcode system capable of holding much more retrievable information than current UPC codes. It is composed of triangles of eight different colors arranged from left to right. The new barcode will be useful not only to vendors but also to consumers, who will be able to scan the barcode and obtain such information as product ratings, promotions, and pricing.

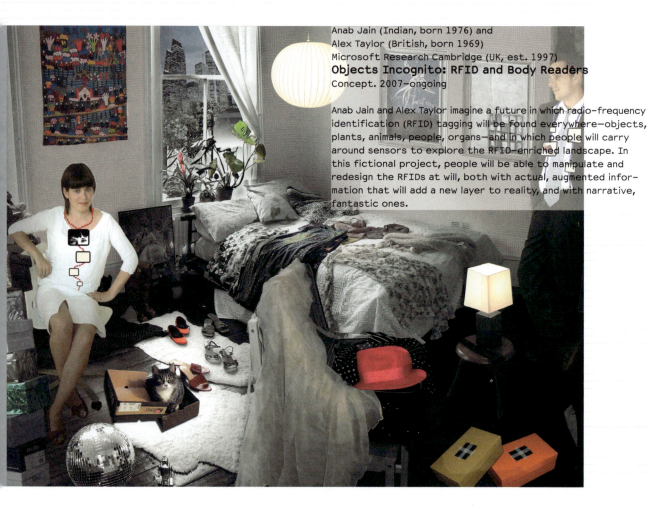

Anab Jain (Indian, born 1976) and
Alex Taylor (British, born 1969)
Microsoft Research Cambridge (UK, est. 1997)
Objects Incognito: RFID and Body Readers
Concept. 2007–ongoing

Anab Jain and Alex Taylor imagine a future in which radio-frequency identification (RFID) tagging will be found everywhere—objects, plants, animals, people, organs—and in which people will carry around sensors to explore the RFID-enriched landscape. In this fictional project, people will be able to manipulate and redesign the RFIDs at will, both with actual, augmented information that will add a new layer to reality, and with narrative, fantastic ones.

Miquel Mora (Spanish, born 1974)
Design Interactions Department (est. 1989),
Royal College of Art (UK, est. 1837)
Flat Futures: Exploring Digital Paper Models. 2007

Smart Tapes
Paper and adhesive tape, 2 × 3 7/8" (5 × 10 cm)

Memory Envelope
Paper and adhesive tape, 8 5/8 × 4 3/8" (22 × 11 cm)

Relying on the latest developments in organic electronics—
which studies conductive polymers as opposed to the tradi-
tional non-carbon-based copper and silicon—and on methods
of using nanotechnology to print dynamic electronics, Miquel
Mora explores ways to create processors, displays, and
batteries on surfaces as flat and flexible as paper. "Objects
will wear technology instead of carrying it inside," explains
Mora. "The technology will become their skin." In Smart Tapes,
a range of electronic components (such as processors,
batteries, speakers, and displays) are printed on adhesive
tapes, allowing a user to "enhance an existing product, making
it smart, or create a new one." Memory Envelopes and Memory
Probes are mailing envelopes and add-ons that record and
display their journey, offering their own narrative memory.

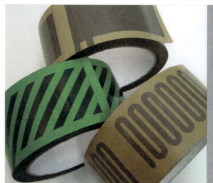

Raúl Cárdenas-Osuna (Mexican, born 1969)
Torolab (Mexico, est. 1995)
LRPT (La Región de los Pantalones Transfronterizos)
Prototype. 2005–06
Global positioning system, MaxScript, and 3d MAX software

"LRPT is a document of urban ethnography that proposes a new form of cartography for the transborder region between Mexico and the United States," explain the members of Torolab, an architecture and art collective based in Tijuana, Mexico. The designer chose five people settled on either side of the border and developed different "transborder clothes" for each of them. A GPS tracking system was integrated into the garments, which stem from Torolab's Toro Vestimente clothing line that addresses transborder identity and inter- action. For five days, as the participants moved through the Tijuana–San Diego region, Torolab tracked their locations, velo- cities, and fuel consumption. The results from the collected data trace the participants' migration on a topographic urban/natural structure where the geographic and political boundaries are left unmarked.

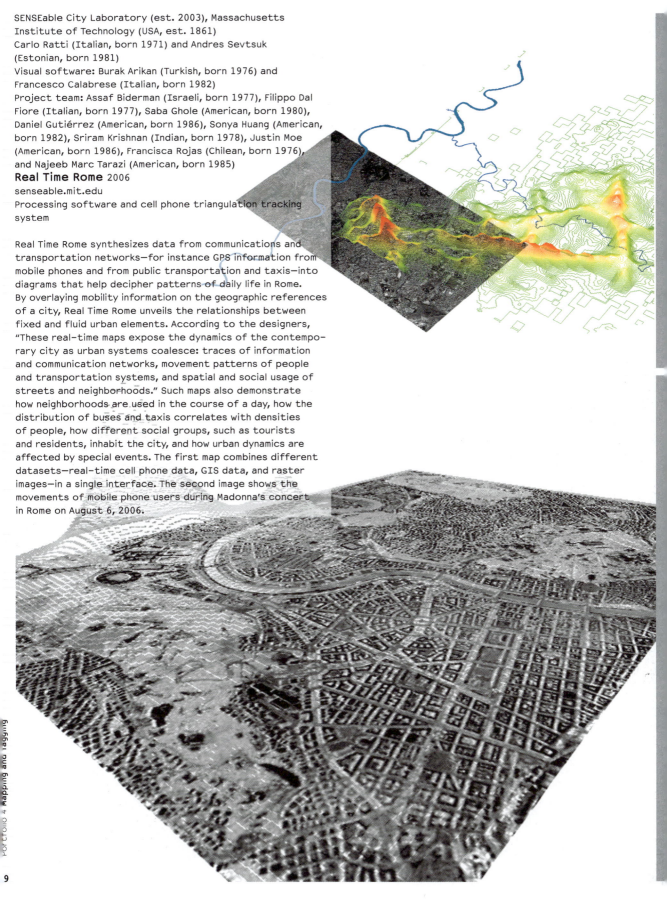

SENSEable City Laboratory (est. 2003), Massachusetts
Institute of Technology (USA, est. 1861)
Carlo Ratti (Italian, born 1971) and Andres Sevtsuk
(Estonian, born 1981)
Visual software: Burak Arikan (Turkish, born 1976) and
Francesco Calabrese (Italian, born 1982)
Project team: Assaf Biderman (Israeli, born 1977), Filippo Dal
Fiore (Italian, born 1977), Saba Ghole (American, born 1980),
Daniel Gutiérrez (American, born 1986), Sonya Huang (American,
born 1982), Sriram Krishnan (Indian, born 1978), Justin Moe
(American, born 1986), Francisca Rojas (Chilean, born 1976),
and Najeeb Marc Tarazi (American, born 1985)
Real Time Rome 2006
senseable.mit.edu
Processing software and cell phone triangulation tracking
system

Real Time Rome synthesizes data from communications and
transportation networks—for instance GPS information from
mobile phones and from public transportation and taxis—into
diagrams that help decipher patterns of daily life in Rome.
By overlaying mobility information on the geographic references
of a city, Real Time Rome unveils the relationships between
fixed and fluid urban elements. According to the designers,
"These real-time maps expose the dynamics of the contempo-
rary city as urban systems coalesce: traces of information
and communication networks, movement patterns of people
and transportation systems, and spatial and social usage of
streets and neighborhoods." Such maps also demonstrate
how neighborhoods are used in the course of a day, how the
distribution of buses and taxis correlates with densities
of people, how different social groups, such as tourists
and residents, inhabit the city, and how urban dynamics are
affected by special events. The first map combines different
datasets—real-time cell phone data, GIS data, and raster
images—in a single interface. The second image shows the
movements of mobile phone users during Madonna's concert
in Rome on August 6, 2006.

All Together Now!
Paola Antonelli

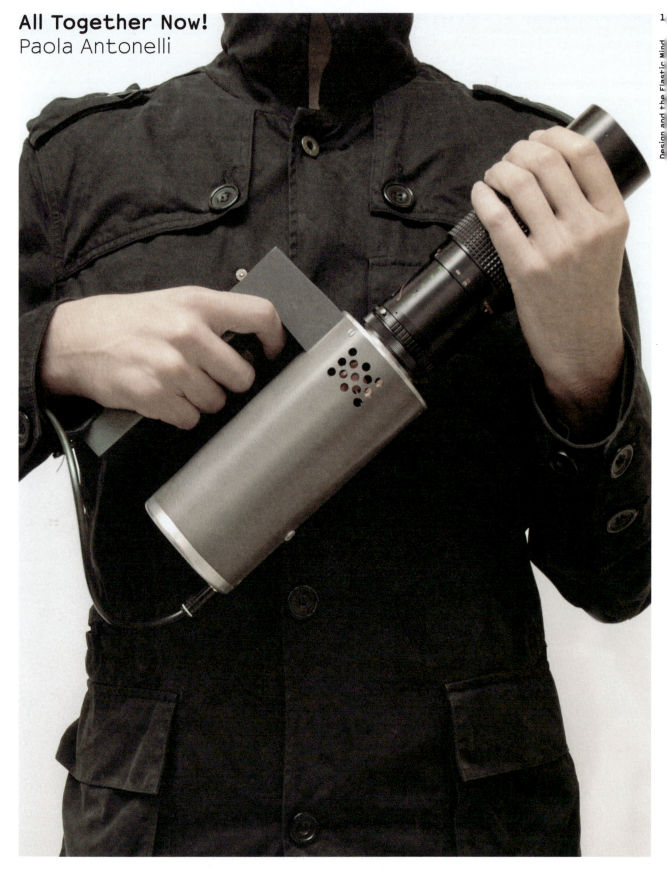

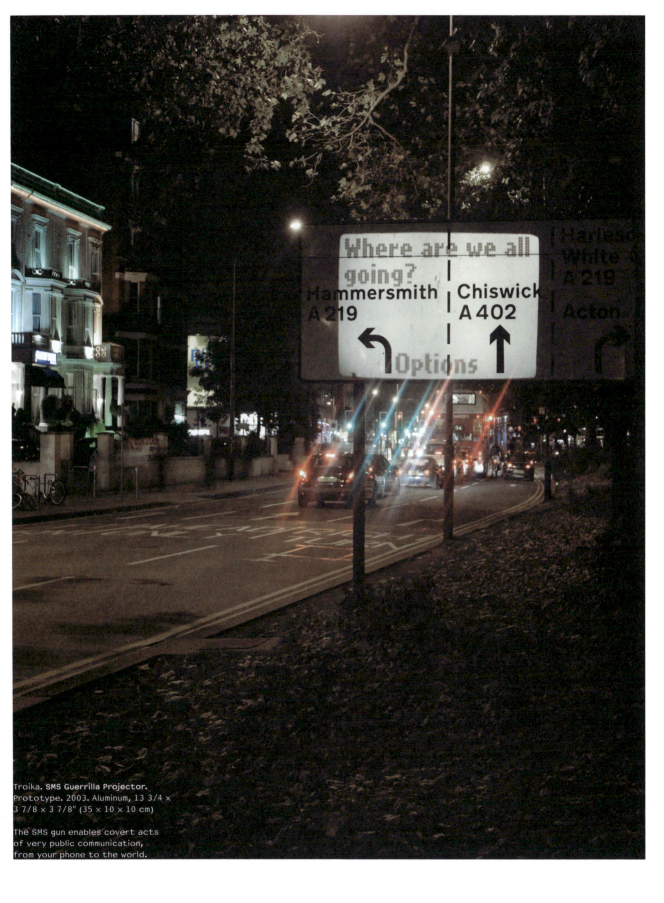

Troika. **SMS Guerrilla Projector.**
Prototype. 2003. Aluminum, 13 3/4 ×
3 7/8 × 3 7/8" (35 × 10 × 10 cm)

The SMS gun enables covert acts
of very public communication,
from your phone to the world.

Communities, as they used to be called before the term became frayed by overuse, today are groups whose homogeneity is no longer easily described by historical definers of age, gender, race, class, region, or religion, but rather by a shared interest or passion. Design supports them by providing the modeling data, the language, and the objects that give access to connective networks. Designers create computers, mobile communicators, cell phones, and the interfaces that run on these and other devices—on the objects that will give us access to functions, to information, and to other people like us. Since these objects will be used by a wide cross section of people with different knowledge and customs, designers' attention is focused on traits common to as many cultures as possible, such as instinctive gestures (the interfaces of the Nintendo Wii and Apple iPhones, for instance) or recognizable images (such as the ideograms used in the interface of the project One Laptop per Child or in the toolbars of most computer programs). Paradoxically, the use of archetypes and attention to the spiritual and sensual dimension of life are both a welcome respite from the fast pace of progress and fundamental features of the most technologically and intellectually advanced forms of design.[1]

One of the most compelling phenomena in the evolution of society is what has happened to the balance between the individual and the collective spheres. The concept of privacy has mutated to signify not seclusion but a selective way to make contact with other human beings, with the rest of the world, and with ourselves. Not only has the idea of privacy shifted, but so has the idea of individuality. A famous 1993 New Yorker cartoon by Peter Steiner showed one pooch in front of a computer explaining to another, "On the Internet, nobody knows you're a dog." And nobody knows I'm a woman, you're a man, she's sixty-two, they are CIA agents or terrorists, and he's a sexual predator: Through screen names and virtual alter egos, we build parallel-universe relationships that are sometimes more engaging or dangerous than the ones we can have as our real selves. In the physical world, all the while, individuals are able to build force fields that help isolate them within a crowd by using small devices such as an iPod or a BlackBerry, harvesting energy by carrying a backpack covered with solar cells, and soon even modulating a personal climate control by means of smart materials.[2] As avatars and ghosts, we are followed by private cones—protective spaces of silence, anonymity, and invisibility—so we can selflessly plunge into the ocean of "collective genius" while jealously protecting our personal territory.[3]

To cope with this helter-skelter, objects have had to become lighter and more elastic. The new category of objects designed to provide access to networks and services are meant, as John Thackara states, to be used, not owned.[4] From the appearance of services

Constantin Boym and Laurene Leon Boym. Boym Partners, Inc. **Babel Blocks.** 2007. Wood, 6 × 1 1/2 × 3" (15 1/4 × 3.8 × 7.6 cm)

A collection of wooden figures that represent New York City's cultural and religious diversity, Babel Blocks are a message of tolerance and understanding. The first collection is devoted to New York's Lower East Side, and each character has a name and a MySpace page.

The Family Planning Association of Hong Kong. **Tak Tak Sexual Education Dolls.** 1997. Cotton, 23 × 10 × 5" (58.4 × 25.4 × 12.7 cm)

Where did children once come from? Educational tools from our recent past.

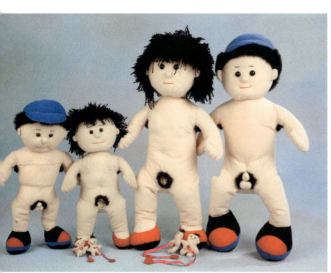

that allow subscribers to share cars and bikes for short-term rentals to the lively and engrossing debate about changing copyright laws or lifting them altogether,[5] open source—a reservoir of information and resources that anybody can use freely and that gets updated and improved by the same users, who give back according to their expertise and experience—has gone from militant ideology to accepted practice.

Humans are forever seeking a comfortable space to inhabit, from an ideal home to an ideal city. Today, the engine that drives our choice of a space to occupy is the search not only for security, protection, and privacy but also for connection. Sharing information and data, forming groups of interest, linking computers and people in wireless networks whose potency grows with the number of users, or collaborating openly on projects as disparate as software programs and charity drives has become the modus operandi at all levels of industrial development and income. There's no place like home, and in the networked age a familiar interface, with all its windows wide open, albeit protected by invisible gates, will do just fine.

The spaces that we find most comfortable are the ones that are designed to accommodate openness and human expansion, and their functionality lies in their capacity to initiate a chain reaction that transcends physical boundaries. The following portfolio explores the modulation of the relationship between individuals and groups by introducing the concept of Existenz-maximum and by examining the impact that virtual and real communities, ubiquitous connection, and the open-source movement are having on design and on the world.

Existenzmaximum

When it was introduced in 1978, the Walkman obliterated long-held beliefs about the human body and the space it inhabits. Its buttons and magnetic heads could magically switch on a portable, individual bubble, a personal environment customizable with the tune of a song. The Walkman marked the beginning of a revolution that has touched numerous facets of our existence, sparked by smaller and smaller electronic and digital devices that can expand one's private space well beyond the physical space occupied by one's public body.

This ongoing transformation is an unintended consequence of technology's leap toward portability and miniaturization. I call it Existenzmaximum (or, tenderly, XMX, not to be confused with the Windows utility),[6] a term coined in response to Existenzminimum, the early twentieth-century German architectural doctrine that defined a person's minimum needs in terms of space and consumption.[7] With a precision that was still Euclidean but that already announced fractal geometry's defiance of scale, these architects organized functions within rooms, rooms within dwellings, dwellings within buildings, buildings within quarters, and quarters within cities with lucidity and

purpose, in an attempt to create a more efficient and wholesome environment in which all human beings, at all levels in society, would thrive.

Over time, Existenzminimum grew to be formulaic and identified with a lower-quality version of high-density life, and it became unintentionally responsible for famously unlivable projects on the outskirts of cities worldwide. In gentler applications, this approach to designing and building became a standard recipe in the planning of private spaces for the lower and middle classes, and has survived even longer in the design of offices and other technical spaces. However, ideas popularized in the 1960s and early 1970s made this inert concept, like many others, burst at its seams: With the introduction of thermoplastic materials—which invited and demanded fluidity—and with the dynamic work of such diverse designers as Joe Colombo, the Archigram group, the Japanese Metabolists, and the Viennese collective Haus-Rucker-Co., to name just a few, came the revolutionary concept of expanding, growing, breathing, walking, and digesting structures and cities. At the same time, over the course of the twentieth century Existenzmaximum was preparing for its conquest with the introduction of new means of communication that rendered the home more permeable to the outside world, beginning with the telephone, then the radio, and eventually the television.[8] Existenzmaximum takes advantage of the advent of new organic metaphors, of the move from anthropometrics to biomorphism that happened when the 1:1 scale ratio of the human body could be transcended by means of miniaturization, portability, and, ultimately, wireless technology.

The move from minimum to maximum echoes the twentieth century's intellectual evolution from the dream of a better society based on objective, almost mathematical rules of distribution of space and resources to the idea of a self-organizing, bottom-up society in which individual initiative can shape a more just and efficient world. The two concepts have often been seen as conflicting, but there is a possi-bility that the newest advances of technology could offer a third way of approaching not only architec-ture but also social engagement. XMX begins with a small object that can be worn or carried, and which enables us to inhabit a comfortable space whose boundaries are protective rather than oppressive. While it lets the senses and the imagination roam free, it filters the outside world selectively. The object can block or produce only sound, or sound and vision, with more senses soon to come—videogames are already equipped with peripherals that integrate the sensorial experience with variations in temperature or even, provocatively, the experience of real pain (see p. 33), while targeted digital olfactory delivery systems are being studied by nearly every major fragrance corporation in the world. The era of Existenzmaximum is upon us, and BlackBerries, iPods,

Günther Zamp Kelp, Laurids Ortner, and Klaus Pinter. Haus-Rucker-Co. **Flyhead Helmet** from the **Environ-ment Transformer project.** 1968. Polyethylene and aluminum, 12 7/8 × 15 3/4 × 11 1/2" (32.7 × 40 × 29.2 cm). Manufactured by Dovoplast, Austria (1968)

The design collective Haus-Rucker-Co. was among the first poets of Existenzmaximum.

Jarkko Saunamaki. Nokia Research Center, Nokia Design. **Nokia Morph flexible communication and sensing device.** Concept. 2007. Communication unit: 2 3/8 × 2 3/8 × 1/4" (6 × 6 × 0.6 cm); display unit: 7 3/8 × 4 1/2 × 1/4" (18.7 × 11.5 × 0.5 cm)

Tags and portable devices will make the world into a live information platform.

3G mobile phones, and Bluetooth headsets are just its first rudimentary manifestations.

The five senses, the delicious vulnerability of the body, and the intricacies of human interactions are welcome and necessary ingredients of technological progress. In fact, extreme technological innovations can even help us reconnect with some of the pillars of human nature. For instance, while the introduction of the telephone made long-distance communication possible, albeit only in the acoustic dimension, VOIP (Voice Over Internet Protocol) telephones coupled with cameras attached to computers have given us back the option of a face-to-face conversation. Beyond the five senses, the products of these innovations also recall the dense and magical objects of mythology, literature, and personal lore that transcend time and space and open hidden doors into lateral dimensions, from the philosopher's stone to the Holy Grail. However, the iPhone is not comparable to the Ark of the Covenant or Marcel Proust's madeleine; it is an attainable object that is devised by humans and highly dependent on the design of its interface. The interface is a home, and as such it is subject to the same very personal stylistic, architectural, and intellectual choices one would reserve for one's dwelling. Mittel-European modern or New England? Mac or PC?

Here, There, and Everywhere

A pillar of Existenzmaximum is wireless technology, mobile phones in particular. People need to move unhindered, through highway tollbooths and airport check-in counters alike, and to carry their network with them at all times. These days mobile phones are not a communication alternative but rather the standard, and they are no longer simply telephones but communication and interaction enablers. They have an enormous impact on the way we live and how we relate to each other. Different parts of the world take advantage of them in different ways—the United States being among the most rudimentary, unimaginative, and latest adopters. In most of the world, the competition among companies is not focused on the lowest incidence of dropped calls, as it is here, but on the accessibility of sophisticated services for paying for car parking, sodas, and bus rides and even making charity donations, and for banking, accessing home security systems, locating other mobile phones by GPS, reserving books in libraries, and much more. According to a 2007 study commissioned by the Japanese mobile communications company NTT DoCoMo, there are 2.5 billion mobile service subscribers in the world, and soon eighty-five percent of the world's population will use cell phones, including the inhabitants of parts of the globe that have never been linked by landlines.[9] Wireless carriers do not see themselves merely as communication or information technology companies but as lifestyle providers.

The research departments of these companies

employ some of the world's brightest minds in an effort to anticipate the future of human communication. In addition to NTT DoCoMo's prolific Mobile Society Research Institute, which produced the extensive report on mobile living referenced above, anthropologist Jan Chipchase at Nokia has conducted a study of how people carry their phones and Stefana Broadbent, who leads the User Adoption Lab at Swisscom, has been considering the "usage patterns associated with different communication technologies,"[10] shedding light on people's use of the different options at their disposal. Interestingly, Broadbent discovered that the dream of convergence of all types of communication within one device is far from real, and that people instead use e-mail, mobile phones, fixed lines, Instant Messaging (IM), and Short Message Service (SMS) in different ways and for different purposes.[11]

The NTT DoCoMo research in particular, with its wide angle, concludes that wireless technology has penetrated all aspects of life, creating an "informative, connected, culturally innovative, participative, and converging society."[12] A bit self-serving in its optimism, perhaps, the NTT DoCoMo study nonetheless convincingly outlines numerous positive effects that mobile phones have already had on the collective sphere. First comes the faster distribution of information, as SMS is more effective and quicker than e-mail messages, especially when it comes to emergency advisories and messages of social urgency.[13]

As often happens with the introduction of new technologies, mobile phones are responsible for other cultural phenomena, from the creation of the signature abbreviated language used in text messages and 3GP videos to the introduction of mobile phone novels (in China) and even SMS prayers (in India). Moreover, the research highlights how mobile phones help to build activist societies with common interests, ranging from dating clubs to groups engaged in social causes, which use mobiles not only to exchange information but also to send financial contributions and set up help lines. Individuals use their power to gain access to a universe of social engagement.

When it comes to the individual sphere, mobile phones embody a new notion of privacy, helping people manage their lives and relationships with technology as a filter and dedicate more and better-quality time for traditional and humane communication. Researcher Kate Fox compares mobile phones to the small-town garden fences that define territory while inviting friendly communication and "fluid connectivity."[14] Moreover, they allow women more freedom to work by enabling a "remote control" connection with children, the elderly, and other household responsibilities, especially in more conservative societies where such duties are considered their exclusive responsibility. Mobile phones are a boon for teenagers in cultures where they could not date without parents' approval.

PlayPumps International. **PlayPumps play-powered water system.** 1994–ongoing. Galvanized steel, plastic, and concrete, water storage tank tower: 25' (762 cm) height; merry-go-round: 32" × 9' 10" (75 × 300 cm) diam.

Unity also makes people stronger in the physical world.

In more permissive countries, they are quintessential self-definers.[15] A mobile phone is akin to a watch or a private diary, a name necklace or a pet, a weapon or a coquettish fan, a no-trespassing sign or a secret passageway to the rest of the world. It is a meaningful object that has to work extremely well and be stylistically distinctive. Its interface has to be clear and innovative, and since its navigation is akin to movement through the spaces of a networked city, it requires a design approach that embraces it as a product, a graphic display, and an architecture that can be explored and inhabited.

The Common Good
On any given day of your life, try to recount the times you have read or heard expressions like "collective intelligence," "collective genius," or "connected intelligence" and paraphrases or alliterations thereof.[16] The enthusiasm for the spontaneous coming together of productive and well-intentioned minds is announced in works such as James Surowiecki's Wisdom of Crowds, Judith Donath's "Public Displays of Connection," and Smart Mobs, by Howard Rheingold, whose blog declares his interest in "mobile communication, pervasive computing, wireless networks, collective action."[17] All of these manifestations can be traced back to the idea of open source, and are symptomatic of the current interest in a multinodal and decentralized distribution of knowledge and of the simple belief that an ocean of minds is better than one.

The open-source phenomenon, which has its roots in the world of computer software, has now embraced the whole spectrum of human production, from music to movies (see p. 166), car design (p. 167), and the building and occupation of alternative worlds (p. 175).[18] Its success has surprised cultural commentators because of its apparently harmonious, self-organizing structure. Illustrious examples and enthusiastic testimonials are brought by luminaries of different fields, such as engineer Cecil Balmond and the firm that employs him, Arup, and physicist Neil Gershenfeld, the director of MIT's Center for Bits and Atoms and founder of the Fab Lab initiative.[19] Mind you, sometimes the source is not completely open: Discographic and pharmaceutical companies in particular do not always see eye-to-eye with their enthusiastic samplers, and we have known since Plato that democracy is not always the best governing model for humankind. Well-publicized disputes and improprieties abound in Wikipedia, yet, perhaps because they celebrate every person's contribution, "wikis" remain one of the most referenced examples of the power of open source, for good or for bad.[20] Google Earth, although not literally open source, is nonetheless an open platform that people can use to passionately map and tag the world for everyone to see, while virtual universes such as Second Life allow people to design a new

world together—and then cordon it off to strangers. However, the case study that put open source on the cultural map was the Linux operating system,[21] and the most successful examples of its use are still software programs such as Mozilla's Firefox browser,[22] Ben Fry and Casey Reas's graphic design program Processing, several applications of which are shown in this volume, and the sophisticated object-modeling program Unified Modeling Language.[23]

In the design of objects, the concept of open source walks hand in hand with the progress of rapid manufacturing (RM) techniques. By transmitting data directly from a computer file to the manufacturing machine, RM allows for countless modifications of the original design. In the 1980s, when it was introduced, RM produced friable sculpted foam models. Today, RM machines take seven days to print a solid chair, but in a few years they will take seven hours, and in a few more, seven minutes. It is plausible to think that in the future anyone will be able to access via the Internet the matrix design of a chair, a radiator, or even a car, and customize it, though still within set parameters dictated by functionality, safety, and branding. This will transform design, production, distribution, and shopping in radical ways.

The difference between prototype and mass production will become moot, as every object will be at the same time a prototype and an element of a diversified series. Some designers will choose to retain their traditional role and delete the original file after a few prints or keep control over most of the variables, but others will instead graduate to a new position as design tutors. They will be working not on single objects but instead on whole families of objects and on design systems. Manufacturers will host forums in which they will communicate with and learn from their customers, perhaps even redrawing their business plans based on such exchanges. Some might invest in chains of RM stores where customers' orders are printed on demand, thus eliminating the need for trucking and warehousing. This approach would eliminate the waste of resources and space, but unfortunately also eliminate end-of-season sales.

A New Etiquette

Prototype and series, individual and collective, single object and families of objects: In order to take full advantage of what the future holds, the connected world will need to develop a set of rules that will ensure respect and trust between individuals and among groups. Left to their own devices, humans and companies tend to be rude and territorial. Here are just a few examples of obstacles in the way of true collective thought and action, to set our minds in motion.

First, a very mundane example of one versus many. Existenzmaximum promises to help ease the strain caused by the increasing density of cities: Lost in their metaphysical individual universes, people are

Lucas Maassen. Untitled Nations. **Sitting Chairs.** 2004. MDF and solid oak, various dimensions

Designers will work not on single objects, but rather on families of objects.

less mindful of physical overlaps on a train, in an open office, or in a queue. In an ideal XMX world, my space does not end where yours begins, but rather the two can coexist and overlap. However, the Existenzmaximum object par excellence, the mobile phone, has broken this idyll. Mobile conversations can be in-your-ears acts of defiance akin to boom boxes of times past, and they have prompted innovative solutions such as quiet cars on trains. While waiting for a new book of manners, fight back with a more powerful XMX device, such as first-rate noise-canceling headsets. Don't leave home without them.

Second, the thorny issue of patent holders versus the world. Two parties face each other, one holding the position that patents and copyrights are necessary to guarantee funding and motivation for research and development—of medications, music, technology, even naming—the other stating that patents and copyrights stifle creativity and economic development and the public domain is a better place for the future of the world to be.

Last but not least, the case of country versus country. Different standards of measurement, broadcasting, and communication are the last vestiges of protectionism, symbols of a world that is not yet completely open source. While cultural diversity is vital to an open-source world, communication standards are the basis of the new global etiquette.

If these obstacles can be overcome, perhaps we will witness design from the bottom up on a massive scale. This has already begun as an outlaw phenomenon, with a few early adopters hacking into their devices —DVD players for example—to make them universally compatible. As the numbers of such individuals grow, we will reach a critical mass that will topple the few unreasonable techno-walls still in place. For the first time in history, a crowd of billions of individuals will be able to unite the power of common sense and the imaginative vision of personal initiative with the most advanced principles of design wisdom.

Notes

1.

Some experiments dealing with social behavior, memory, and loss, such as Synnøve Fredericks's and IDEO's brushes with new etiquette (pp. 170–71) and Michele Gauler's and Auger/Loizeau's work on death (pp. 184–85), are particularly touching and emblematic.

2.

Architect and engineer Michele Addington, faculty at the Yale School of Architecture, is experimenting with the use of smart materials and microelectromechanical systems (MEMS) that will attune buildings and spaces to their environments and will help them modulate the energy they need at any given moment.

3.

In the May 2007 issue of Atlantic Monthly, James Fallows highlights the fact that computers are still often called "personal," but in reality they are used mostly to work with other people. Fallows, "Group Therapy", Atlantic Monthly, (May 2007): pp. 136–37.

4.

John Thackara, In the Bubble: Designing in a Complex World (Cambridge, Mass.: MIT Press, 2005), pp. 81–121. In his introduction to the book, Thackara states: "Objects, as a rule, play a supporting role....The design focus is overwhelmingly on services and systems, not on things" (p. 4).

5.

The debate over copyright is an ongoing saga that pitches those who argue that copyright is necessary to guarantee authors' control over their work against those who consider it an obstacle to a free and fruitful exchange of ideas. Creative Commons (creative commons.org), a leading organization fighting for a radical reform of copyright mores, is a nonprofit that offers an alternative to copyright by letting "authors, scientists, artists, and educators easily mark their creative work with the freedoms they want it to carry." You can use it to change your copyright terms from "all rights reserved" to "some rights reserved." Creative Commons licenses can be found in work by musicians David Byrne and Brian Eno and writer James Boyle. For more on copyright, see also Lawrence Lessig, The Future of Ideas: The Fate of the Commons in a Connected World (New York: Random House, 2001).

6.

Paola Antonelli, "Existenzmaximum," Big Magazine 24 (2001): pp. 32–35.

7.

For an in-depth treatment of this topic, see Internationale Kongresse für Neues Bauen/Städt. Hochbauamt Frankfurt/M. (1930): Die Wohnung für das Existenzminimum. Frankfurt/M: Englert & Schlosser.

8.

In 1927, German philosopher Martin Heidegger in his major work Sein und Zeit (translated in 1962 as Being and Time) reflected on the disruptive consequences of the introduction of the radio, which, he said, would eliminate "the time of situated history."

9.

Mobile Government Consortium International, "Positive Contributions of Mobile Phones to Society," research report for the Mobile Society Research Institute, NTT DoCoMo, Inc., February 28, 2007. According to Japan's Corporate News and Marketwatch, NTT DoCoMo, with 51 million subscribers and 56 percent of the market, is the largest wireless communication company in Japan. A few interesting facts from the study: In São Paulo in 2006 there were more mobile phones than either landlines or Internet connections; the same thing was true in China in 2003. India is one of the fastest-growing markets: Now landlines are for the rich and cell phones for the common people, such as milkmen and vegetable vendors and all the other workers who have traditionally been mobile and are now freed from spatial constraints. Lithuania, with a population of 3.4 million, boasts 3.7 million mobile phones with an amazing spread of services provided, including banking, car parking payment, home security, and mobile locator, and with 98 percent of the country covered. In Korea, more than 81 percent of the population has access to multimedia mobile communication services, and these services have contributed to the development of both individual initiative and collective engagement, as well as the government-supported idea of a ubiquitous network covering the whole territory—called u-Korea.

10.

"Home Truths About Telecoms," Technology Quarterly, special section in The Economist, June 9, 2007, p. 16.

11.

"The fixed-line phone 'is the collective channel, a shared organizational tool'....Mobile calls are for last-minute planning.... Texting is for 'intimacy, emotions, and efficiency.' E-mail is for administration and to exchange pictures, documents, and music. Instant-messaging (IM) and voice-over-Internet calls are 'continuous channels,' open in the background while people do other things." Ibid.

Sebastien Noel. Troika. **Exploded Monologues wearable voice-amplifier device.** 2003. Aluminum and electronic components, 37 3/8 × 37 3/8 × 19 3/4" (95 × 95 × 50 cm)

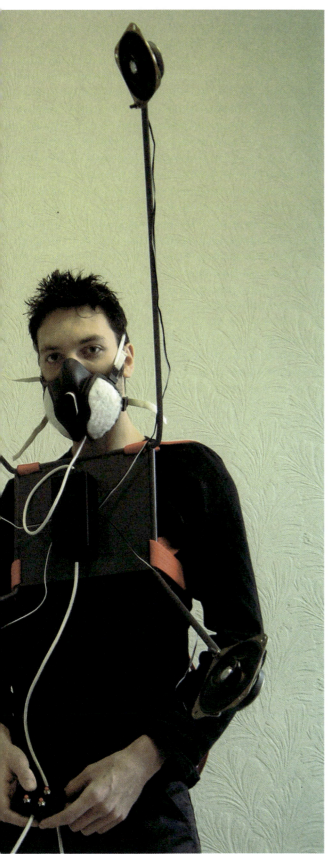

12.
"Positive Contributions of Mobile Phones to Society," p. 2.

13.
Following the catastrophic tsunami in December 2004, India, Indonesia, Sri Lanka, and Thailand have begun to set up an SMS warning system, and SMS has also been used to spread information about SARS and AIDS, social equality, and political candidates, as well as to bridge geographic gaps created by war.

14.
Kate Fox, "Society: The New Garden Fence," in The Mobile Life Report 2006. How Mobile Phones Change the Way We Live (London: The Carphone Warehouse, 2006).

15.
Teenagers in England consider cell phones and SMS more important than the Internet, and from the ring tones to the hardware and interface and even the accessories available, every choice is a statement of style and an expression of identity.

16.
"Collective intelligence" can be described as the wisdom and perceptiveness that comes from the coexistence and collaboration of many individuals. It seemingly has a mind of its own and is often more precise and efficient than individual intelligence. Among the texts that consider this topic are Peter Russell's The Global Brain (Los Angeles: J.P. Tarcher, 1983), Tom Atlee's The Tao of Democracy: Using Co-Intelligence to Create a World That Works for All (Cranston, R.I.: The Writers' Collective, 1993), and Pierre Lévy's L'Intelligence collective: Pour une anthropologie du cyberespace (Paris: La Découverte, 1994). Steven Johnson's Emergence: The Connected Lives of Ants, Brains, Cities, and Software (New York: Scribner, 2002) is an engrossing read on "connected intelligence."

17.
James Surowiecki, The Wisdom of Crowds (New York: Doubleday, 2004). In her article, Donath explores "the social implications of the public display of one's social network" in social sites on the Internet; Judith Donath, "Public Displays of Connection," BT Technology Journal 22, no. 4 (October 2004): pp. 71–82. Howard Rheingold, Smart Mobs: The Next Social Revolution (New York: Perseus Books Group, 2002); Rheingold's blog is www.smartmobs.com.

18.
As a strategy to improve source software by making it legible and available to members of user groups, open source harks back to the 1950s and to IBM's SHARE group. The term was coined by Christine Peterson of the Foresight Institute, at a meeting with Eric Raymond, Larry Augustin, and a few others, in Silicon Valley in 1998, and canonized a few weeks later at the O'Reilly freeware summit, where people proposed names, voted, and agreed to abide by the results.

19.
Balmond's and Arup's embrace of open collaboration as vital to both creativity and engineering precision is well portrayed in David Owen's article "The Anti-Gravity Men," New Yorker, June 25, 2007, p. 72. Fab Labs, popping up all over the world and already open in India, Norway, Ghana, and Costa Rica, are educational offsprings of the Center for Bits and Atoms where pupils can learn practical engineering with the support of the appropriate software and hardware, including precision tooling and rapid manufacturing machines, and apply it to everyday problems.

20.
A "wiki" is a Web site that can be visited and easily edited by anyone via a Web browser. People contribute by adding to or amending previously written entries, creating a layered system of edits that visualization expert Martin Wattenberg, in his project History Flow (p. 138), with Fernanda Bertini Viégas, renders almost like a formation of geological sediment.

21.
Linux is an operating system that was created by Finnish student Linus Torvalds. His work began in 1991, and the first version of the software was released in 1994. The kernel of the Linux system "is developed and released under the GNU (acronym for "GNU's Not Unix") General Public License and its source code is freely available to everyone," the Linux Web site says. Because it is adaptable and flexible, Linux, now in version 2.6, is at the basis of innumerable computer systems all over the world.

22.
Mozilla, involved in the creation of Mosaic, continues its fundamental role in the history of open source. Its most used program is the Firefox Web browser, but several other programs are also available for free download.

23.
The program is also supported by the nonprofit organization Object Management Group.

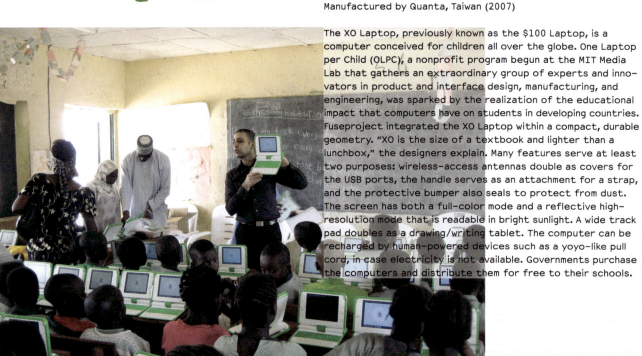

Antenna With Integrated Seal and Latch
Antenna Seal
Latch Catch
Side Monitor Frame/Seal
Game Controller
Display Toggle
LED Keypad Lights
Keypad
Monitor Bumper
Slide Latch
Track Pad
Control Buttons
Slide Latch
Keyboard Frame/Seal
Keyboard Base
Hinge Cover
LED Indicators
Power Button
Game Control Buttons
Side Monitor Frame/Seal
Camera
Microphone
Latch Catch
Antenna With Integrated Seal and Latch
Monitor Frame/Seal Top

Nicholas Negroponte (American, born 1943), Rebecca Allen
(American, born 1953), Mary Lou Jepsen (American, born 1965),
Mark Foster (American, born 1960), Michail Bletsas
(Greek, born 1967), and V. Michael Bove (American, born 1960)
of One Laptop per Child (USA, est. 2005)
Yves Béhar (Swiss, born 1967) and Bret Recor
(American, born 1974) of fuseproject (USA, est. 1999)
Jacques Gagné (Canadian, born 1959) of Gecko Design
(USA, est. 1996)
Colin Bulthaup (American, born 1976) of Squid Labs
(USA, est. 2004)
John Hutchinson (South African, born 1952) of Freeplay
Energy Plc. (South Africa, est. 1996)
Quanta (Taiwan, est. 1988)
XO Laptop from the **One Laptop per Child
(OLPC) project** 2005–ongoing
PC/ABS plastic and rubber, 9 1/2 × 9 × 1 1/8"
(24.2 × 22.8 × 3 cm)
Manufactured by Quanta, Taiwan (2007)

The XO Laptop, previously known as the $100 Laptop, is a
computer conceived for children all over the globe. One Laptop
per Child (OLPC), a nonprofit program begun at the MIT Media
Lab that gathers an extraordinary group of experts and inno-
vators in product and interface design, manufacturing, and
engineering, was sparked by the realization of the educational
impact that computers have on students in developing countries.
Fuseproject integrated the XO Laptop within a compact, durable
geometry. "XO is the size of a textbook and lighter than a
lunchbox," the designers explain. Many features serve at least
two purposes: wireless-access antennas double as covers for
the USB ports, the handle serves as an attachment for a strap,
and the protective bumper also seals to protect from dust.
The screen has both a full-color mode and a reflective high-
resolution mode that is readable in bright sunlight. A wide track
pad doubles as a drawing/writing tablet. The computer can be
recharged by human-powered devices such as a yoyo-like pull
cord, in case electricity is not available. Governments purchase
the computers and distribute them for free to their schools.

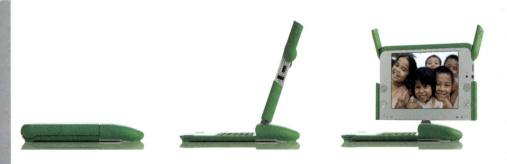

Lisa Strausfeld (American, born 1964), Christian Marc Schmidt (German, born 1977), and Takaaki Okada (Japanese, born 1978) of Pentagram (UK and USA, est. 1972) Eben Eliason (American, born 1982) and Walter Bender (American, born 1956) of One Laptop per Child (USA, est. 2005) Marco Pesenti Gritti (Italian, born 1978) and Christopher Blizzard (American, born 1973) of Red Hat, Inc. (USA, est. 1993)*

Sugar interface for the **XO Laptop** 2006–07
Design: Illustrator, Photoshop, Flash, Inkscape, and GIMP (GNU Image Manipulation Program) software; implementation: Python, GTK+ (GIMP Toolkit), and Cairo software

Teams from Pentagram and Red Hat have created an icon-driven interface that recognizes and exploits the user's potential to be "both a learner and a teacher." Collaboration is placed at the core of the experience and the laptop encourages activities and social interaction. Most activities center on the creation of an object—a drawing, a song, a story, a game— and on "real-world metaphors" such as chatting, sharing, and gathering as the primary sources of creative expression. All the laptops are connected in a wireless network, both to the Web and to one another. "By exploiting this connectivity within the community, among people, and their activities," the information designers explain, "OLPC makes use of what people already know in order to make connections to new knowledge."

*Ideas and efforts regarding the design and development of this open-source project have come from various entities. Although this is the core team, it cannot take sole credit for everything that has come to define the user interface.

Multilingual Interface ?
JUST WRITE !

Handwritting interface for
primary education

Picopeta Simputer October 2003

Designers wish to prevent diversity of language, illiteracy, or lack of resources from becoming impediments to connecting with the global network of knowledge and exchange.

P. R. Subramanya (Indian, born 1969), Swami Manohar (Indian, born 1960), K. S. Vivek (Indian, born 1975), and V. Vinay (Indian, born 1964)
PicoPeta Simputers Pvt. Ltd. (India, est. 2001)
Interface for Amida Simputer 2004
Linux and OpenAlchemy software, 5 5/8 × 2 7/8 × 7/8" (14.2 × 7.2 × 2 cm)
Manufactured by Bharat Electronics Limited, India (2004)

The Amida Simputer is a low-cost handheld computer designed for use in developing countries and other environments where personal computers are not readily available. "The word 'Simputer,'" its creators explain, "is an acronym for 'simple, inexpensive, and multilingual people's computer.'" By providing multiple user-interface options, including handwriting recognition, multilingual text, audio, and images, Simputer strives for universal accessibility.

Chris Vanstone (British, born 1977) and Mickaël Charbonnel
(French, born 1977) of Human Beans (UK, est. 2001)
What's Cooking Grandma? 2006
www.humanbeans.net/whatscookinggrandma
HTML, Dreamweaver, Photoshop, and Illustrator software

With proportions given in pinches, dashes, and handfuls, grandma's
recipes are almost impossible to transcribe. Instead, Human
Beans proposes to collect videos of women cooking in their
own kitchens so that one can appreciate not only the process
but also the story behind each recipe. The What's Cooking
Grandma? Web site brings together grandmothers from around
the world and centuries of cooking experience, preserving
traditions and oral histories. Each video clip has an emotional,
cultural, and historic value. The project will take on even more
meaning as great-grandchildren and beyond will be able to learn
directly from women whom they might never have met, and
serves as an example of the Internet working "as a collective
memory and a keeper of family records, allowing grandma to
reach across many generations."

Nana Ruth's Blackcurrant Jam and Scones, Lancaster UK

What's Cooking Grandma?

http://www.whatscookinggrandma.net/

Q Google

What's Cooking Grandma?

What's
Cooking
Grandma?

Grandmas of the world share their special recipes...read more

Share
How to send in your recipe

Film
Tips on filming a grandma

Record
Tips on recording audio

Upload

Subscribe to Podcast
iTunes RSS PODCAST

News: Nana Ruth and Grandaughter Lauren (they're in the photo above) featured on Radio 4's Woman's Hour. Listen again here for Lemon Meringue Pie...
Tell us what you think of What's Cooking Grandma?: hello@whatscookinggrandma.net

As featured on
Woman's
Hour

Nana Ruth
Coming soon to What's Cooking Grandma?
Nana Ruth's Lemon Meringue Pie. Until then
why not try her jam and scones...
Add comment

Pain d'épice de Mémée Denise
Denise from Arles makes a delicious spiced
bread with honey, aniseed and orange peel.
Add comment

Jackie's Scones
Jackie & her scones are the main attraction
at Casey Cosy Corner Cafe, Lancaster.
Add comment

Latest recipes

Le pain d'épice de Mémée Denise
Filmed by Mickaël Charbonnel

Mémée Denise shows us the secret of her French spiced
bread.
Add comment

Grandma Anna's Berry Quark
Filmed by Taina Rahkol

Finnish Grandma Anna makes Berry Quark with her
grandson Jyri.
Add comment

Gran Hilda's Parkin

Nana Ruth's Jam and Scones

Elephants Dream 2005–06

Producer: Ton Roosendaal (Dutch, born 1960);
director: Bassam Kurdali (American, born Syria 1973);
art director: Andreas Goralczyk (German, born 1985);
lead artists: Matt Ebb (Australian, born 1979), Bastian Salmela
(Finnish, born 1974), and Lee Salvemini (Australian, born 1986)
Blender Foundation (The Netherlands, est. 2002)
The Netherlands Media Art Institute (The Netherlands,
est. 1978)
Blender, GIMP, and Inkscape software

Elephants Dream, a 3-D open-source movie, "tells the story
of Emo and Proog, two people with different visions of the
surreal world, full of strange mechanical creatures and tech-
nological landscapes, in which they live." Along with all its com-
ponent files, the film has been released under the Creative
Commons "some rights reserved" license, which "allows individuals
and companies to redistribute, publish, screen, learn from,
copy, edit, re-create, and even sell their own animations based
on the original data files used to create the movie," explains
the movie's producer. Moreover, Elephants Dream has established
the viability of the open-source model even in a production
environment by benefiting from the collaboration of hundreds
of people who "volunteered 3-D object textures, animation,
translations, and...intensive enhancement and retooling of
the Blender software."

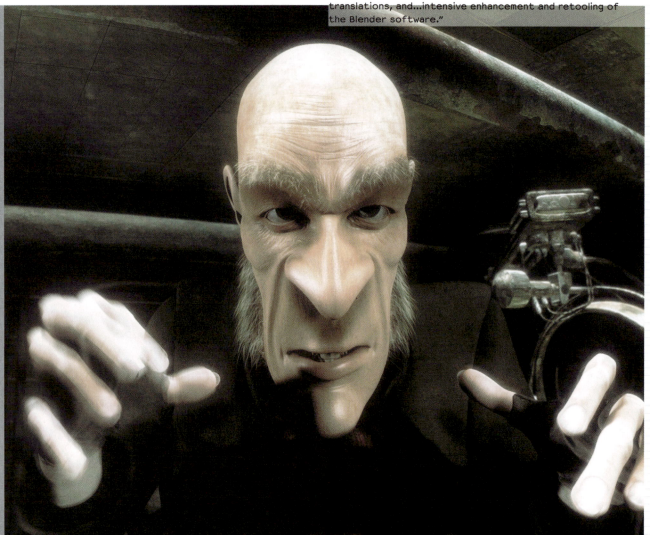

Design and the Elastic Mind

1

The Netherlands Society for Nature and Environment
(The Netherlands, est. 1972), Delft University of Technology
(The Netherlands, est. 1842), Eindhoven University of
Technology (The Netherlands, est. 1956), and University of
Twente (The Netherlands, est. 1961)

c,mm,n open-source car Prototype. 2006–07
Aluminum chassis and Xenoy iQ, Lexan, and HPPC thermoplastics,
59" × 69" × 12' 6" (150 × 175 × 380 cm)
Exterior: Remco Timmer (Dutch, born 1982); interior:
Neele Kistemaker (Dutch, born 1980) and Caroline Klop (Dutch,
born 1982); branding: Jacco Lammers (Dutch, born 1981)
Engineering: Gilbert Peters (Dutch, born 1981), Martin
Leegwater (Dutch, born 1983), Niels Scheffer (Dutch, born
1981), Stefan van Loenhout (Dutch, born 1982), Bart de Vries
(Dutch, born 1983), Gert Jan Endeman (Dutch, born 1982),
Jeroen Terlouw (Dutch, born 1982), Jos Thalen (Dutch, born
1984), and Lucien De Baere (Dutch, born 1981)

C,mm,n (say it out loud and in one breath and you will understand
both the name and the philosophy of the project) is "an open-
source platform in which the car is further refined by students
of three Dutch universities with any enthusiasts interested in
the future of the automobile." Constantly being developed and
improved to keep pace with our demands for smarter, more
sustainable products, c,mm,n runs on fuel cells powered by
ecologically produced hydrogen and also uses other strategies,
such as regenerative braking, to further its energy efficiency.
The car is the focus of a networked community that empowers
consumers, giving them control over the quality and sustainability
of their means of transportation.

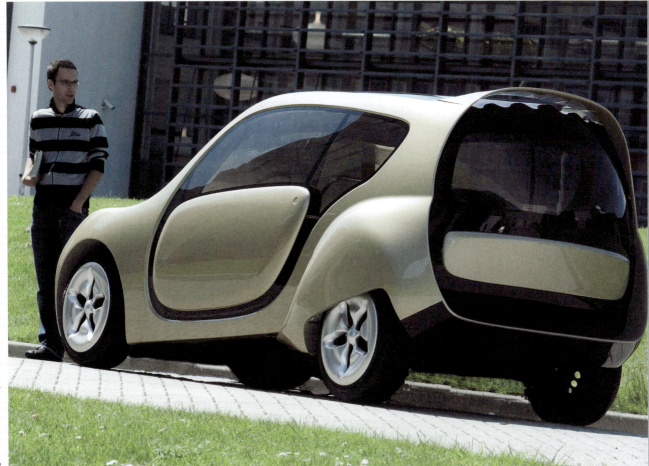

Much contemporary production is the result of the synthesis of different sources. In Jamaican reggae culture, mashups are elaborations of existing tunes remastered with different words and covered by different musicians with distinctive styles and arrangements. Web mashups are applications that combine different sources into a single platform, making them one face of collaborative design on the Internet. Examples using Google Maps are perhaps the most well known, complete with the familiar red markers—defined as pushpins, upside-down teardrops, or even apostrophes—that people use to tag their maps and share their world, their passions, and their knowledge. In other cases, mashups may be coordinated by public authorities and used to spread practical information about subjects ranging from crime rates to sex offenders' domiciles.

Janis Mussat (Canadian, born 1970) and Adam Putter (Canadian, born 1975) of Bad Math Inc. (Canada, est. 2001)
beerhunter.ca 2005–ongoing
PHP, MySQL, Photoshop, and Google Maps API software

Spots where you can find beer in Toronto in real time.

Alex Tingle (British, born 1969) of firetree.net (UK, est. 2002)
flood.firetree.net 2006–ongoing
Debian GNU/Linux, Apache, Google Maps API, and Flood Maps custom software

Flood maps from all over the world.

Ian Spiro (American, born 1981)
fastfoodmaps.com 2005–ongoing
JavaScript, PHP, SQL, HTML, CSS, Awk, Sed, Bash, Illustrator, and Google Maps API software

Fast-food joints all over the United States.

Bailey Stevens (American, born 1984)
Genderqueer Hackers Collective (USA, est. 2006)
safe2pee.org 2006–ongoing
Linux, Apache, MySQL, PHP, Yahoo Geocoding API, Phoogle, and Google Maps API software and S2P engine
Nine hundred eighty-six public bathrooms in 296 cities in the United States and Canada (and counting).

Paul Degnan (American, born 1971)
www.gmap-pedometer.com 2005–ongoing
JavaScript, HTML, PHP, and Google Maps API software

Calculates distances for projected treks.

Morgan Clements (American, born 1969) of TransitSecurityReport.com, Inc. (USA, est. 2006)
globalincidentmap.com 2006–ongoing
MySQL, RSS, KML, Google Maps API, and proprietary software
Display of terrorist incidents and other suspicious events around the world.

David Troy (American, born 1971) of Popvox LLC (USA, est. 2004)
twittervision.com 2007–ongoing
JavaScript, Ruby On Rails, MySQL, and Google Maps API software

A mapped version of twitter.com, a site where people from all over the world send pictures and state what they are doing at that precise moment.

Kara Oehler (American, born 1978), Christopher Allen (American, born 1980), Jesse Shapins (American, born 1980), Brian House (American, born 1979), Geoffrey Guinta (American, born 1984), and Nathan Phillips (American, born 1976) of Counts Media, Inc. (USA, est. 2004)
Kapono Chung (American, born 1981) and Chahn Chung (American, born 1977) of School of Thought (USA, est. 2006)
yellowarrow.net/capitolofpunk 2006–ongoing
PHP, JavaScript, TextWrangler, Flash, Illustrator, Photoshop, After Effects, Dreamweaver, and Google Maps API software

Punk history sites around Washington, D.C.

Adrian Holovaty (American, born 1981) and
Wilson Miner (American, born 1981)
chicagocrime.org 2005–ongoing
Django and Google Maps API software

Database of crimes reported in Chicago in 2006 and 2007.

David McNamara (Irish, born 1980) of mackers.com
(Ireland, est. 1999)
dartmaps.mackers.com 2005–ongoing
PHP, XML, HTML, JavaScript, CSS, and Google Maps API software

Real-time location of all the trains in Dublin's suburban rail network (DART).

Robert Jan de Heer (Dutch, born 1972) of J3Trust B.V. (The Netherlands, est. 2006)
misdaadkaart.nl 2006–ongoing
PHP, MySQL, Linux, and Google Maps API software

Real-time crime information in The Netherlands, organized by street.

Noel Gorelick (American, born 1968) and
Michael Weiss-Malik (American, born 1978)
Mars Space Flight Facility, Arizona State University
(USA, est. 1990)
Google, Inc. (USA, est. 1998)
www.google.com/mars 2005–ongoing
ImageMagick, DaVinci, Google Earth Fusion, and Google Maps API software

There is not much tagging on Mars (yet), but we could not resist featuring one of the most exciting new entries.

David Troy (American, born 1971) of Popvox LLC (USA, est. 2004)
flickrvision.com 2007–ongoing
JavaScript, Ruby On Rails, MySQL, and Google Maps API software

A mapped version of Flickr, the photo-sharing Web site.

Synnøve Fredericks (British, born 1983)
Central Saint Martins College of Art and Design (UK, est. 1989)
Doffing Headphones Concept. 2006
Bluetooth-powered headphones, brass, faux tortoise shell, and hand-carved English holly wood, earpiece: 13 3/8 × 1/2" (35 × 1.4 cm) diam.; handle: 3 3/8 × 1 1/8 × 3/8" (8.5 × 3 × 1 cm)

New technologies such as cell phones and portable music players, which immerse users in an inner world, demand their own code of etiquette. With this in mind, designer Synnøve Fredericks created the Doffing Headphones, inspired by two episodes: an article in The Chap—a British magazine that proposes a return to a dandified way of life—protesting the decline of manners, and a mobile clubbing event in Liverpool Street station in London. Mobile clubbing happens when "a group of people gather with their personal stereos to listen to their own choice of music, while dancing with their friends" who are also listening to their preferred tunes. Watching the participants interact, Fredericks "noticed they would take one earpiece off if they were greeting someone but didn't want to stop, and both if they were stopping for conversation." This mimics the tradition of hat-doffing, where a gentleman would lift his hat and replace it when greeting someone in the street, or remove it completely when stopping for a conversation, especially in front of a lady. The Doffing Headphones call upon the traditions and social graces of the top hat to create a code of manners for the users of an everyday technology.

Crispin Jones (British, born 1974), Graham Pullin (British, born 1964), Matthew Hunter (British, born 1970), and Anton Schubert (British, born 1968)
IDEO London (UK, est. 1971)
SoMo3 Musical Mobile from the **Social Mobiles project** Model. 2002
Limewood, steel, ABS plastic, and GSM phone,
11 3/4 × 2 3/8 × 7/8" (30 × 6 × 2 cm)

The Social Mobiles project consists of "five phones that modify their users' behavior in different ways in order to make it less disruptive," explain the designers. The handsets have not been conceived as actual products but rather as sparks for further discussion about the social impact of mobile phones. SoMo1 delivers an electric shock whose intensity varies depending on how loudly the person at the other end of the line is speaking. It is intended for "repeat offenders who persistently disturb others with their intrusive conversations." SoMo2 allows the person receiving a call in a quiet place to converse without any words but rather with highly expressive individualized sounds. The SoMo3 musical phone (featured here) requires its user "to 'play' the melody of the telephone number he wishes to call. The public performance that dialing demands acts as a litmus test of whether or not it is appropriate to make a call." With SoMo4, "the user knocks on his phone to communicate the urgency of the call. Given time people would learn to recognize each other's knocking mannerisms." The SoMo5 catapult mobile can be used to launch sound bombs into other people's annoying phone conversations—no doubt a product many people have dreamed of using on more than one occasion.

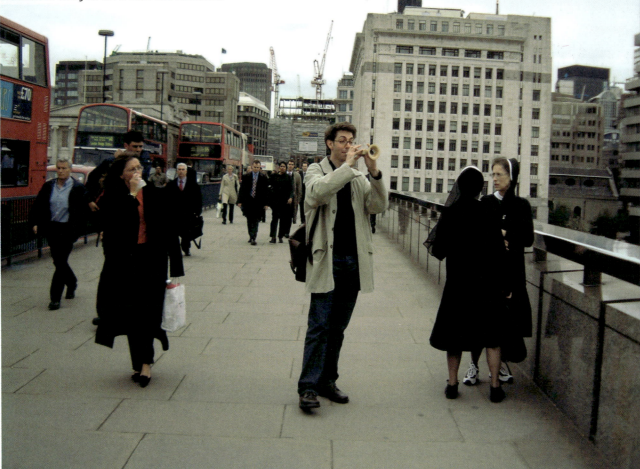

Energy can be renewed biologically within the individual
with some good old-fashioned sleep.

Marie-Virginie Berbet (French, born 1979)
École nationale supérieure de création industrielle
(ENSCI-Les Ateliers) (France, est. 1982)
Narco from the **Analeptic project** Prototype. 2006
Polycarbonate, 70 7/8 × 47 1/4 × 63" (180 × 120 × 160 cm)

"Narco is a cell for napping," designer Marie-Virginie Berbet
says of one of two devices she created for Analeptic, her
project that aims to guarantee optimal physiological conditions
at the workplace. The interior of the cocoon consists of a
series of strips that offer sound and visual insulation from
the surroundings without creating a feeling of claustrophobia.
The number of strips increases around the sleeper's head for
better support and insulation while the hammocklike position
suggests levitation. The cell detects the exact moment the
user falls asleep, and ten minutes later—enough time to be
restorative but right before deep sleep sets in—the cocoon's
strips begin emitting a soft light to gently awaken him or her.

Marie-Virginie Berbet (French, born 1979)
École nationale supérieure de création industrielle
(ENSCI-Les Ateliers) (France, est. 1982)
Cyclo from the **Analeptic project** Prototype. 2006
Injected polymethyl methacrylate, lamp: 8 × 6 1/4" (20 × 16 cm)
diam.; desk blotter: 31 1/2 × 23 5/8" (80 × 60 cm)

Cyclo, the second part of Marie-Virginie Berbet's Analeptic
project, is a rotating light consisting of "a desk blotter with
behavioral and physiological sensors that detect the user's
arousal level" and a rotating light with interdependent strips
that switch on and off in sequence. The intensity of the light
and the speed of the switching and rotation vary according
to the user's stimulation and activity levels, from hyperactive
to tired, in an effort to detect the extreme behaviors that
keep the vicious circle of stress and exhaustion going.
At normal levels, "the light turns slowly, passing imperceptibly
from one strip to the next." When hyperactivity is high,
"the light turns fast and generates shadows on the desk-
blotter." When this happens, Cyclo progressively slows down,
inducing the user to do the same and relax. If the person
is instead sleepy and fatigued, "the light stops turning.
Its intensity rises in the front strips to provide a screen of
blue light, which has stimulating effects. Following the latest
advances in phototherapy, the light emitted (446–477nm) is
centered in the blue wavelength, specifically responsible
for the biological effects of light: the blocking of melatonin
secretion," and the subsequent increase of arousal level.

Julien Arnaud (French, born 1974) with scientific
consultant Alain Nicolas (French, born 1965)
École Supérieure Art & Design Saint-Étienne (ESADSE/
Cité du Design) (France, est. 1857)

Le Temps Blanc Concept. 2006
DuPont Corian, neon tubes, speakers, soundproof foam, MDF,
aluminum, and polyethylene, 15 3/4 × 8 × 6" (40 × 20 × 15 cm)
Model manufactured by Florian Mery, France (2006)

Somnolence is one of the foremost dangers on the road.
Le Temps Blanc, a personal rest area, provides a controlled
ambience that gradually leads the driver toward a refreshing
sleep. Scientific consultant Alain Nicolas, a specialist in sleep
disorders and hypnosis, helped designer Julien Arnaud define
the parameters that take the user toward sleep and then
bring him back to a waking phase so that he can continue with
his journey. The driver pulls his car into a white box in which
light, sound, and temperature are adjusted to guarantee a
restorative sleep. During the twenty-minute sequence, light
and sound fade away into complete darkness and silence, and
then come back gradually to assure complete awakening. The
space itself has been conceived as a ghostly apparition—a
reference to the legend of the dames blanches (white ladies),
the souls of women killed on the road that are said to appear
to warn drivers of danger.

Peter Frankfurt (American, born 1958) of Imaginary Forces
(USA, est. 1996)
Greg Lynn (American, born 1964) of Greg Lynn FORM
(USA, est. 1994)
Alex McDowell (British, born 1955) of Matter Art and Science
(USA, est. 2001)
New City Concept. 2008

New City, like Second Life, Protosphere, OLIVE, the teen world
Habbo, and Multiverse—which aspires to link them all—is a "real
virtual place" to visit and explore. In this project, developed
for Design and the Elastic Mind, the whole world is seen as a
city and "the topology of the earth is mapped onto a folded
virtual manifold," explain the designers. A dense, urban place
of perpetual transformation and self-generation, New City
develops a new model of urbanism in which "contemporary
communication, lifestyle, and globalization are engaged into an
ideal urban and architectural space of historical, economical,
cultural, social, and intellectual interactions." Architecture is
built to reflect the physical laws of a manifold city in motion.
The movement and behavior of its population is reflected in
the dynamic motion of the city in, around, and through itself.
Immersive but not fantastic, New City attempts to change
our perception and experience of the real world.

James Auger (British, born 1970) and
Jimmy Loizeau (British, born 1968)
Interstitial Space Helmet (ISH) Prototype. 2004
Polycarbonate and electronic media, 8 5/8 × 11 3/4 × 17 3/4"
(22 × 30 × 45 cm)

The Internet, Webcams, and other forms of digital mediation
of human representation have created new behaviors and
complex forms of social interaction. We have become so used
to this new dimension that without the safeguard of the
computer screen and our artificial personae, we might have
difficulties dealing with real people in the physical world. The
Interstitial Space Helmet (ISH) makes it possible for the user
to exist as a screen-based entity in the real world, super-
imposing the preferred digital form over an actual presence.
On its own, the ISH offers a reflective space for meditative
therapy where a user with low self-esteem can get back in
touch with his or her inner self. With two or more users, it
provides an environment that avoids the awkwardness of a
first encounter with a stranger and helps in dealing with
potentially embarrassing situations. The user can regain
control over the face he presents to the world by "manipu-
lating his live digital image, both in real and interstitial
meetings, through an electronic filter offering different
camera angles, lighting, and digital effects."

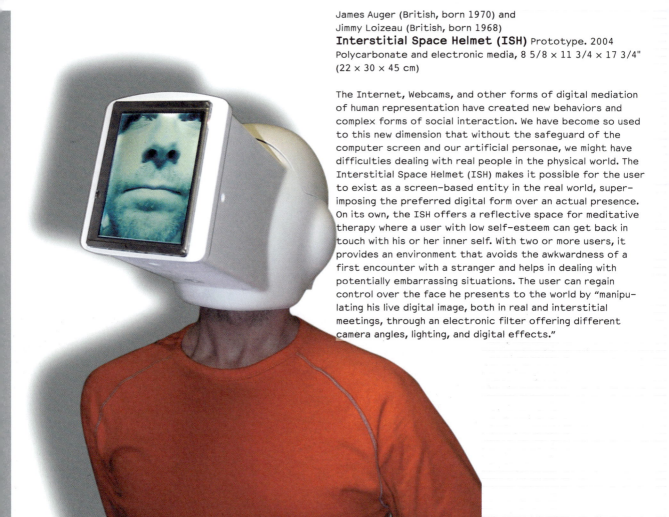

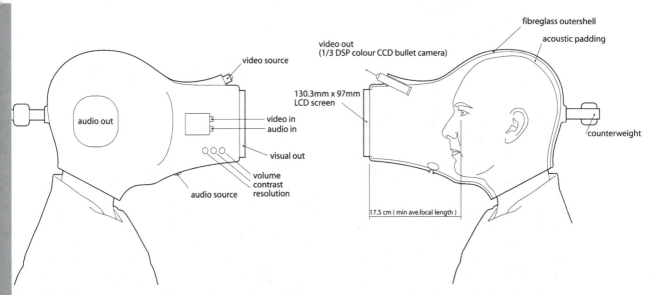

video out
(1/3 DSP colour CCD bullet camera)

fibreglass outershell

acoustic padding

video source

130.3mm x 97mm
LCD screen

audio out

video in
audio in

visual out

volume
contrast
resolution

audio source

counterweight

17.5 cm (min ave.focal length)

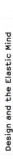

Design and the Elastic Mind

1

James Auger (British, born 1970) and
Jimmy Loizeau (British, born 1968)
Design Interactions Department (est. 1989),
Royal College of Art (UK, est. 1837)
Social Tele-presence Prototype. 2001
Acrylic plastic, aluminum, electronic media, Sony Glasstron
glasses, video and R/C radio receivers, 15 3/4 × 19 3/4 × 31 1/2"
(40 × 50 × 80 cm)

"Tele-presence can be defined as the experience of being fully
present at a real (nonvirtual) location remote from one's own
physical position by removing all visual and auditory senses
from the body's location and having them operate in real time
from somewhere else," according to designers James Auger and
Jimmy Loizeau. Such technology is currently being used for military
and exploratory purposes by making it possible to subsist in
dangerous or inhospitable environments. Auger and Loizeau's
project explores the application of tele-presence in a social
context—for some a very inhospitable place indeed. Social Tele-
presence consists of a small camera and a binaural microphone
attached to the remote "rented" body or moving object. The
user gets the images from the camera through a wireless con-
nection and views them on a set of TV glasses. The body becomes
a host; its senses are removed and it can only hear the voice
instructions and follow the head movements of its user, trans-
lated in real time. This remote body could allow shy individuals
to visit a sex club or go on blind dates, businesspeople to
attend meetings remotely, and a disabled person to take a walk
while remaining stationary, to name just a few examples.

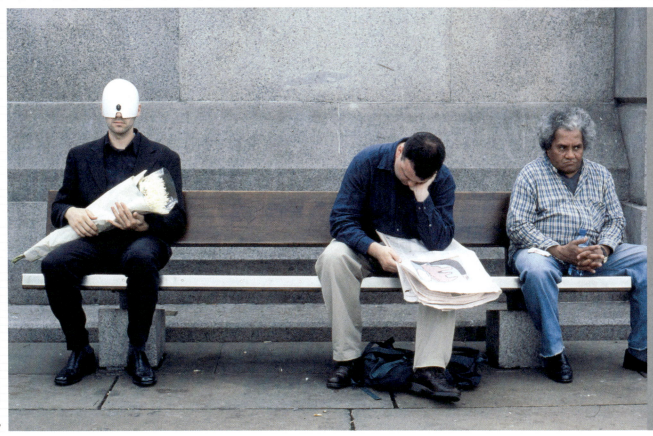

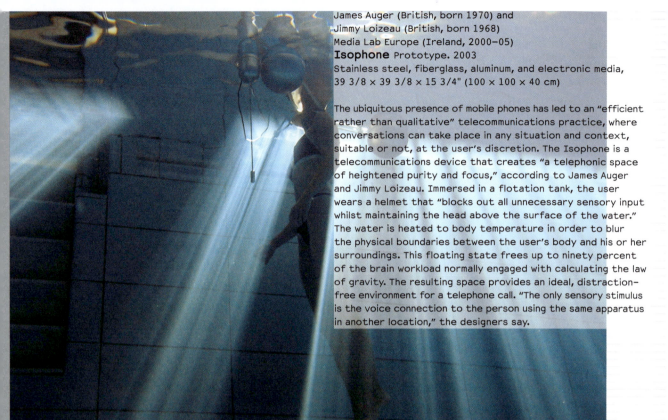

James Auger (British, born 1970) and
Jimmy Loizeau (British, born 1968)
Media Lab Europe (Ireland, 2000–05)
Isophone Prototype. 2003
Stainless steel, fiberglass, aluminum, and electronic media,
39 3/8 × 39 3/8 × 15 3/4" (100 × 100 × 40 cm)

The ubiquitous presence of mobile phones has led to an "efficient rather than qualitative" telecommunications practice, where conversations can take place in any situation and context, suitable or not, at the user's discretion. The Isophone is a telecommunications device that creates "a telephonic space of heightened purity and focus," according to James Auger and Jimmy Loizeau. Immersed in a flotation tank, the user wears a helmet that "blocks out all unnecessary sensory input whilst maintaining the head above the surface of the water." The water is heated to body temperature in order to blur the physical boundaries between the user's body and his or her surroundings. This floating state frees up to ninety percent of the brain workload normally engaged with calculating the law of gravity. The resulting space provides an ideal, distraction-free environment for a telephone call. "The only sensory stimulus is the voice connection to the person using the same apparatus in another location," the designers say.

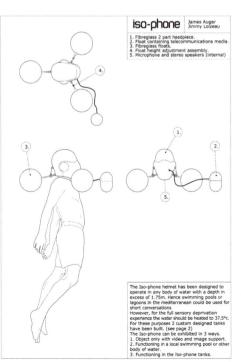

iso-phone James Auger
 Jimmy Loizeau

1. Fibreglass 2 part headpiece.
2. Float containing telecommunications media.
3. Fibreglass floats.
4. Float height adjustment assembly.
5. Microphone and stereo speakers (internal)

The Iso-phone helmet has been designed to operate in any body of water with a depth in excess of 1.75m. Hence swimming pools or lagoons in the mediterranean could be used for short conversations
However, for the full sensory deprivation experience the water should be heated to 37.5°c. For these purposes 2 custom designed tanks have been built. (see page 2)
The Iso-phone can be exhibited in 3 ways.
1. Object only with video and image support.
2. Functioning in a local swimming pool or other body of water.
3. Functioning in the Iso-phone tanks.

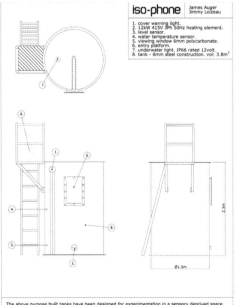

iso-phone James Auger
 Jimmy Loizeau

1. cover warning light.
2. 12kW 415V 3Ph 50Hz heating element.
3. level sensor.
4. water temperature sensor.
5. viewing window 6mm polycarbonate.
6. entry platform.
7. underwater light. IP66 rated 12volt.
8. tank - 6mm steel construction. vol: 3.8m³

The above purpose built tanks have been designed for experimentation in a sensory deprived space. Their current primary usage is in combination with the Iso-phone helmet. They create a controlled environment for testing and exhibition.
The tanks have a built in 3 phase heating element for heating the water to 37.5°c (body temperature) Heating, lighting and all control sensors have been wired through a purpose build electrical control panel. The tanks are portable requiring only 3 phase electrical input and a water supply for full functionality.

Tim Edler (German, born 1965) and
Jan Edler (German, born 1970)
realities:united (Germany, est. 2000)
reinraus mobile balcony unit Prototype. 1993/2001
Steel, aluminum, Pevolon, vulcanized rubber, seat belt strap,
and rope, 47 1/4" × 59" × 8' 2 1/2" (120 × 150 × 250 cm)

Realities:united's reinraus (meaning "clean room") is a proto-
type for a piece of furniture that exploits the space between
buildings "to extend the living area in high-rise urban dwellings."
It can be easily assembled and suspended from the supporting
wall struts on standard windows. Conceived as a temporary
attachment for individual use, reinraus is mounted from within
the user's own apartment, placing it outside the legal sphere
of the building owners, neighbors, and local authorities. With
this project, the designers explore the middle ground between
self and society, creating new border zones.

Many people today are aware of their impact on the earth's finite resources and of the need to offset it through conservation and personal responsibility. Local harvesting of energy from the sun or the wind is one way to alleviate our burden on the environment.

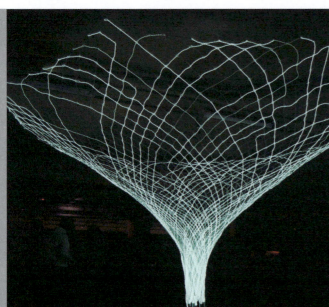

Rachel Wingfield (British, born 1978) and
Mathias Gmachl (Austrian, born 1974)
Loop.pH (UK, est. 2003)
Sonumbra 2006
Electroluminescent lace, camera, speakers, and software,
9' 10" × 16' 4 7/8" (300 × 500 cm) diam.

Sonumbra is "a sonic shade of light," the designers say, an exploration of the roles of new textiles and how they can respond to global ecological concerns. An architectural textile with embedded solar cells is stretched into "an umbrellalike structure fabricated from electroluminescent wires that form an animated lacelike membrane." By day, it offers shelter from the sun; by night, it sheds light using the energy collected during the daylight hours. The temporary installation has been designed to respond to the physical presence of people orbiting around the umbrella. "An omnidirectional camera installed in the mast captures all surrounding activity, translating each person's exact location into sound and light," and the visitors' movements give shape to "an atmosphere of musical rhythms and luminous patterns in which each individual person plays a role and becomes a note in the composition." The designers, from Loop.pH, also are responsible for the biology-inspired Biowall on page 119.

Jeroen Verhoeven (Dutch, born 1976), Joep Verhoeven (Dutch, born 1976), and Judith de Graauw (Dutch, born 1976)
Demakersvan (The Netherlands, est. 2004)
Light Wind Prototype. 2006
Polyester textile, stainless steel, and wood, 15" × 7' × 7' 10 3/8" (38 × 215 × 240 cm)

With the traditional windmills of their country in mind, the designers from the studio Demakersvan have created an outdoor lamp that generates its own energy. With every breeze the Light Wind stores energy, which is then used to produce light.

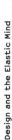

Damian O'Sullivan (Irish, born 1969)
Solar Lampion Model. 2004
Polycarbonate and solar cells, 9 7/8 × 6 1/4" (25 × 16 cm) diam.

Unlike most solar lamps, which are left in a fixed position
outdoors, Damian O'Sullivan's Solar Lampion has been conceived
so that at night users can take the light with them into their
homes. The designer came in contact with solar technology at
a very young age, as his father was responsible for the energy
supply for the satellites launched by the European Space Agency.
The geometric spiraling of the Solar Lampion recalls both natural
structures, such as pinecones, and the shape of traditional
Chinese paper lanterns. The lamp is composed of layers of
concentric rings, each one holding six solar cells inclined thirty
degrees to better catch the sun's rays. Each solar cell is
connected to an LED fed by a rechargeable battery.

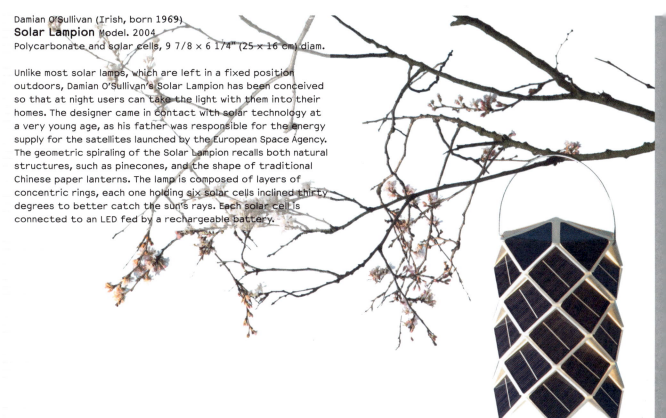

Mathieu Lehanneur (French, born 1974)
Bel-Air organic air-filtering system
Prototype. 2007
Fans, Pyrex glass, aluminum, and plants, 14 1/2 × 16 1/8 ×
26 3/8" (37 × 41 × 67 cm)

Mathieu Lehanneur, attentive to the possibility of incorpo-
rating scientific discoveries into the most ordinary scenarios,
explains that in the mid-1980s NASA identified the ability of
certain plants—Gerbera, Philodendron, Spathiphyllum, and
Chlorophytum are among the most effective—to absorb the
toxins emitted by manufactured goods. A high level of toxic
volatile compounds had been found in astronauts' tissues,
demonstrating that the plastics and synthetic materials of
the spacecraft were slowly poisoning their bodies. The same
effect is being detected in our everyday living environments:
the invisible emissions from paints, plastics, glues, insulation,
and more continue for years after the substances are
manufactured. Lehanneur defines Bel-Air as "a living filter"
that utilizes greenery to absorb the toxic compounds in the
air that surrounds us. The air circulates through the filter
and is purified by the leaves and roots of the plant.

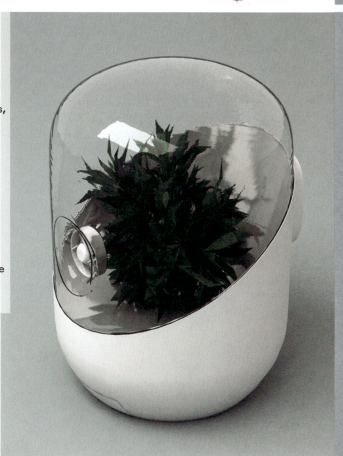

Alberto Meda (Italian, born 1945) and
Francisco Gómez Paz (Argentinean, born 1975)
Solar Bottle Prototype. 2006
PET plastic, 15 3/8 × 2 3/8 × 10 7/8" (39 × 6 × 27.7 cm)

One-sixth of the world's population has no access to safe drinking water. The water that is available is often subject to secondary contamination during collection, transport, and storage, leading to a high incidence of waterborne diseases, a major cause of death among children under the age of five. This reality led designers Alberto Meda and Francisco Gómez Paz to explore new ways to deliver more potable water to areas in need. The Solar Bottle employs the Solar Water Disinfection (SODIS) method, which uses UV-A radiation and the heat of solar energy to destroy the pathogenic micro-organisms that cause waterborne illness. The system works by exposing untreated water to full sunlight for at least six hours in transparent plastic bottles, some enhanced with reflective surfaces such as corrugated iron sheets. The Solar Bottle "improves this method while integrating a transport solution," the designers explain. The molded PET plastic container has a transparent face for the collection of infrared rays and a reflective side to increase the temperature of the water. The integrated handle allows for angular regulation to sun exposure.

Sheila Kennedy (American, born 1959), Sloan Kulper (American, born 1980), Jason O'Mara (American, born 1983), Patricia Gruits (American, born 1983), and Casey Smith (American, born 1972)
KVA MATx (USA, est. 2000)
Portable Light Prototype. 2004–ongoing
PET plastic, aluminized antimicrobial nonwoven textile, copper indium gallium deselenide nano-solar cells, high-brightness LEDs, microprocessor, cotton, and acrylic and wool yarns, folded: 7 × 16" (17.8 × 40.6 cm); unfolded: 24 × 36" (61 × 91.4 cm)

In order to provide "off-grid, renewable electrical power" to the large number of people who do not have access to energy sources, the KVA MATx team, an interdisciplinary design practice at Kennedy & Violich Architecture, focused on integrating solar nanotechnology and soft optics into textiles. Their Portable Light is a renewable, self-sufficient, and sustainable source of power, and unlike traditional silicon-based solar panels it can be easily folded and transported. Moreover, the textile "can be integrated by local cultures using traditional weaving and sewing technologies in an open-source model." The use of familiar materials creates "the opportunity for greater levels of cultural acceptance of this technology," particularly by developing countries' most important resource, women. According to the designers, "Each Portable Light unit generates about one hundred lumens of white light, enough to read by and do domestic tasks, and generates two watts of electrical power. Individual units may be grouped to work together to create up to five hundred lumens of light, and power can be pooled up to twelve volts to charge medical equipment and laptops."

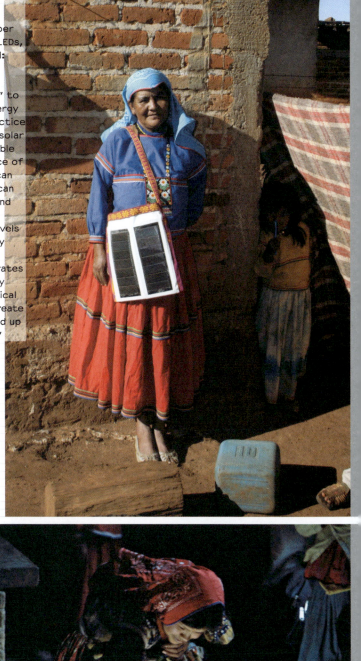

3

The more we live at different scales and in different dimensions, the more our roots become emotionally and psychologically important. That is why so many excellent designers are focusing on the ineluctable qualities that we carry with us through our dimensional journeys—our feelings, emotions, and our memories of ourselves and of the people we love. These last two projects deal with the final frontier—death—and update our coping mechanisms to fit the current technological zeitgeist.

Michele Gauler (German, born 1973)
Design Interactions Department (est. 1989),
Royal College of Art (UK, est. 1837)
Digital Remains Prototype. 2006
Aluminum, wood, acrylic, and electronic media,
8' 9" × 6' 6 3/4" × 6' 6 3/4" (270 × 200 × 200 cm)

We are no longer simply products of our physical environment. Our world is in our computers, portable media players, and wireless handheld devices; our data is stored on remote networks, creating digital archives of entire generations of people. Designer Michele Gauler raises the question of what happens to all of this information when we pass away—mydeathspace versus myspace. In a time when our data is stored in a virtual space, "physical access keys to these data would become objects of remembrance," she postulates. By means of a beautiful, personalized data storage artifact equipped with a Bluetooth connection, Digital Remains "allows us to log on to the digital remains of a person and receive their data on our own digital devices." Search algorithms dig through a deceased person's data, pulling out personal traces most likely relevant to us, like a photograph from a holiday spent together or a favorite piece of music, evoking the presence of the deceased. "New technologies bring new ways of mourning," Gauler says.

James Auger (British, born 1970) and
Jimmy Loizeau (British, born 1968)
Design Interactions Department (est. 1989),
Royal College of Art (UK, est. 1837)
Philips Design (The Netherlands, est. 1891)
Microbial Fuel Cell from the **AfterLife project**
Concept. 2001–ongoing
Polycarbonate and aluminum, 6' 8" × 22" × 18"
(203.2 × 55.9 × 45.7 cm)

James Auger and Jimmy Loizeau have envisioned a "technologically
mediated service providing an expression of life after death
for those who are spiritually disconnected or demand tangible
evidence." The AfterLife Microbial Fuel Cell is charged with the
decomposed gastric acids of the deceased. The battery can
be engraved with an epitaph and can power a full range of
electronic products, like a flashlight ("Shine on Dad") or even a
vibrator. "As our lives are increasingly mediated by technolog-
ical interventions, the AfterLife project raises the issue of
our increasing faith in technology and our decreasing belief in
organized religion," the designers say. "This electronic state
may be interpreted as a form of regeneration," providing the
skeptic with a "proof of life after biological expiration."

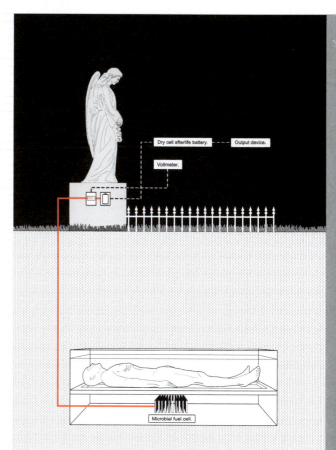

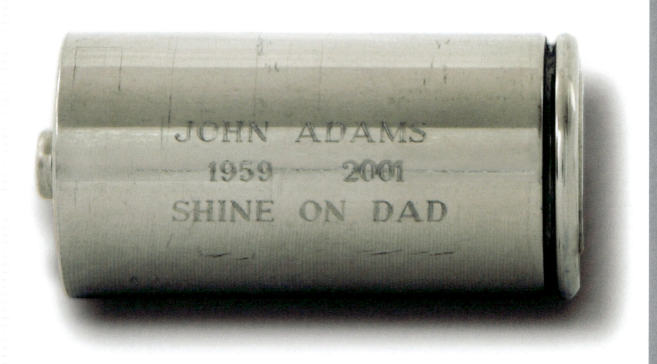

Index

//////// fur //// art entertainment interfaces, Germany, 33
&made, UK, 30
2D:3D, UK, 40

A

Academy of Media Arts, Cologne, Germany, 33
Acron Formservice AB, Sweden, 67
Adai, Alex: Protein Homology Graph, 132
Adam Opel GmbH, Germany, 71
AEDS Ammar Eloueini Digit-all Studio, France, 70
Aesthetics + Computation Group, MIT Media Laboratory, 142
Akishima Laboratories (Mitsui Zosen), Inc., Japan, 65
Aldersey-Williams, Hugh, 18
Allen, Christopher: yellowarrow.net/capitolofpunk, 169
Allen, Rebecca: XO Laptop, 162
Allen, Shawn: Digg Arc, 136
Aranda, Benjamin, 17, 18, 23, 86
Archigram Group, 154
Ardern, Jon: ARK-INC, 29
area/code, 17
Arikan, Burak: Real Time Rome, 149
Arnaud, Julien: Le Temps Blanc, 174
aruliden, USA, 19
Auger, James: 21; LED Dog Tail Communicator, 35; Smell +, 44; Interstitial Space Helmet (ISH), 176; Social Tele-presence, 177; Isophone, 178; Microbial Fuel Cell, 185

B

Bad Math Inc., Canada, 168
Balmond, Cecil, 23, 85, 157
Bannasch, Rudolf: Aqua_ray, 78
Béhar, Yves: XO Laptop, 162
Ben-Ary, Guy: The Pig Wings Project, 114
Bender, Walter: Sugar interface for XO Laptop, 163
BENNETT4SENATE, 16-17
Berbet, Marie-Virginie: 20; Narco, 172; Cyclo, 173
Beta Tank, UK, 42, 64
Biderman, Assaf: Real Time Rome, 149
Biomechatronics Group, Massachusetts Institute of Technology, USA, 73
Biomimetic Devices Laboratory, Tufts University, USA, 79
Blender Foundation, The Netherlands, 166
Bletsas, Michail: XO Laptop, 162
Blizzard, Christopher: Sugar interface for XO Laptop, 163
Boeke, Kees, 46
Bove, V. Michael: XO Laptop, 162
Blue Beetle Design, Singapore, 100
Boontje, Tord, 54
Boym, Constantin, 152
Boym, Laurene Leon, 152
Broadbent, Stefana, 156
Brown, John Seely, 19
Bulthaup, Colin: XO Laptop, 162
Burstein, Eyal: 21; Eye Candy, 42; Bubble Screen, 64

Burton, Michael: 17; Nanotopia, 107; The Race, 108
Business Architects Inc. for Nikon Corporation, Japan, 22-23

C

Caccavale, Elio: 17; MyBio-reactor Cow, 31; MyBio Xenotransplant, 31; MyBio Spider Goat, 31; Future Families, 32; Utility Pets, 113
Cadora, Eric, 130-31
Calabrese, Francesco: Real Time Rome, 149
California NanoSystems Institute, University of California, Los Angeles, USA, 101
Cameron, David: Standby, 30
Carden, Tom: Digg Arc, 136
Cárdenas-Osuna, Raúl: LRPT (La Región de los Pantalones Transfronterizos), 148
Carnegie Mellon University, USA, 137
Catts, Oron: 56; The Pig Wings Project, 114; Victimless Leather, 115
Center for Systems and Synthetic Biology, The University of Texas at Austin, USA, 132
Central Saint Martins College of Art and Design, UK, 170
Chalayan, Hussein, 24-25
Charbonnel, Mickaël: What's Cooking Grandma?, 165
Chipchase, Jan, 156
Chung, Chahn: yellowarrow.net/capitolofpunk, 169
Chung, Kapono: yellowarrow.net/capitolofpunk, 169
Clements, Morgan: globalincidentmap.com, 168
Cochran, Samuel Cabot, 80
Colombo, Joe, 154
Computational Synthesis Lab, Cornell University, USA, 116
Cooperative Association for Internet Data Analysis, San Diego Supercomputer Center, University of California, San Diego, USA, 133
Corner, James, 128
Cosgrove, Denis, 130
Counts Media, Inc., USA, 169
CRAFT Laboratory, Centre de Recherche et d'Appui pour la Formation et ses Technologies, École Polytechnique Fédérale de Lausanne, Switzerland, 35
crasset, matali: Splight table lamp, 74
Crescent, Japan, 67
Crisform, Portugal, 43

D

Dal Fiore, Filippo: Real Time Rome, 149
Daimler AG/Mercedes-Benz Design, Germany, 76
DASK, 16-17
Dawes, Brendan: Cinema Redux: Serpico, 143
De Baere, Lucien: c,mm,n open-source car, 167
de Graauw, Judith: Light Wind, 180
de Heer, Robert Jan: misdaadkaart.nl, 169

de Vries, Bart: c,mm,n open-source car, 167
Deffenbaugh, Bruce: Powered Ankle-Foot Prosthesis, 73
Degnan, Paul: www.gmap-pedometer.com, 168
Deleuze, Gilles, 128
Delft University of Technology, The Netherlands, 167
Demaine, Erik: Computational Origami, 60
Demaine, Martin: Computational Origami, 60
Demakersvan, The Netherlands, 180
Department of Chemistry and Biochemistry, University of California, Los Angeles, USA, 101
Department of Design | Media Arts, School of the Arts and Architecture, University of California, Los Angeles, USA, 135
Department of Naval Architecture and Ocean Engineering, Osaka University, Japan, 65
Department of Physics, California Institute of Technology, USA, 98
Department of Physics, Cornell University, USA, 98
Department of Robotics and Mechatronics, Faculty of Engineering, Kanagawa Institute of Technology, Japan, 65
Design Interactions Department, Royal College of Art, UK, 29, 36, 38, 41, 43, 44, 63, 102-11, 145, 147, 177, 184
d'Esposito, Martino: Wizkid, 35
Digital Image Design Incorporated, USA, 137
Dixit, Sham: Fresnel lens, 61
Donath, Judith, 157
Dunne, Anthony: 22; 102; Technological Dreams Series: no 1, Robots, 28
Dunne & Raby, UK: 28
DuPont, Belgium, 40

E

Eames, Charles and Ray, 10, 20, 46-47, 48-51, 57
Ebb, Matt: Elephants Dream, 166
École cantonale d'art de Lausanne (écal), Switzerland, 27, 62
École nationale supérieure de création industrielle (ENSCI-Les Ateliers), France, 172, 173
École Supérieure Art & Design Saint-Étienne (ESADSE/Cité du Design), France, 174
Edler, Jan: reinraus mobile balcony unit, 179
Edler, Tim: reinraus mobile balcony unit, 179
Eindhoven University of Technology, The Netherlands, 167
Einstein, Albert, 52, 80, 84
Eliason, Eben: Sugar interface for XO Laptop, 163
Eloueini, Ammar: CoReFab #71 chairs, 70
Endeman, Gert Jan: c,mm,n open-source car, 167
Ernstberger, Matthias, 56
Evenhuis, Jiri: Laser-sintered textiles, 69;

Punchbag handbag, 69
EvoLogics GmbH, Germany, 78
Ezer, Oded: Typosperma, 101

F

The Family Planning Association of Hong Kong, China, 153
Feinberg, Jonathan: The Dumpster (Valentine's Day), 137
Festo AG & Co. KG Corporate Design, Germany, 78
Festo Great Britain, UK, 64
Feynman, Richard, 46, 53, 57
Fischer, Markus: Aqua_ray, 78; Airacuda, 78
firetree.net, UK, 168
Foch, Ferdinand, 14
Foster, Mark: XO Laptop, 162
Fox, Kate, 156
FOXY LADY, 16-17
Franke, Uli: Hektor spray-paint output device, 62
Frankel, Felice, 17; Microphotography, 99
Frankfurt, Peter: New City, 175
Fredericks, Synnøve: Doffing Headphones, 170
Freedom Of Creation, The Netherlands, 68, 69
Freeplay Energy Plc., South Africa, 162
Front Design, Sweden, 67
Fry, Ben: 17; 125-27, 139, 158; Genomic Cartography: Chromosome 21, 12-13; Distellamap (Pac-Man), 141; isometricblocks, 142; Humans vs. Chimps, 142
Fukumoto, Takaya: N702iS water-level interface, 39
fuseproject, USA, 162

G

Gagné, Jacques: XO Laptop, 162
Galison, Peter, 18
Gauler, Michele: 21; Eye Candy, 42; Digital Remains, 184
Gecko Design, USA, 162
Genderqueer Hackers Collective, USA, 168
Gershenfeld, Neil, 157
Ghole, Saba: Real Time Rome, 149
Gmachl, Mathias: Biowall, 119; Sonumbra, 180
Google, Inc., USA, 137, 169
Goralczyk, Andreas: Elephants Dream, 166
Gore, Al, 124
Gorelick, Noel: www.google.com/mars, 169
Greg Lynn FORM, USA, 175
Gritti, Marco Pesenti: Sugar interface for XO Laptop, 163
Gruits, Patricia: Portable Light, 183
Guattari, Felix, 128
Guilak, Farshid, 20-21
Guinta, Geoffrey: yellowarrow.net/capitolofpunk, 169
GustavoG: The FlickrVerse: A Graph Depicting the Social Network of the Flickr Community, 135
Gutiérrez, Daniel: Real Time Rome, 149

H

Hadden, Toby: Standby, 30
Hadji, Moloudi, 27
Haeckel, Ernst, 56
Hall, Peter, 18
Harman, Jayden D.: Lily Impeller, 77
Harris, Jonathan: 20, 56; We Feel Fine: An Exploration of Human Emotion in Six Movements, 136
Harvard University, USA, 99
Harzheim, Lothar: Engine mount production component, 71
Haus-Rucker-Co., 154
Heijdens, Simon: Lightweeds wall installation, 118
Heisenberg, Werner, 52, 84
HELL, 16–17
Hernandez, Carlos J.: 18; LithoParticle Dispersions: Colloidal Alphabet Soup, 101
Herr, Hugh: Powered Ankle-Foot Prosthesis, 73
Herrman, Carl T., 53
Hillis, Danny, 20
Hnoosh, Firas, 85
Hoberman Associates, Inc., USA, 37
Hoberman, Chuck, 24; Emergent Surface, 37
Hochschule für Grafik und Buchkunst Leipzig, Germany, 64
Holovaty, Adrian: chicagocrime.org, 169
Hooke, Robert, 47, 52
House, Brian: yellowarrow.net/capitolofpunk, 169
Huang, Sonya: Real Time Rome, 149
Human Beans, UK, 165
Hunter, Matthew: SoMo3 Musical Mobile, 171
Hutchinson, John: XO Laptop, 162
Hyde, Roderick: Fresnel lens, 61
Hyun, Young: Walrus graph visualization tool, 133

I

IBM Research, USA, 137
IBM Thomas J. Watson Research Center, USA, 138
IDEO London, UK, 171
Imaginary Forces, USA, 175
Institute of Bioengineering and Nanotechnology, Singapore, 100
Interactive Telecommunications Program, Tisch School of the Arts, New York University, USA, 38, 139
iWalk, Inc., USA, 73

J

J3Trust B.V., The Netherlands, 169
Jain, Anab: Objects Incognito: RFID and Body Readers, 146
Jancke, Gavin: Microsoft High Capacity Color Barcode, 146
Japanese Metabolists, 154
Jaworska, Agata, 87
Jencks, Charles, 54
Jepsen, Mary Lou: XO Laptop, 162
Jeremijenko, Natalie, 128–29
Jones, Crispin: SoMo3 Musical Mobile, 171
Jones, Richard A. L., 17, 24
Jouin, Patrick: One_shot.MGX foldable stool, 66

K

Kamvar, Sep: We Feel Fine: An Exploration of Human Emotion in Six Movements, 136
Kaplan, Frédéric: Wizkid, 35
Karten, Stuart: Epidermits Interactive Pet, 115
Kelp, Günther Zamp, 154
Kennedy, Sheila: Portable Light, 183
Kerridge, Tobie: 56; Biojewellery, 111
King, James: 18, 56; Fossils from a Nanotech Future, 103; Dressing the Meat of Tomorrow, 106
Kistemaker, Neele: c,mm,n open-source car, 167
Klop, Caroline: c,mm,n open-source car, 167
Kniese, Leif: Aqua_ray, 78
Knubben, Elias Maria: Airacuda, 78
Koblin, Aaron: Flight Patterns, 135
Krishnan, Sriram: Real Time Rome, 149
Kulper, Sloan: Portable Light, 183
Kurdali, Bassam: Elephants Dream, 166
Kurgan, Laura, 130–31
KVA MATx, USA, 183
Kyttänen, Janne: Macedonia fruit bowl, 68; Laser-sintered textiles, 69; Punchbag handbag, 69

L

Laarman, Joris: 56; Bone Chair, 71
Lagerkvist, Sofia: Sketch Furniture, 67
Lammers, Jacco: c,mm,n open-source car, 167
Lang, Robert J.: Origami crease patterns for Eupatorus gracilicornis, opus 476, 58; Scorpion varileg, opus 379 and its Origami TreeMaker file, 59; Origami Simulation software, 60; Fresnel lens, 61
Lasch, Chris, 17, 18, 23, 86
Lauher, Joseph W., 52
Lawrence Livermore National Laboratory, USA, 61
Leegwater, Martin: c,mm,n open-source car, 167
LeFevre, David B., 85
Lehanneur, Mathieu: 20, 54; Elements project, 45; Bel-Air organic air filtering system, 181
Lehni, Jürg: Hektor spray-paint output device, 62
Leonardo da Vinci, 8, 47
Leroi, Armand Marie, 17
Levin, Golan: The Dumpster (Valentine's Day), 137
Li, Huayou, 85
Libertíny, Tomáš Gabzdil: The Honeycomb Vase "Made by Bees", 117
Liden, Johan, 19
Lindgren, Anna: Sketch Furniture, 67
Lipson, Hod: Molecubes functional robots, 116
Loizeau, Jimmy: 21; LED Dog Tail Communicator, 35; Smell +, 44; Interstitial Space Helmet (ISH), 176; Social Tele-presence, 177;

Isophone, 178; Microbial Fuel Cell, 185
Loop.pH, UK: 18, 119, 180
Lynn, Greg, New City, 175
Lyon, Barrett, 53, 120–21

M

Maassen, Lucas, 158–59
mackers.com, Ireland, 169
magneticNorth, UK, 143
Mandelbrot, Benoit, 17, 54
Manohar, Swami: Interface for Amida Simputer, 164
Mann, Michael E., 124–25
Marcotte, Edward: Protein Homology Graph, 132
Mars Space Flight Facility, Arizona State University, USA, 169
Marsh, Bill, 126–27
Mason, Thomas G., 18; LithoParticle Dispersions: Colloidal Alphabet Soup, 101
Massachusetts Institute of Technology, USA, 60, 75
Materialecology, USA, 75
Materialise NV, Belgium, 66,70
Matsumura, Eriko: Hu-Poi, 38
Matter Art and Science, USA, 175
McDowell, Alex: New City, 175
McLuhan, Marshall, 55
McNamara, David: dartmaps.mackers.com, 169
McNulty, William E., 126–27
Meda, Alberto: Solar Bottle, 182
Media Lab Europe, Ireland, 178
Metthey, Mikael: Pox Teddy, 104; The Minutine Space, 105
Michaelis, E. H., 122
Microsoft Research, USA, 146
Microsoft Research Cambridge, UK, 146
Migurski, Mike: Digg Arc, 136
Minard, Charles Joseph, 128
Miner, Wilson: chicagocrime.org, 169
Moe, Justin: Real Time Rome, 149
Mora, Miquel, 41; Flat Futures: Exploring Digital Paper, 41, 147
Morawe, Volker: PainStation, 33
Moutos, Franklin, 20–21
Mussat, Janis: beerhunter.ca, 168
MW2MW, USA, 140
Mytilinaios, Stathis: Molecubes functional robots, 116

N

Naito, Shigeru: AMOEBA (Advanced Multiple Organized Experimental Basin), 65
NEC Design, Ltd., Japan, 39
Negroponte, Nicholas: XO Laptop, 162
Nelson, George, 54
nendo, Japan, 39
Newton, Sir Isaac, 53, 55, 80, 84
Ngan, William, 54–55
Nicolas, Alain: Le Temps Blanc, 174
Nigam, Kamal: The Dumpster (Valentine's Day), 137
Nitta, Michiko: Body Modification for Love, 109; Animal Messaging Service, 145
Noel, Sebastien, 160–61
Nokia Research Center, Nokia Design, Finland, 155

NTT DoCoMo, Japan, 39, 156
Number 27, USA, 56, 136

O

Okuyama, Etsuro: AMOEBA (Advanced Multiple Organized Experimental Basin), 65
O'Mara, Jason: Portable Light, 183
O'Sullivan, Damian: Solar Lampion, 181
Oehler, Kara: yellowarrow.net/capitolofpunk, 169
Okada, Takaaki: Sugar interface for XO Laptop, 163
Olsen, Ken, 14
One Laptop per Child, USA, 20, 152, 163
Ortner, Laurids, 154
Oxman, Neri: The Eyes of the Skin, 75

P

Paley, W. Bradford: 126; TextArc, 137
PAX Scientific, Inc., USA, 77
Paz, Francisco Gómez: Solar Bottle, 182
Pentagram, UK and USA, 134, 163
Peters, Gilbert: c,mm,n open-source car, 167
Pfeiffer, Peter: Mercedes-Benz bionic car, 76
Phiffer, Dan: Atlas Gloves, 38
Philips Design, The Netherlands, 44, 185
Phillips, Nathan: yellowarrow.net/capitolofpunk, 169
PicoPeta Simputers Pvt. Ltd., India, 164
Pinter, Klaus, 154
Piorek, Steve: Epidermits Interactive Pet, 115
Planck, Max, 84
Plastic Logic, UK, 41
PlayPumps International, 156–57
Popvox LLC, USA, 168, 169
Popp, Julius: bit.fall, 64
Powderly, James, 16–17
Powell, Dick, 18–19
Priestley, Joseph, 47
Pullin, Graham: SoMo3 Musical Mobile, 171
Putter, Adam: beerhunter.ca, 168
Pyke, Matt: Lovebytes 2007 identity generator, 144

Q

Quanta, Taiwan, 162

R

Raby, Fiona: Technological Dreams Series: no 1, Robots, 28
Ratti, Carlo: Real Time Rome, 149
realities:united, Germany, 179
Reas, Casey, 139, 158
Recor, Bret: XO Laptop, 162
Red Hat, Inc., USA, 163
Reiff, Tilman: PainStation, 33
Reinfurt, David, 130–31
Rheingold, Howard, 157
Robinson, Arthur, 122, 123
Roosendaal, Ton: Elephants Dream, 166
Rojas, Francisca: Real Time Rome, 149

Roth, Evan, 16–17
Rothemund, Paul W. K., 18, 82, 83
Roukes, Michael: Measurement of the Quantum of Thermal Conductance, 98

S
Sabin, Jenny E., 85
Sagmeister, Stefan, 56
Salmela, Bastian: Elephants Dream, 166
Salvemini, Lee: Elephants Dream, 166
Sargent, Ted, 18
Sato, Oki: N702iS water-level interface, 39
Saunamaki, Jarkko, 155
Sävström, Katja: Sketch Furniture, 67
Scheffer, Niels: c,mm,n open-source car, 167
Schmidt, Christian Marc: Sugar interface for XO Laptop, 163
Schmidt, Karsten: Lovebytes 2007 identity generator, 144
School of Thought, USA, 169
Schrödinger, Erwin, 52, 55, 84
Schubert, Anton: SoMo3 Musical Mobile, 171
Schwab, Keith: 17; Measurement of the Quantum of Thermal Conductance, 98
Sears, James Nick: "Rewiring the Spy," 134
SENSEable City Laboratory, Massachusetts Institute of Technology, USA, 149
Sevtsuk, Andres: Real Time Rome, 149
Shapins, Jesse: yellowarrow.net/capitolofpunk, 169
Shneiderman, Ben, 127
Smith, Casey: Portable Light, 183
Smith, Richard, 18–19
Snow, John, 123, 124
Soares, Susana: 21; BEE'S, New Organs of Perception, 43; Genetic Trace: New Organs of Perception, 110; Genetic Trace, Part Two: Sniffing Others, 110
Sollberger, Simon: Epidermits Interactive Pet, 115
Spherical Robots, Germany, 64
Spiro, Ian: fastfoodmaps.com, 168
Squid Labs, USA, 162
Stamen Design, USA, 136
Stevens, Bailey: safe2pee.org, 168
Stott, Nikki: 56; Biojewellery, 111
Strausfeld, Lisa: "Rewiring the Spy," 134; Sugar interface for XO Laptop, 163
Stuart Karten Design, USA, 115
Studio Libertiny, The Netherlands, 117
Subramanya, P. R.: Interface for Amida Simputer, 164
Surowiecki, James, 157
Swift, Jonathan, 53

T
Tarazi, Najeeb Marc: Real Time Rome, 149
Taylor, Alex: Objects Incognito: RFID and Body Readers, 146
Terlouw, Jeroen: c,mm,n open-source car, 167
Terraswarm, 128–29
Thackara, John, 152
Thalen, Jos: c,mm,n open-source car, 167
The Netherlands Media Art Institute, The Netherlands, 166
The Netherlands Society for Nature and Environment, The Netherlands, 167
The Tissue Culture & Art Project hosted by SymbioticA, The Art and Science Collaborative Research Laboratory, School of Anatomy and Human Biology, University of Western Australia, Australia, 114, 115
Thompson, D'Arcy, 52
Thompson, Ian: 56; Biojewellery, 111
Timmer, Remco: c,mm,n open-source car, 167
Tingle, Alex: flood.firetree.net, 168
Toran, Noam: 22; Accessories for Lonely Men, 34
Torolab, Mexico, 148
toxi, UK, 144
TransitSecurityReport.com, Inc., USA, 168
Trimmer, Barry: SoftBot, 79
Troika, UK, 39, 160–61
Troy, David: twittervision.com, 168; flickrvision.com, 169
Tufte, Edward, 123–25, 127–30
Tyler, Demetrie: Hypothetical Drawings about the End of the World, 139

U
Universal Everything, UK, 144
University of Twente, The Netherlands, 167
Untitled Nations, 158–59

V
van Loenhout, Stefan: c,mm,n open-source car, 167
Vanstone, Chris: What's Cooking Grandma?, 165
van Wijk, Jarke, 123, 127, 128
Verhoeven, Jeroen: Light Wind, 180
Verhoeven, Joep: Light Wind, 180
Viégas, Fernanda Bertini: History Flow, 138
Vilabo, Portugal, 43
Vinay, V.: Interface for Amida Simputer, 164
Vivek, K. S.: Interface for Amida Simputer, 164
von der Lancken, Charlotte: Sketch Furniture, 67

W
Walczak, Marek: Thinking Machine 4, 140
Waldemeyer, Moritz: Pong Table, 40
Walker, John, 18
Ware, Colin, 122, 123, 125–27, 130
Watson, Theo, 16–17
Watt, James, 47
Wattenberg, Martin: History Flow, 138; Thinking Machine 4, 140
Weber, Jeff: Powered Ankle-Foot Prosthesis, 73
Wedgwood, Josiah, 47

Weiss-Malik, Michael: Google Mars, 169
Williams, Sarah, 130–31
Wilson, Edward O., 57
Wilson, Scott, 26
Wingfield, Rachel: Biowall, 119; Sonumbra, 180
Woebken, Christopher: 17, 24; New Sensual Interfaces, 102
Worthington, Philip: Shadow Monsters, 63
Wren, Christopher, 47

Y
Yamamoto, Keijiro: Power Assist Suit, 72
Yanagisawa, Tomoaki: Living Sensors, 36
Yoon, Seonhee, 85

Z
Zanuck, Darryl F., 14
Zer-Aviv, Mushon: Atlas Gloves, 38
Zosen, Mitsui, 55
Zurr, Ionat: 56; The Pig Wings Project, 114; Victimless Leather, 115
Zykov, Viktor: Molecubes functional robots, 116

Acknowledgments

In the planning of this book and of the exhibition Design and the Elastic Mind, I relied on a wide network of extraordinarily elastic, lively, and generous minds. A diverse team of colleagues, volunteers, friends, and accidental consultants contributed immeasurably to the realization of both undertakings, and I will be forever indebted to them.

On behalf of The Museum of Modern Art, I wish to thank all the designers, engineers, artists, scientists, and manufacturers featured here for their cooperation and enthusiasm. I also wish to thank the sponsors for making this endeavor possible, and the lenders for agreeing to part, temporarily, with their possessions.

We in the field of design are in the concept business, and concepts need endless discussion and reconsideration. Together with my co-organizer, Patricia Juncosa Vecchierini, Curatorial Assistant, Department of Architecure and Design, I would like to thank our closest friends and partners, who so often became sounding boards. Larry Carty, first and foremost, and Lisa Gabor, Jane Nisselson, and Jordi Magrané Fonts were the moving targets for our whole team's lucubrations and doubts. Thank you.

In the research phase, Adam Bly, founder and editor-in-chief of the magazine Seed, was our precious resource and interlocutor. He taught me about science and helped me find unexpected shared interests and objectives between science and design. Along with my colleagues and with Meg Rand from his office, in December 2006 we initiated a monthly salon in which designers and scientists were free to discuss and brainstorm topics that then became pillars of the thesis behind the show. Some of the participants, including Benjamin Aranda and Chris Lasch, Felice Frankel, Ben Fry, and Jonathan Harris, are included here and in the exhibition, but all of them should be considered contributors to our enterprise.

A number of authoritative and imaginative advisors suggested some of the works included in the show. I would like to thank them one by one, but space limitations make it impossible. I would, however, like to mention Janine Benyus and Bryony Schwan from the Biomimicry Institute, Steve Sacks from bitforms gallery, Bruno Giussani, and Twan Verdonck, as well as Shumon Basar, Katy Borner, John Calvelli, Curro Claret, Dalton Conley, Elyssa Da Cruz, Niles Eldredge, Neil Gershenfeld, David Imber, Alan Kay, Sulan Kolatan, Sylvia Lavin, Liane Lefaivre, John Maeda, Alexandra Midal, Louise Neri, Enrique Norten, Alice Rawsthorn, Michael Rock, Stefan Sagmeister, Jukka Savolainen, David Schafer, Arne Sildatke, Cornelia Spillmann-Meier, Paul J. Steinhardt, Matt Taylor, Brian Tempest, Maholo Uchida, Luis Villegas, and Garth Walker.

Many of the designers and artists featured in this book also contributed invaluable suggestions. I would like to thank in particular Jon Ardern, Laurene Leon Boym, Anthony Dunne, Felice Frankel, Peter Frankfurt, Ben Fry and Casey Reas, Chuck Hoberman, Agata Jaworska, James King, Lisa Strausfeld, and Moritz Waldemeyer.

This book comes from the hyperelastic mind of one of the most inventive and perceptive designers in the world, Irma Boom, who was able to straddle space and time to produce an amazing visual synthesis of ideas. In MoMA's Department of Publications I wish to thank Christopher Hudson, Publisher; Kara Kirk, Associate Publisher; David Frankel, Editorial Director; Marc Sapir, Production Director; Elisa Frohlich, Associate Production Manager; Libby Hruska, Editor; and Rebecca Roberts, Senior Assistant Editor, for their efforts in bringing the book to light. Interns Isabel Bohrer, Jamieson Bunn, and Lilit Sadoyan provided vital assistance as well. I also wish to thank Joshua Roebke, Associate Editor, and Laura McNeil, Deputy Editor, at Seed Media Group for their help with editing some of the most scientific bits of the volume. Thanks are due as well to David Lo and Martijn Kicken for their valuable technical advice.

Members of the Museum's Board of Trustees deserve special acknowledgment. In particular, I wish to thank Ronald S. Lauder, Honorary Chairman, and Agnes Gund, President Emerita, knowledgeable and enthusiastic fans of design; David Rockefeller, Honorary Chairman; Robert B. Menschel, Chairman Emeritus; Donald B. Marron, President Emeritus; Jerry I. Speyer, Chairman; and Marie-Josée Kravis, President, for their passionate support of the Museum's curators. Glenn D. Lowry, Director, provided early and unwavering support that was crucial to the realization of the exhibition. Jennifer Russell, Senior Deputy Director for Exhibitions, Collections, and Programs, and Peter Reed, Senior Deputy Director, Curatorial Affairs, were integral in successfully bringing this huge ship to port.

I also wish to thank Maria DeMarco Beardsley, Coordinator of Exhibitions, and Randolph Black, Associate Coordinator of Exhibitions, for working out the complicated administrative details; Ramona Bronkar Bannayan, Director, Collection Management and Exhibition Registration, Susan Palamara, Registrar, Exhibitions, Allison Needle, Assistant Registrar, Exhibitions, and Ellin Burke, Project Registrar, for keeping track of the diverse loan items; and Eliza Sparacino, Manager, Collection and Exhibition Technologies, and Ian Eckert, Assistant, Collection and Exhibition Technologies, for helping us keep all our information in order. I would also like to extend thanks to Linda Zycherman, Conservator, and Roger Griffith, Associate Sculpture Conservator, for caring for all the objects.

The installation was indeed a challenge even for our heroic Department of Exhibition Design and Production. Jerry Neuner, Director, and Lana Hum, Production Manager, designed the installation, and their incomparable crew built it, as usual, to perfection. My gratitude goes to them and to Charlie Kalinowski, Media Services Manager, A/V, and to K Mita, Director, Technology Services, and his whole team, who performed miracles in order to ensure that the technology worked smoothly and effectively. The exhibition also lives on the Web, thanks to the magic touch of Allegra Burnette, Creative Director, Digital Media, and Shannon Darrough, Senior Media Developer, Digital Media.

I also thank Todd Bishop, Director, Exhibition Funding; Mary Hannah, Associate Director, Exhibition Funding; and Lauren Stakias, Senior Associate, Exhibition Funding, in the Department of Development and Membership, for securing the necessary funding, not a negligible feat. I thank Kim Mitchell, Director of Communications, and Daniela Stigh, Manager of Communications, for brilliantly condensing the whole show to get the press irresistibly interested, and Peter Foley, Director of Marketing, for promoting it.

I thank the whole Department of Education for their invaluable suggestions on how to communicate the show to the public, in particular Wendy Woon, Deputy Director for Education; Pablo Helguera, Director, Adult and Academic Programs; and Associate Educators Larissa Bailiff, Laura Beiles, Sara Bodinson, and Lisa Mazzola, and I also thank Jennifer Tobias, Librarian, Reader Services, and David Senior, Acquisitions Coordinator, Library, for their enthusiastic assistance with our research.

In the Department of Architecture and Design, I am deeply grateful to Barry Bergdoll, The Philip Johnson Chief Curator of Architecture and Design, who believed strongly in the exhibition and offered his support throughout the project. The entire department was helpful and encouraging and I thank each of its members, especially Peter Christensen, Curatorial Assistant, who participated in the organization of the show in the beginning. A special mention goes to Linda Roby, Department Coordinator, and Candace Banks, Department Assistant, for their untiring assistance. Several brilliant interns worked on this project; I wish to thank Andrea Lipps, Catharine Rossi, and Nadine Stares. Special thanks also go to Hideki Yamamoto, who helped us secure many loans in Asia and contributed ideas, texts, and invaluable criticism.

Lastly, I would like to thank the person with whom I shared this adventure, Patricia Juncosa Vecchierini. Yet another adventure, I should say, and once more she has proved to be the most valuable partner. I am very lucky to have had so many chances to work with her.

Design and the Elastic Mind celebrates the endless and restless curiosity of human beings and praises design as an expression of creativity and an affirmation of life. For this reason, I would like to dedicate this book and this show to the late Herbert Muschamp, who certainly knew what I am talking about.

Paola Antonelli
Senior Curator, Department of Architecture and Design